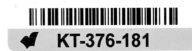

PHOTOGRAPHY YEARBOOK 2000

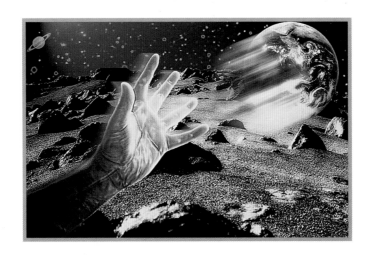

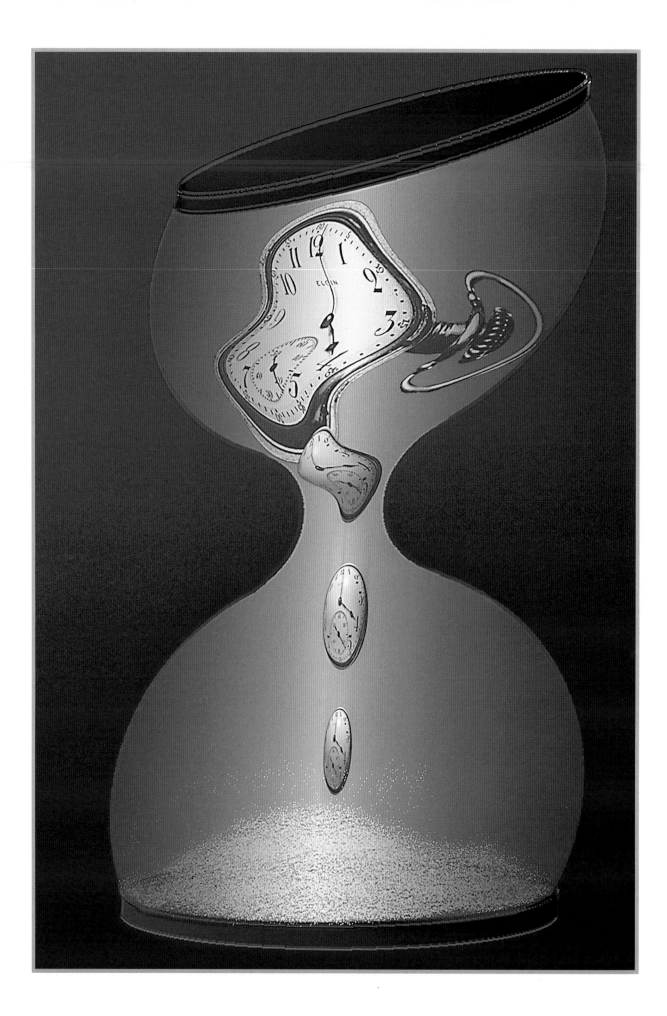

PHOTOGRAPHY YEARBOOK 2000

EDITOR
Chris Hinterobermaier

DESIGNER
Grant Bradford

FOUNTAIN PRESS

PHOTOGRAPHY
YEARBOOK
2000

Published by
FOUNTAIN PRESS LIMITED
Fountain House
2 Gladstone Road
Kingston-upon-Thames
Surrey KT1 3HD

Editor
CHRIS HINTEROBERMAIER

Designed by
GRANT BRADFORD
Design Consultants
Tunbridge Wells, Kent

Reproduction
SETRITE DIGITAL GRAPHICS
Hong Kong

Printed by
SUPREME PUBLISHING
SERVICES

© Fountain Press 1999
ISBN 0 86343 333 2

Title page photograph 'Time Warp' by Nicholas Muskovac

CONTENTS

EDITOR'S MESSAGE

Undoubtedly photography has changed our view of the world in the 20th century. The camera has been the witness of conflict and other historic events, has helped selling goods through advertising as well as recording private joy and tragedy. It has been and will always be the principle of the Photography Yearbook to present the world's most outstanding pictorial photography as a lasting gift to its viewers and as a memorial for those photographers published on the following pages. I am very pleased to be able to continue the tradition in this Millennium edition!

As usual the Photography Yearbook is divided into two parts: a portfolio section enabling the Editor to feature the work of well-known photographers and a gallery section offering the opportunity for photographers from all over the world to have their work published.

For the portfolio section we are continuing the presentation of major photographers and in this edition I am pleased to present the work of Howard Schatz from New York, one of the world's most celebrated photographers, who is famous for his commercial work as well as for his fine art photographic projects, which have been published in eight books.

Francisco Hidalgo from Paris is a living legend of European photography. His city portraits from the seventies have expanded our way of 'sightseeing by photography'. The grandmaster of the creative use of light and filters concentrates on details. What make his prints so remarkable is all the photographs are taken inside the camera and have no digital work.

The French photographer Jean-Daniel Lemoine works in the tradition of surrealism. Well known for his colour print mask technique in the eighties he is now exploring the unlimited possibilities of digital imaging, combining it with the traditional techniques of 19th century photography.

Maggie Taylor from Gainesville, Florida is a young fine art photographer who has had great success in the gallery scene of the United States. She frequently uses her scanner as a camera and often can be found at flea markets, where she gathers together the objects of her photographic desire.

Lin Dung Leung from Hong Kong is the first Asian photographer honoured with a portfolio in the Photography Yearbook. His outstanding success in the international salons of photography and his leading position in the Hong Kong photography scene justifies his place in the portfolio section.

For the first time last year we added a special portfolio to this section, not bound by one personality, but focusing on a region or a theme. As a tribute to the Millennium issue we have this year decided to present the phenomenon of 'Time' from many different viewpoints, seen through the lenses of photographers from around the globe.

Innovation not only in the presented prints, but also in printing technology was necessary to produce this year's edition. Ron Redfern, a scientist by profession and a panorama photographer by vocation could not be shown without making the section containing his works to be expanded. Discover the fascination of his panoramic views in an outstanding fold-out format. And as a premiere we for the first time are able to present holography, the 3-D sister of photography in this book. Martin Richardson discovered holograms whilst a student at the Royal College of Art and he is now one of the few artists working exclusively with holographics. Martin has started recording a holographic library of personalities that interest him. We present a special limited edition hologram with this portfolio.

The second part of the book, the gallery section, is the forum for the best imaginative and creative photography in the world. It is the place for people, who have chosen the camera to record and interpret their view of the world. This unique gallery is open to everyone who wants to send messages to other people by means of photography.

Photography is truly a language for all of us fortunate enough to be able to see and if your thoughts and feelings are influenced by pictures in this edition of the Photography Yearbook then we again have made a small contribution to what we all love so much: Photography!

Dr. Chris. Hinterobermaier

Editor

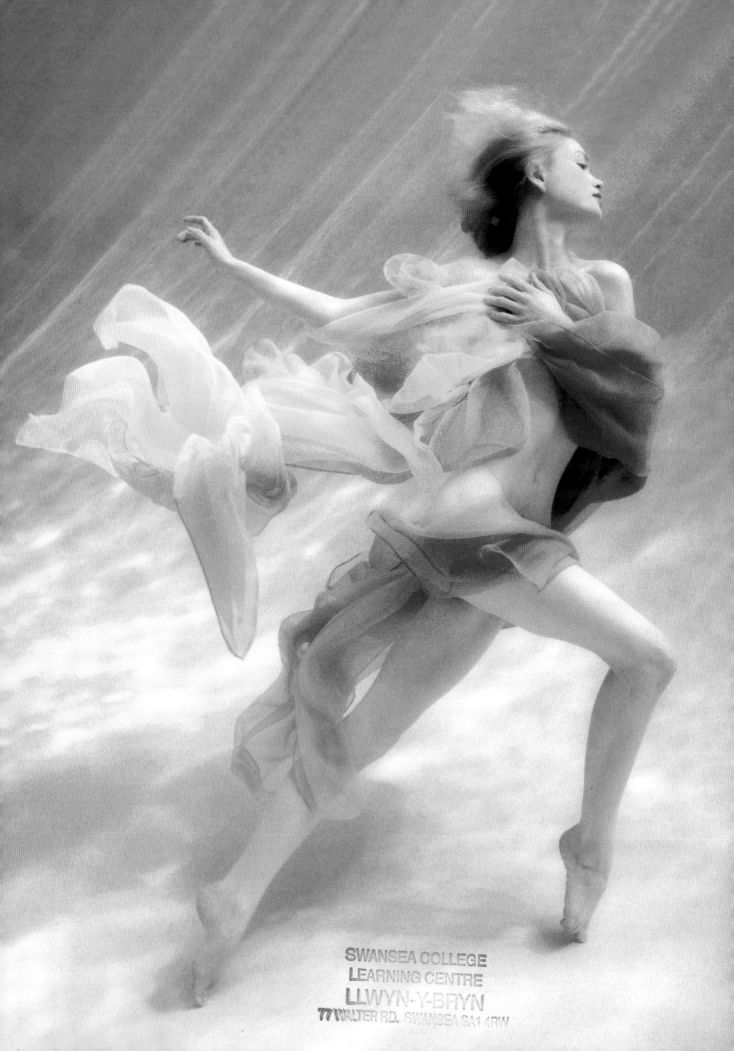

Howard SCHATZ

BODY & SOUL

The images in this portfolio have been selected from the two most recent books of photographs by acclaimed New York photographer Howard Schatz. Passion and Line is a superb collection of photographs of dancers in his studio, bursting with beautiful images of dancers striving to push the limits of the human body. The second - Pool Light - was photographed underwater in a specially equipped pool. Over 400 dancers, models and swimmers were auditioned to find those who could relax underwater and who were able to open their eyes, smile, laugh, hold their breath as well as a pose and make it look natural!

Howard Schatz had to also be underwater to take the photographs without breathing apparatus and only a pair of swimming goggles to enable him to look through the camera viewfinder. When the model surfaced to take a breath, he would also surface and urge and inspire them to more difficult or expressive poses.

"Every time you hear the camera click" he tells the model "imagine its the sound of applause, so next time do more, go over the top, let's hear that applause" and so photographer and model submerge and try over and over again for the image Schatz carries in his imagination.

As he says "I'm not freezing action, I'm finding moments in a dream".

Howard Schatz is clearly obsessed with controlling the images he makes, whether with dancers - leaping, stretching or reaching for that pose or movement that is just out of reach on a specially constructed stage in his New York studio or the models and dancers striving to hold poses and moving underwater in a specially prepared pool.

Howard is driven by a relentless energy, his enthusiasm for making photographs is equalled by an insatiable appetite for the pursuit of the most beautiful image. Whether working on one of his personal projects or on assignment for an advertising, fashion or editorial client, over and over again he has been heard to say "I want to look through the viewfinder of the camera and fall in love. I want to look through my viewfinder and see an image I've never seen before anywhere else".

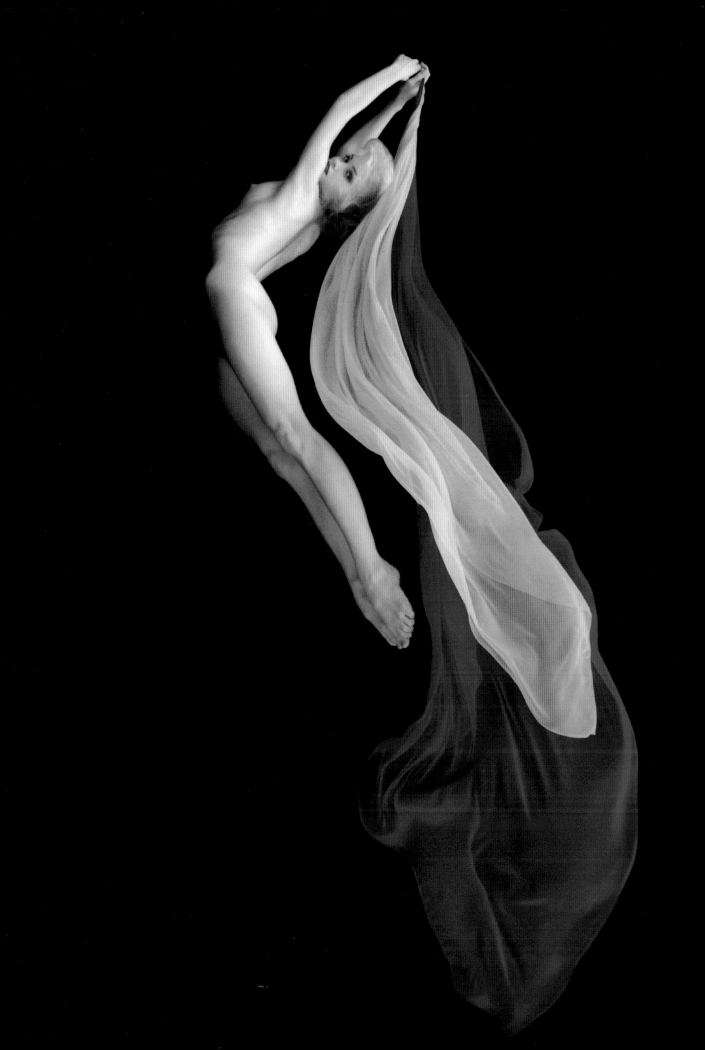

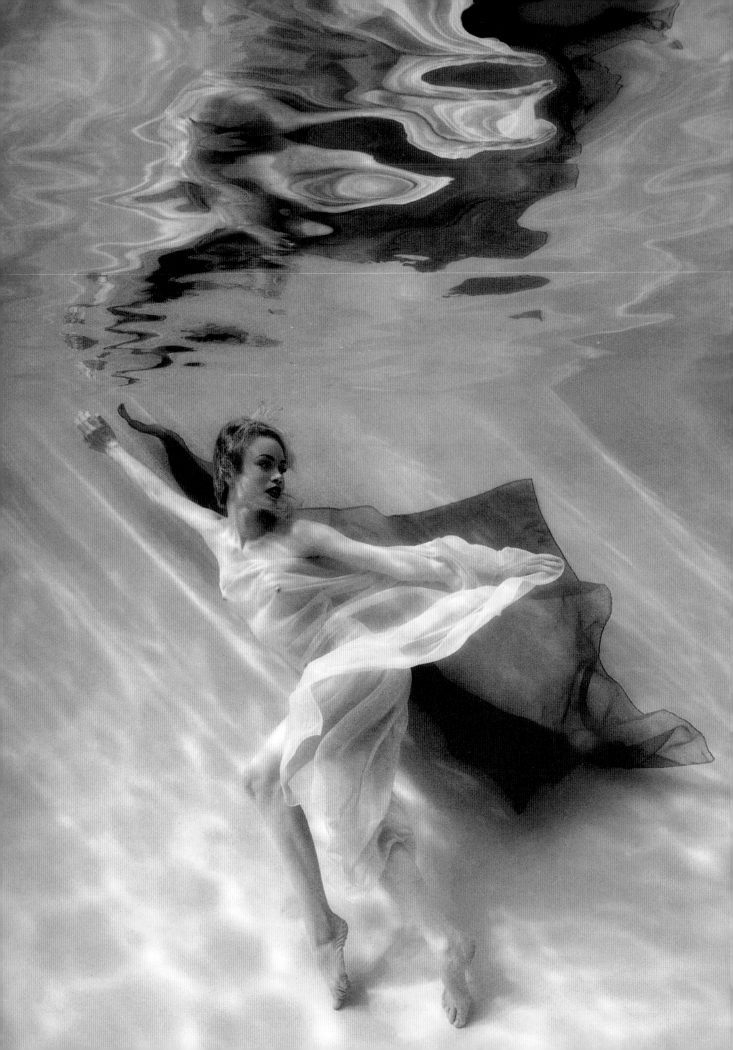

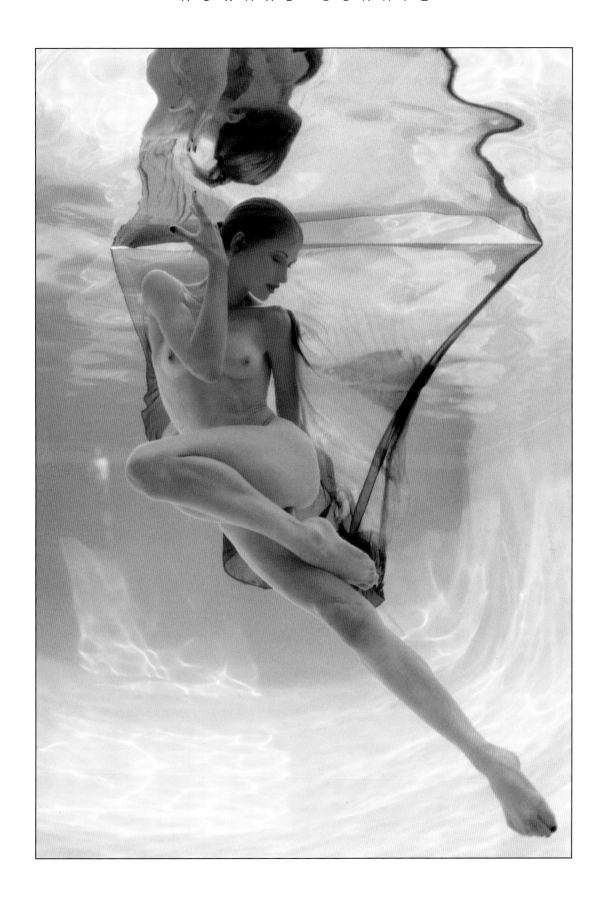

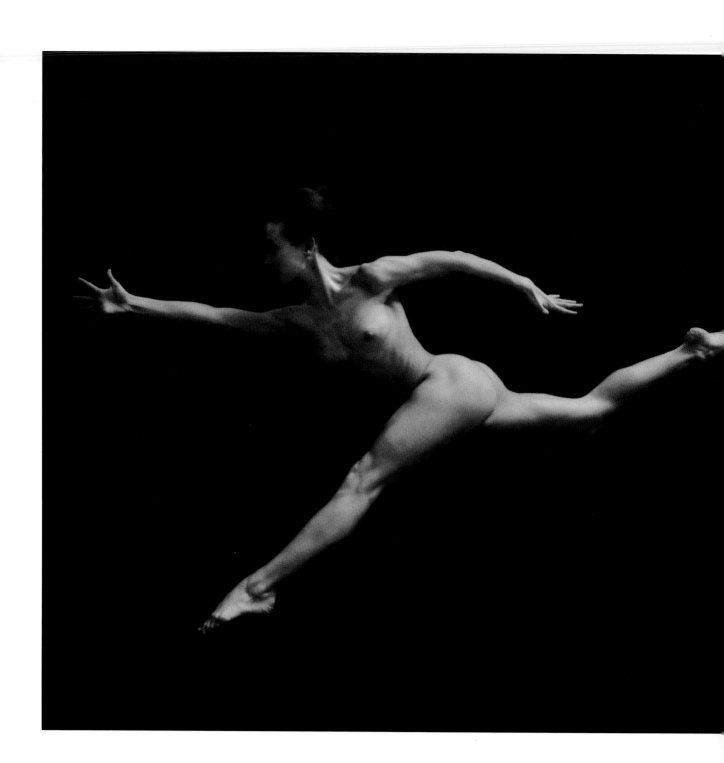

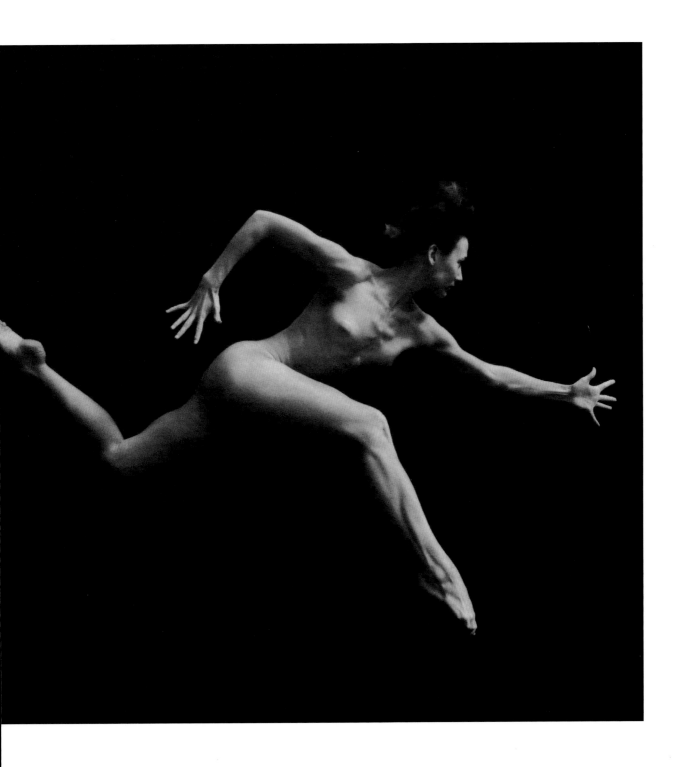

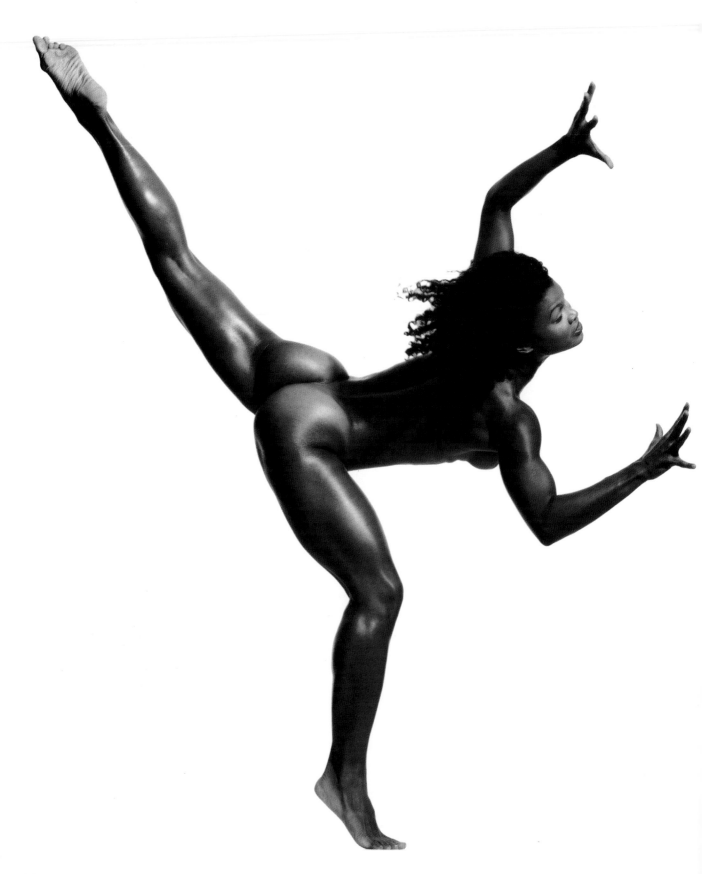

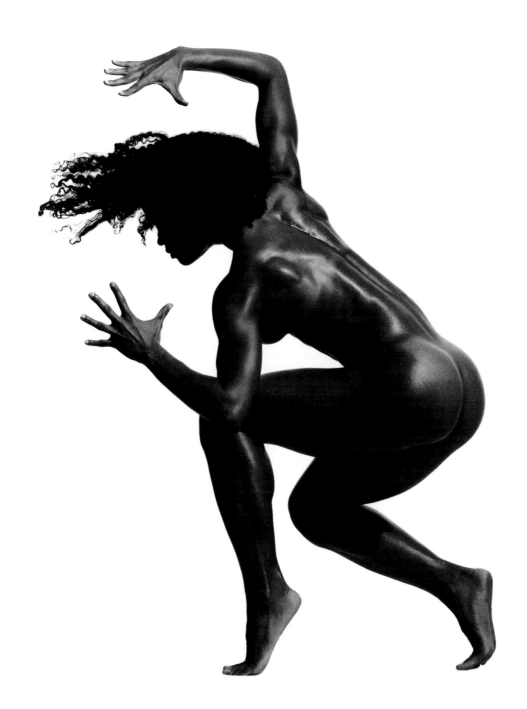

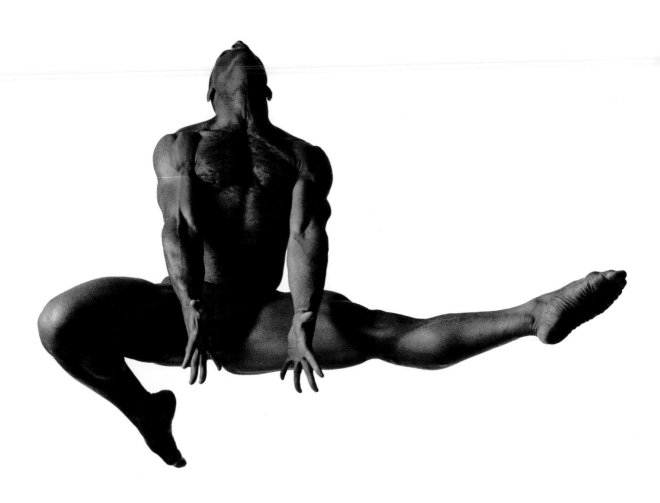

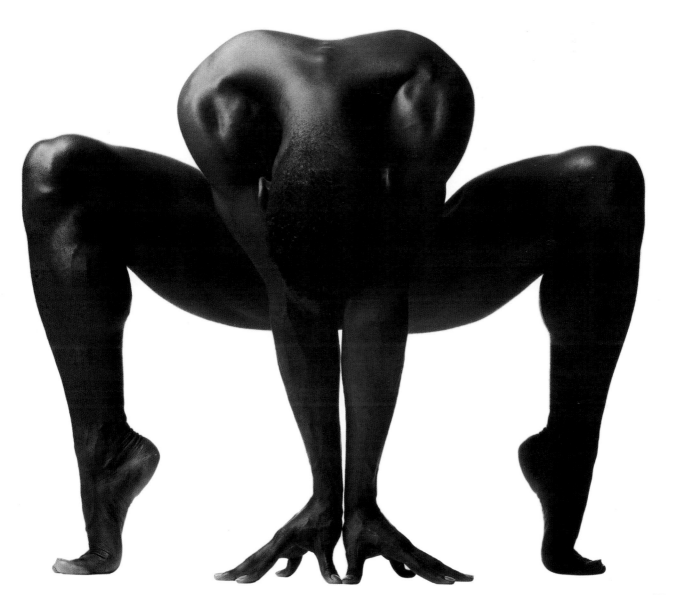

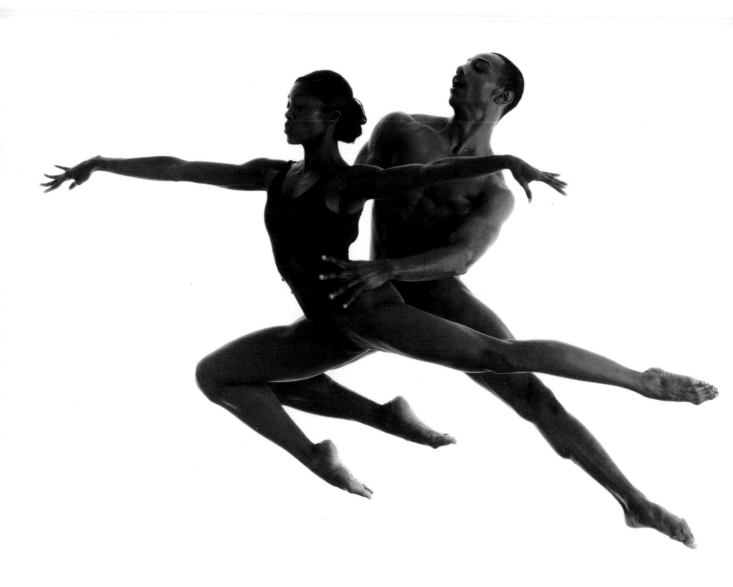

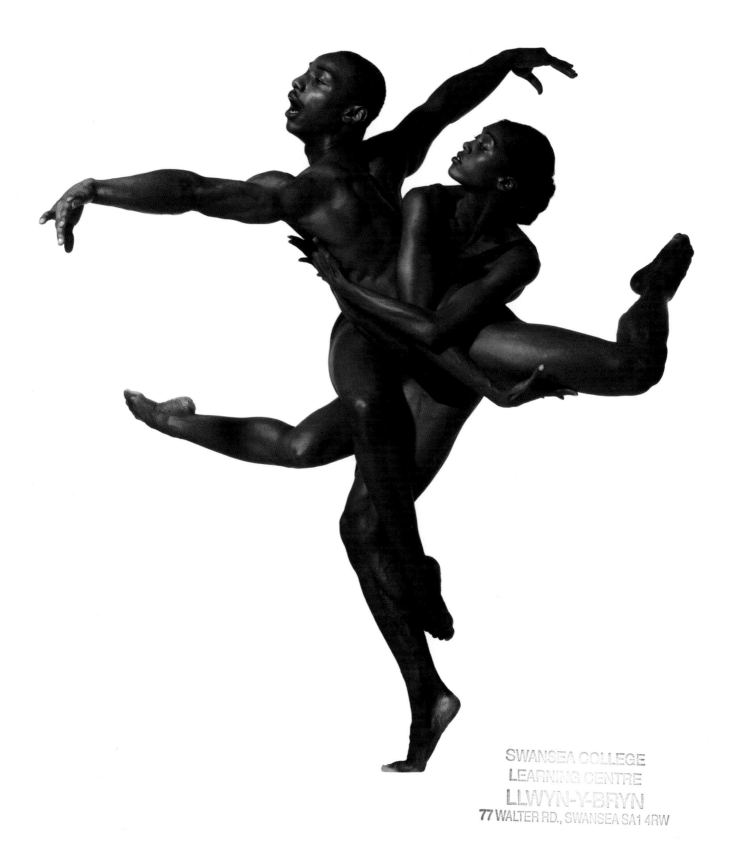

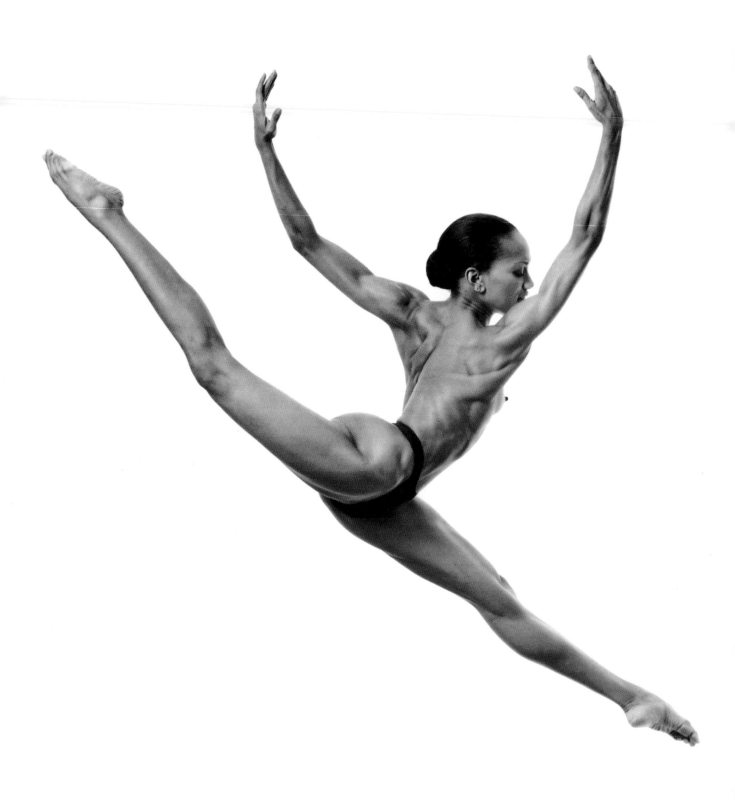

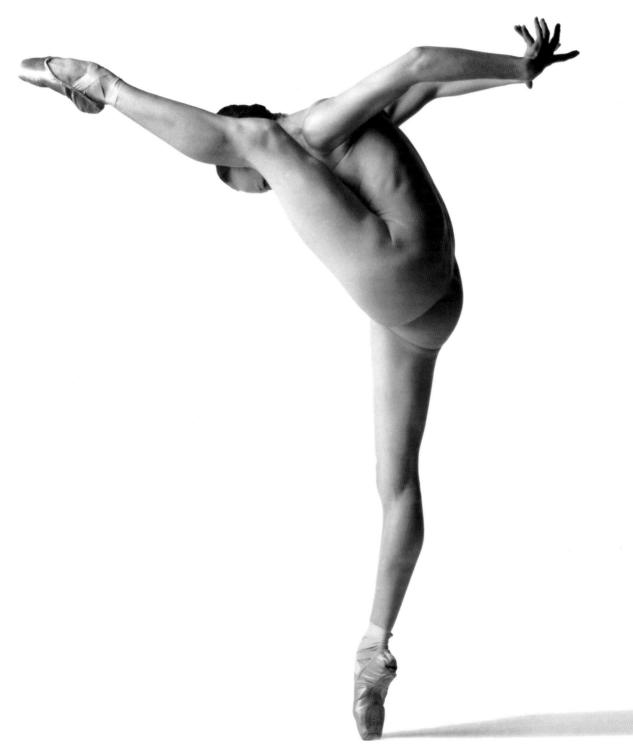

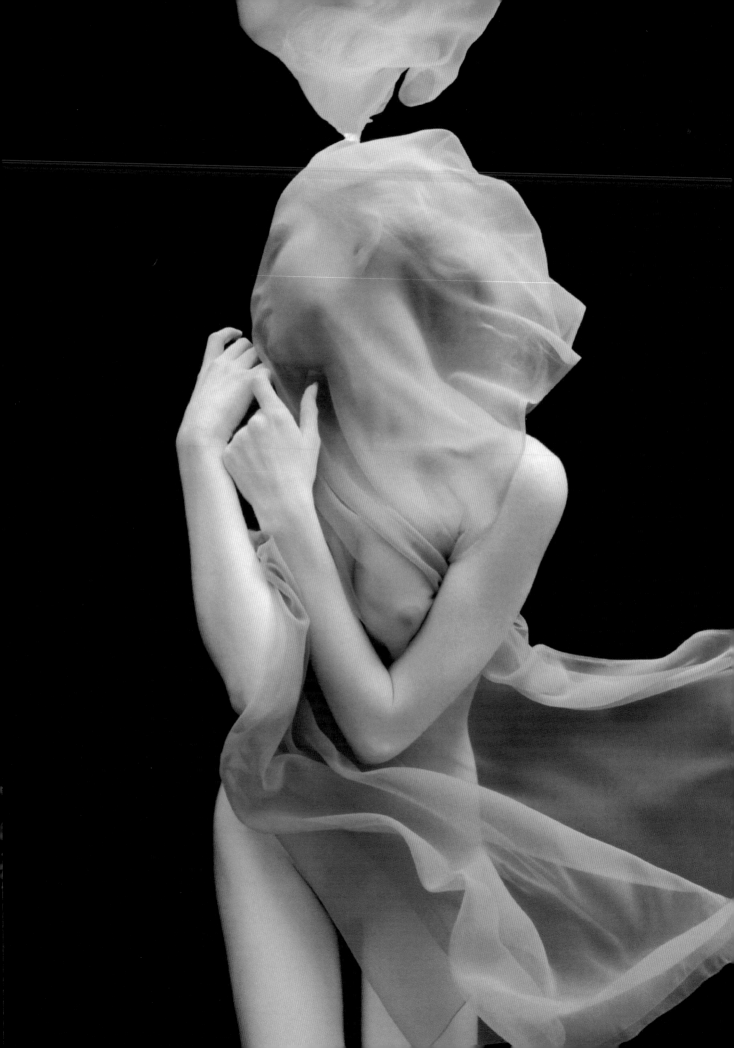

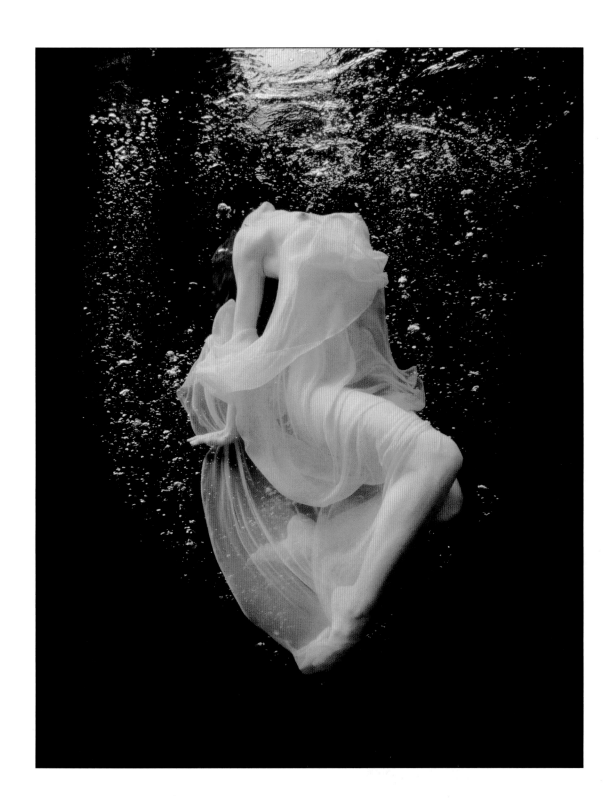

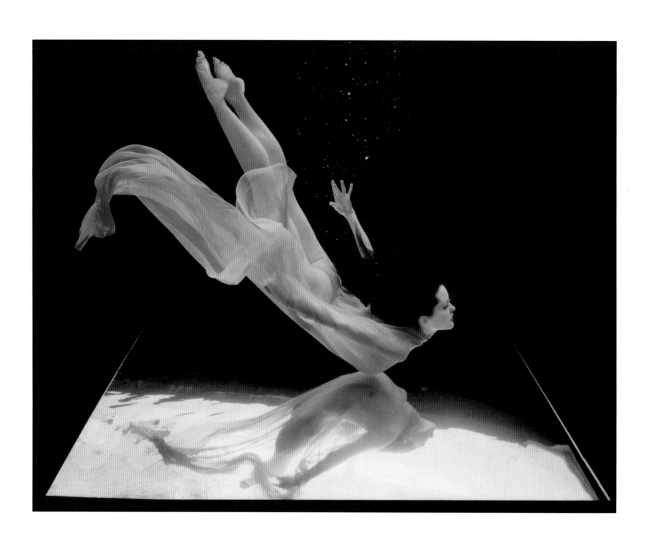

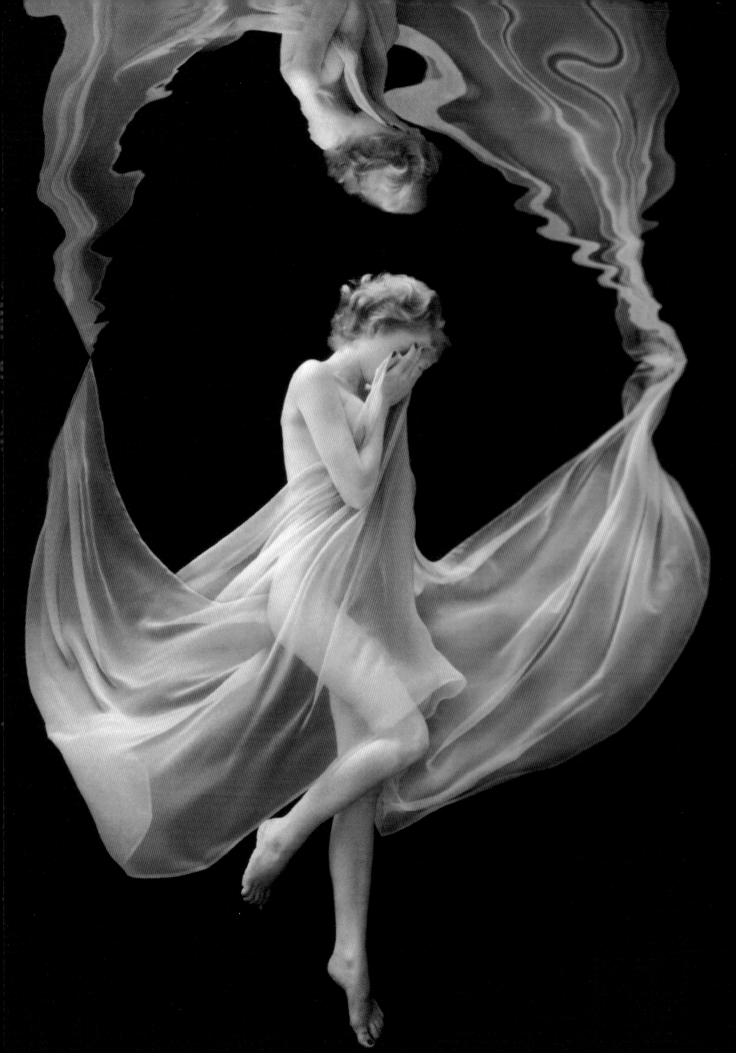

MARTIN
Richardson

HOLOGRAPHICS

Martin Richardson was born in the suburbs of South London just over forty years ago. He has spent most of his life living, studying and working in London and is presently based at his studio in the landmark OXO Tower on the south bank of the River Thames.

Martin discovered holograms whilst a student at the Royal College of Art and he is now one of the few artists working exclusively with holographics. He was chairman of the Royal Photographic Society holography group from 1993-6 and this year he has been awarded the Millennium Fellowship by the Millennium Commission which recognised his imagination, achievement and commitment to furthering technological avenues in the community.

The process of holography is a fascinating combination of leading edge technology and traditional techniques. The image is made by the bombardment of the subject with high speed, low energy laser beams refracted from multiple angles, however the final image is captured on a sensitised photographic plate that hardly differs from the first experiments made by Daguerre and Fox Talbot.

Martin has started recording a holographic library of personalities that interest him including the painter Peter Blake, film director Martin Scorcese, journalist Auberon Waugh, author Will Self and the chameleon rock star David Bowie. He is attempting to capture with the illusory 3D of holography the multi-faceted personas of his subjects. Martin says of this project, "There's something inherently anarchistic about working with a technology that undermines the fragile respectability of photography. Holography is not for the squeamish it is brash and often dysfunctional, making it the perfect visual for advertising moguls and massive egos, idle amusement and pseudo revolutionists. The fact it mirrors all the wrong aspirations to traditional art is the very thing that makes it so worthwhile and challenging. It is the ultimate mirror of life, a mirror with a memory".

Martin is planning a major exhibition of his work for the year 2000 plus the publication of two books, one (titled Space Bomb) to mark his ten years of personal exploration of holograms and another to comprehensively describe and illustrate how holography can be used both commercially and as a fine art.

SPACE SHUTTLE

This hologram was created to celebrate the
dawning of a new millenium, heralding
man's achievements in space travel.
The material from which it is made is called
'photopolymer' and is no longer produced
for image making. This hologram is a rare
and collectable special limited
edition piece.

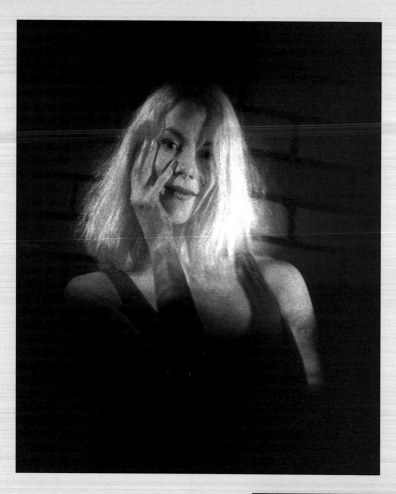

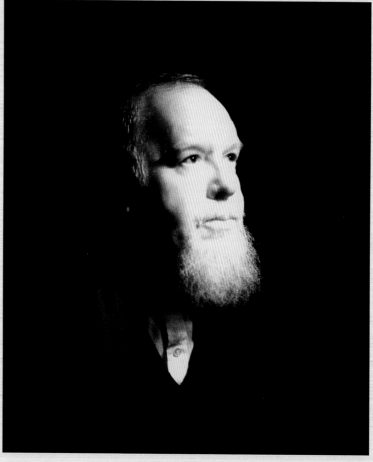

"You are brought up to think that the future is about little men running about in silver suits and then something like this happens to remind you that the future is already here".

Peter Blake during the take of his holographic portrait.

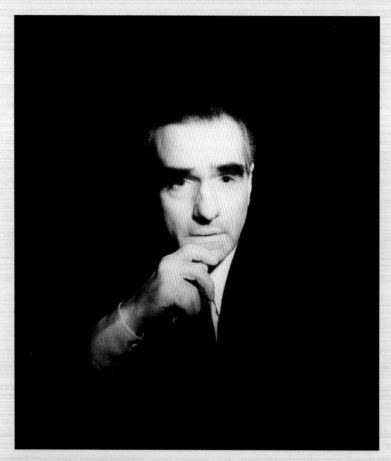

*"This medium is great,
absolutely fantastic.
A chance to say something
original knowing it's never
been said before".*
Martin Scorsese after being recorded

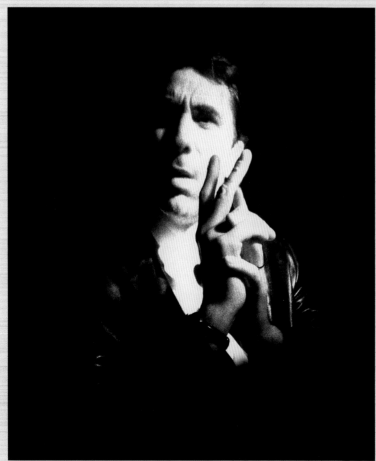

Maggie Taylor

SHADOWS & LIGHT

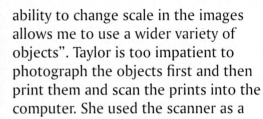

Maggie Taylor was born in Cleveland, Ohio in 1961 and studied philosophy at Yale University. Her interest in photography started in a traditional manner while watching friends at Yale using a darkroom in her dormitory. Borrowing her first camera from her father, she soon learned how to make very basic prints. For the next two years she took courses in photography and was working in the darkroom nearly every day.

Maggie became frustrated with the rather traditional colour photography she was making and began to experiment with assembling collages which she then started setting up still life scenes under natural light, she built from powerfully evocative objects and so created mystical tableaus that allowed the viewer to become part of the creative process. The computer as an art making tool has been an important part in her photography for many years and she consequently continues to create both straight colour photographs and digital images, but always in her typical style. Speaking about the role of the computer in her work: "it's not a question of what is missing in conventional photography, but what else can be added with the computer. I feel that the computer's unlimited

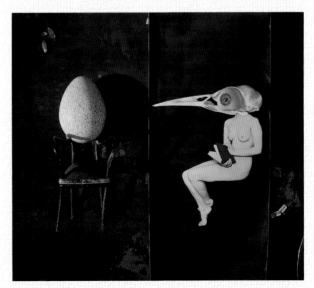

ability to change scale in the images allows me to use a wider variety of objects". Taylor is too impatient to photograph the objects first and then print them and scan the prints into the computer. She used the scanner as a camera, placing her small objects and backgrounds directly on the glass, scanning them diectly into digital form.

Dolls, insects, pages from books and painted backgrounds are her raw material. She always searches flea markets and antique shops when travelling for new objects to use. After several days of assembling the collage-like image using Adobe Photoshop and making a series of small proof prints the final digital file is printed on an Iris printer, which sprays almost four million droplets of ink per second onto a spinning drum which holds the fine art watercolour print paper.

"Rather than working with a definite theme or philosophical construct in mind, I prefer to work intuitively with the objects themselves. While my images suggest narratives, they allow the viewer to respond on an individual basis. My hope is for the work to be both playful and disturbing. Anyhow, there are always as many different interpretations of the photographs as there are viewers".

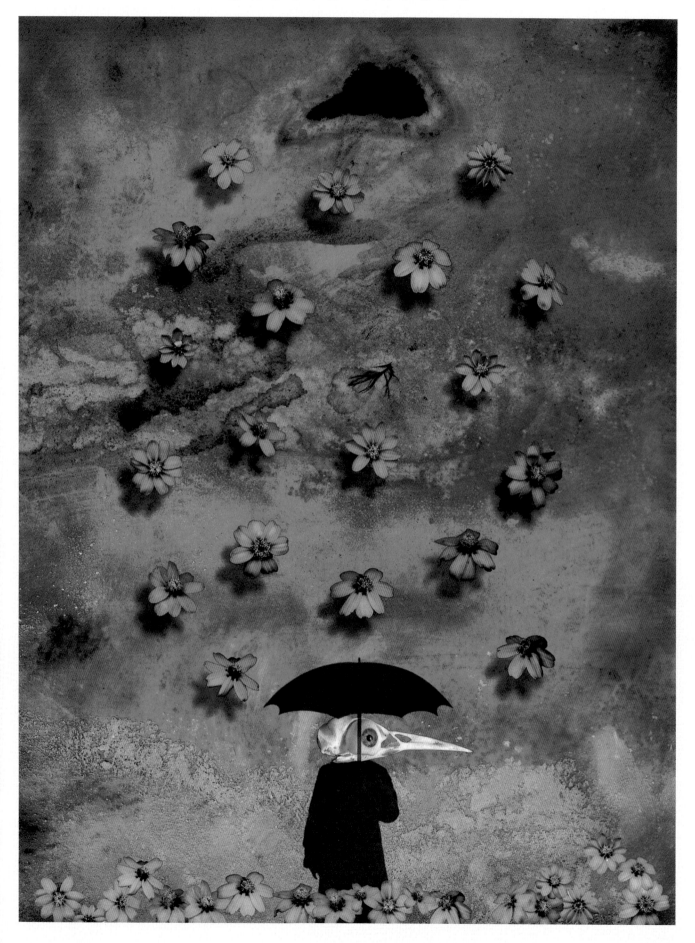

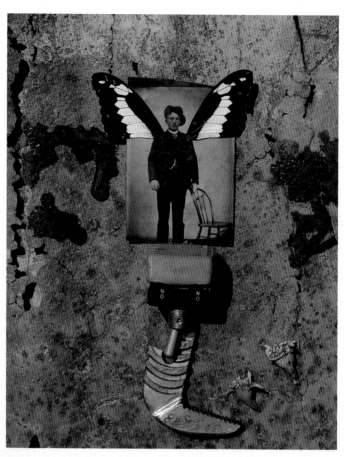

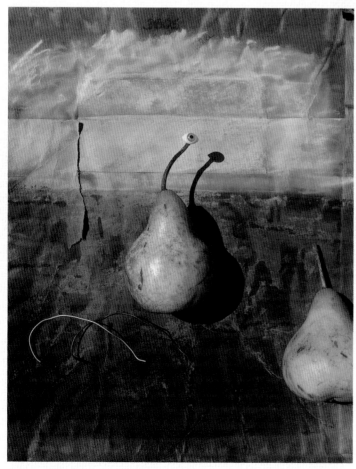

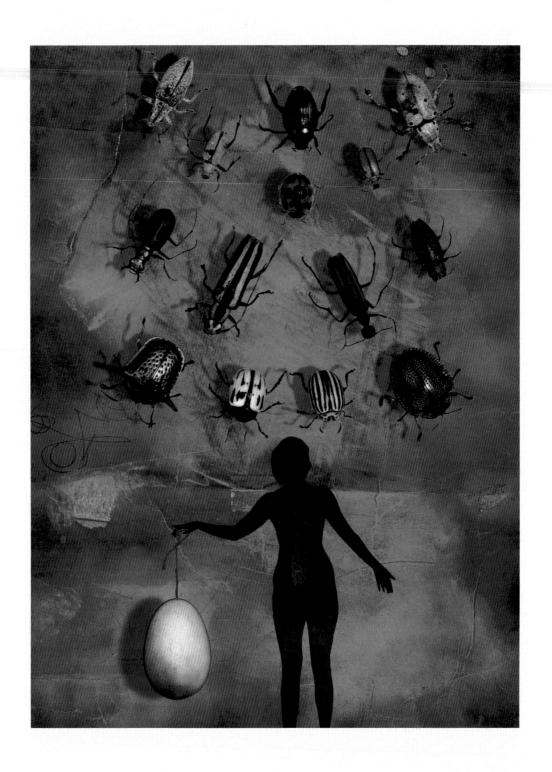

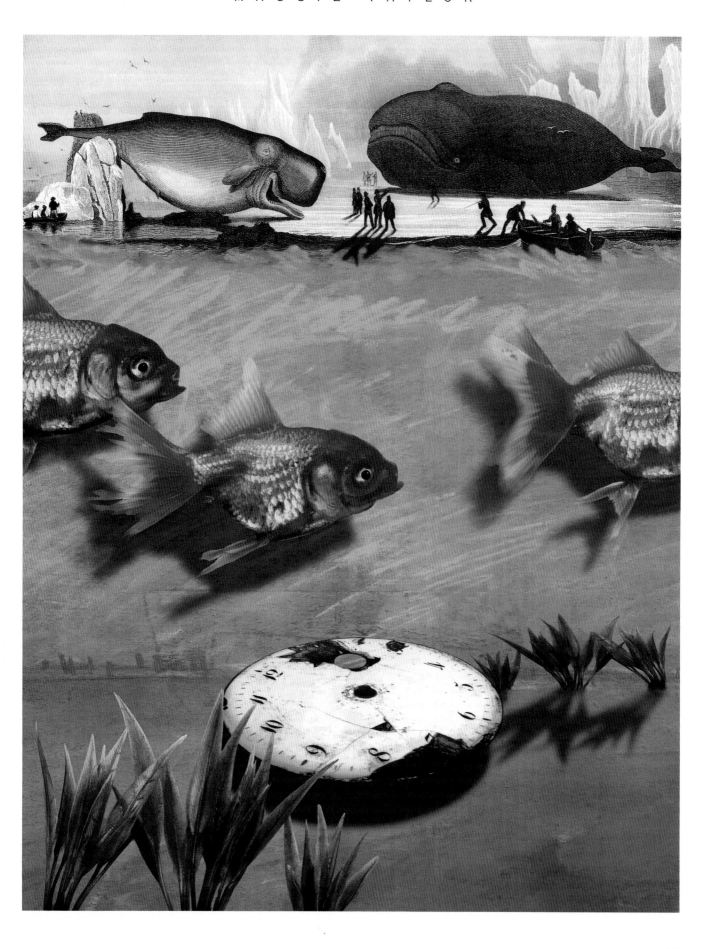

Ron REDFERN

THE PANORAMIC VIEW

My interest in photography began with the need to illustrate technical articles for publication in monthly trade journals in the 1950s. Later, as a consultant in the food and pharmaceutical manufacturing industries, I produced explanatory audio-visual presentations for clients. After disposing of my business interests in 1975, I worked out of Denver, Colorado, for almost twenty years. Here, I wrote books and originated television series on the natural sciences. In 1996, I returned to England where this work continues with a strong electronic twist. The powerful computers that have become available at desk-top level in recent times have completely changed the method of producing illustrated books.

From the start I decided to illustrate books with panoramic landscapes – the best way of interpreting the story behind the scenery of the Colorado Plateau, my prime interest at first. This decision resulted in the problem of deciding how to take such pictures. Linhof had just developed a 3:1 single lens panoramic camera but this camera (and its imitators) was incapable of producing large format pans. On the other hand, the traditional circuit camera that could do so, was too cumbersome to use in remote back-country locations. I decided to adopt an overlapping-frame method of production that would give me complete freedom to determine both the composition and the format of any potential panoramic shot.

In the autumn of 1975 I packed a Hasselblad with a motor-drive, a selection of lenses, a Polaroid back, and various types of medium-format roll film. In addition I purchased a strong but compact tripod on which to mount a heavy-duty universal-joint platform, and a sturdy, good quality, pan-head. To this collection I added some unusual items – spirit levels, a nylon net-bag, a meat-hook, a roll of white masking tape, a frame-mounted back-pack, and a large ice-box in which to store film. I then set off from Denver in a motor-home, towing a jeep.

My objective was to spend a few months taking experimental panoramas in the less accessible localities of what is termed *Four-Corners country* – the states of Colorado, Utah, Arizona and New Mexico, the only ones in the USA that intersect at one point.

And that unusual photographic equipment? On location the net bag was filled with rocks – as many as I could lift. The hook was used to hang this from the underside of the tripod-head so that the tripod could not vibrate or be moved accidentally. With the universal-joint platform in place on the tripod, the spirit levels were temporarily tacked with masking tape onto the surface of the platform at right-angles to one another. These were removed when the platform had been made perfectly level and securely locked into place.

The pan-head was mounted on the platform with a strip of white masking tape tacked around the circumference of its base. The frame over-lap stop-points were then marked on the pan-head tape by viewing the scene throughout the intended circuit of the camera. The arc could vary from 90° to 270°, its extent entirely dependent on the composition of the scene. The amount of overlap at the edges of overlapping frames was in the order of 10 percent of the width of the frame. The marked-up tape was stripped off after taking the pan and re-used repeatedly for the same camera-body and lens. Wide-angle lenses were never used for multipans because they reduce the scale of the scene by elongating, and therefore distorting, the perspective.

The frame-mounted back-pack ensured that the seventy-pound loads that I had to carry in difficult country, sat firmly on my hips. This lowered my centre of gravity and reduced the danger of an unexpected trip over the edge of a welcoming cliff.

During that first sortie I learnt a few of the basic tenets of pan-photography. But it took years to

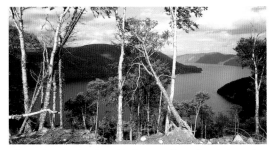

The Cabot Fault, Grand Lake, Newfoundland, Canada

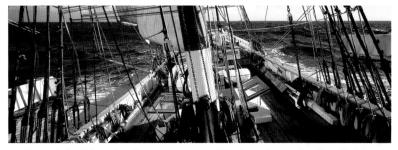

Aboard the Brigantine *Romance,* at sea off Antigua, Lesser Antilles, N. Atlantic

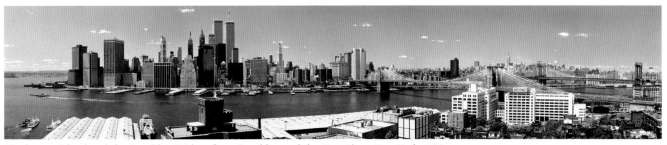

Manhattan Island and the Brooklyn Bridge, from Brooklyn and the East River, New York, USA

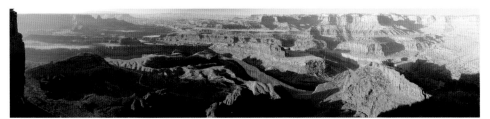

The View from Deadhorse Point, Canyonlands National Park, Utah, USA.

Aspen at Cedar Breaks, Utah, USA.

perfect the techniques of taking multiframe panoramas and assembling individual frames into one piece of film for publication. Today, the assembly of multiple frames into a single electronic image is achieved by using a high-resolution scanner in conjunction with a powerful computer. But in those early days such photocomposition was achieved by emulsion-stripping. This method involved literally stripping the emulsified image off the film-base and re-assembling the pieces on a second piece of blank film.
A later technique involved masking, duplicating, and hand-finishing joins.

The first experimental overlapping multiframe panorama that I produced had its horizon stretching from side to side across the centre of the scene. I soon learned that to work with such a 'fixed horizon' is one of the main difficulties of pan-photography. The problem results from the absolute need to mount the camera on a perfectly horizontal platform to avoid distortion by parallax, and in my case, also to ensure the perfect horizontal and vertical fit of frame to frame.

I needed to take panoramas from the top of cliffs looking down on the scene below. Alternatively, I would need to take shots from the bottom of a canyon looking upwards without a distant horizon and without distortion. It seemed that I had a major parallax problem to solve!

The solution was to use a 2 $\frac{1}{4}$" roll-film back with a view camera fitted with 4 X 5 format lenses. With this combination I found that I could control the horizon by racking the front of the camera downwards or upwards as needed. Importantly, I found that I could do this without distorting the image, or affecting horizontal frame to frame alignment, or losing uniform corner-to-corner exposure – all crucial factors in multiframe pan-photography.

As a science writer it has always been my objective to produce photographs that permit me to accent the aesthetic qualities of the scenes I describe in the text, as well as their technical values. The panoramas in this portfolio demonstrate some of the progress made to this end.

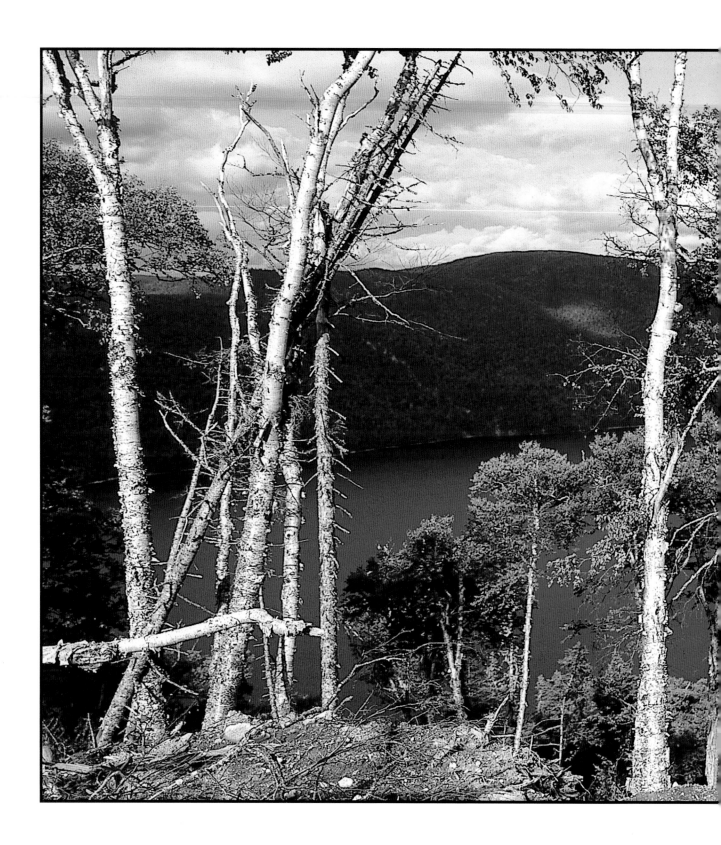

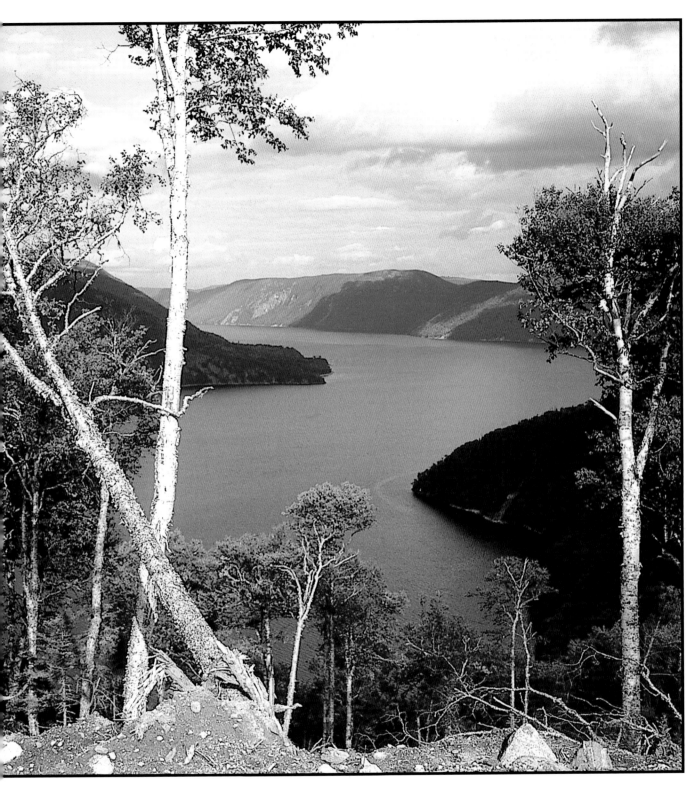

The Cabot Fault, Grand Lake, Newfoundland, Canada.

The Cabot Fault in Newfoundland, containing Grand Lake, is related to the Great Glen Fault in Scotland, containing Loch Ness and Loch Lochy. Although these localities are now two thousand miles apart, many millions of years ago they were in close proximity. Both were intrinsic parts of the same fault system during the assembly of Pangea. The panorama was taken to illustrate this general subject.

The problem in taking the Cabot Fault shot was that Grand Lake is surrounded by dense forest, it took several days of exploration to find this lumberjack's clearing which permitted an indirect view of the lake, and therefore of the fault.

Linhof Technorama, Kodak Ektachrome, Frames: one: $6^3/_4$ x $2^1/_4$ (ends cropped)

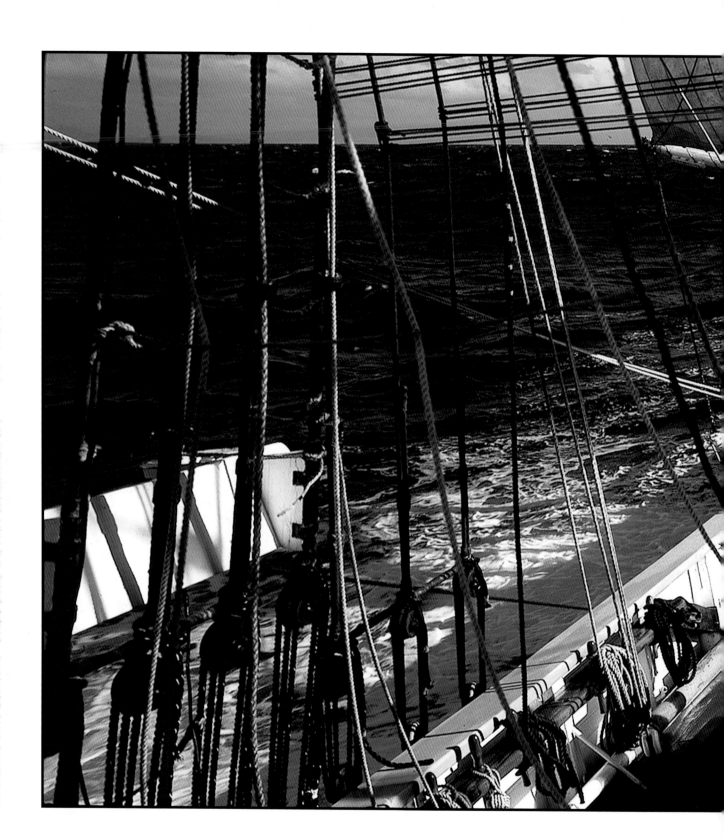

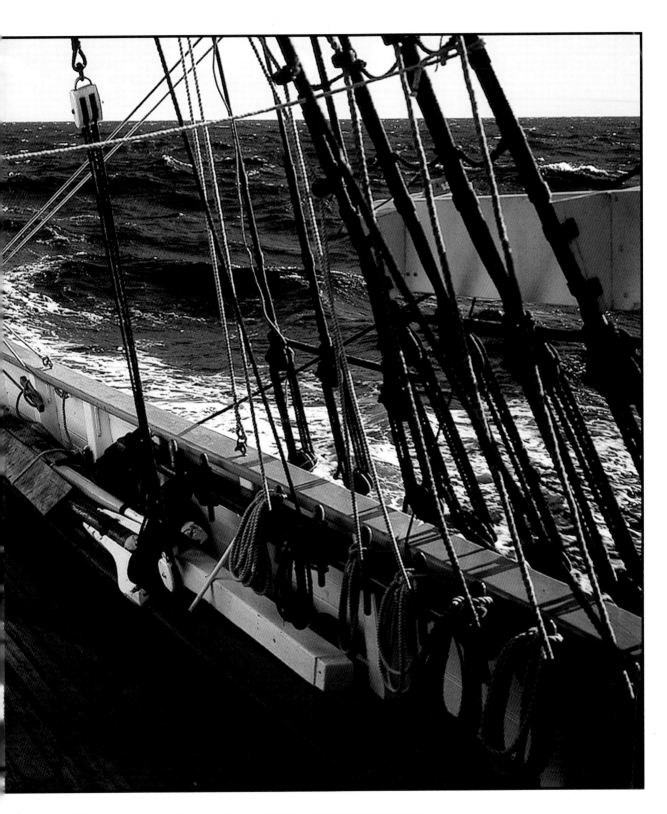

series of illustrations, was to demonstrate the development of three-masted square-rigged ship-technology. This technology precipitated a major revolution in the means of human communication in the 16th Century, a revolution that parallelled today's electronic revolution in its dynamic effect on mankind.

Linhof Technorama (inset: Hasselblad), Kodak Ektachrome 120 roll, Frames: one: $6^3/_4$ x $2^1/_4$

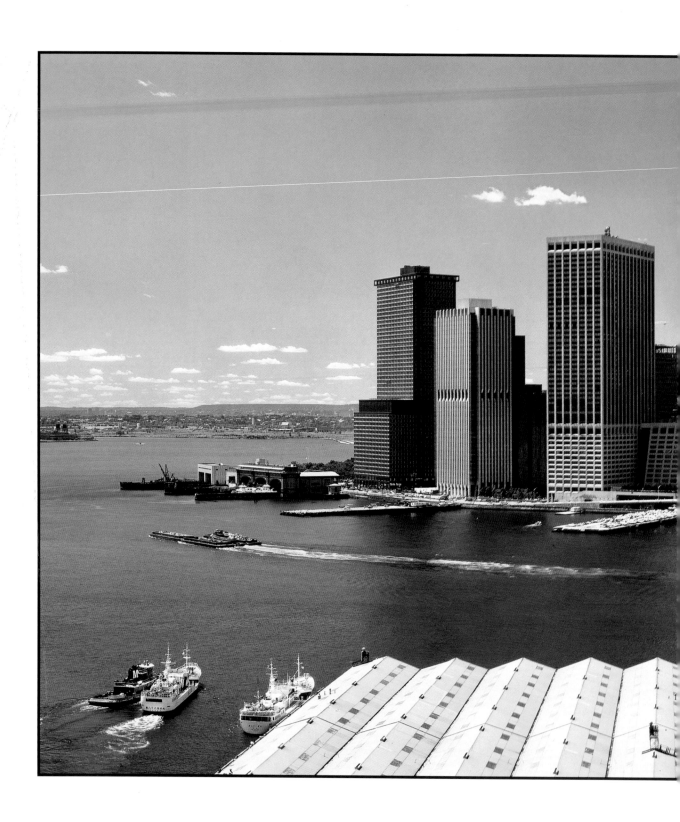

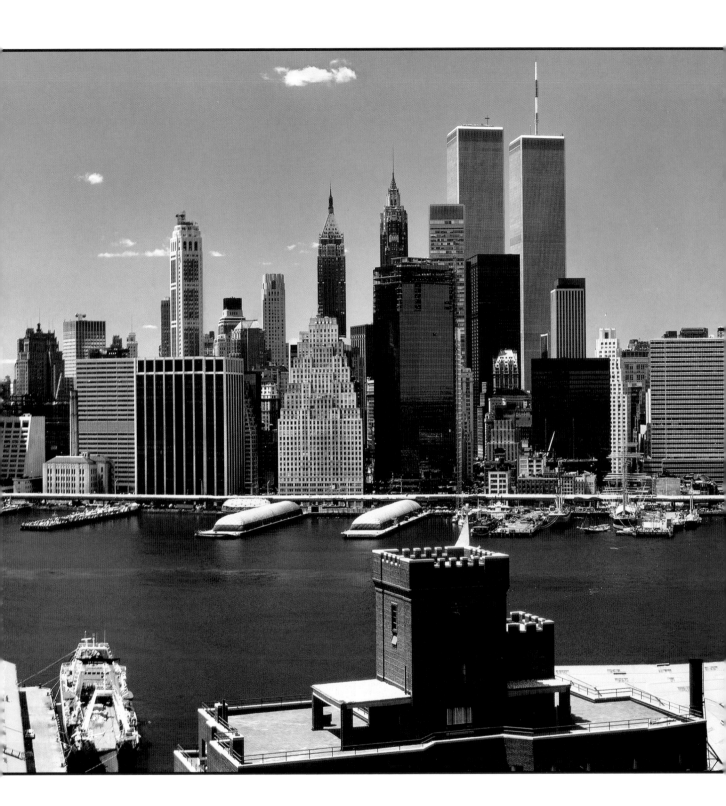

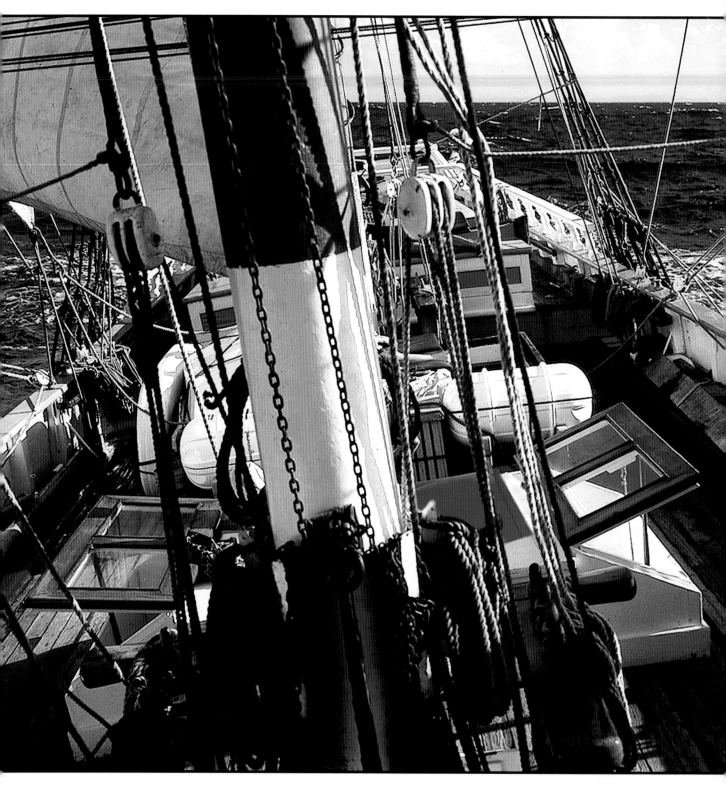

Aboard the Brigantine *Romance* at sea off Antigua, Lesser Antilles

There is nothing that quite compares with the exhilarating experience of sailing fair and square before the wind on an unbelievably deep-blue sea, in a square-rigged ship.

However, that sentiment aside, the panorama's prime purpose as one of a

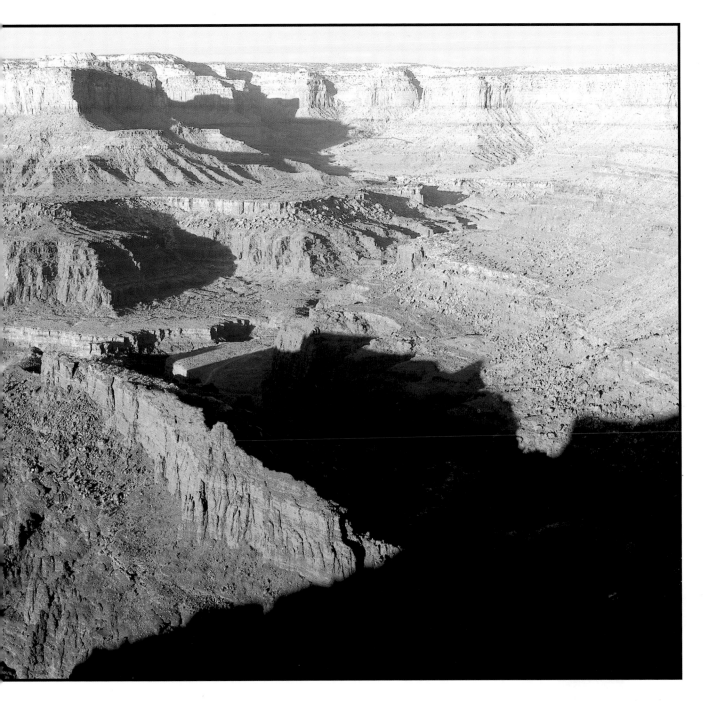

Overleaf – 'Golden Moment' aspen glade in the fall at Cedar Breaks, Utah, USA

These matched vertical panoramas were taken with a Linhof Technorama through an angle of 180° with no overlap – each frame fits flush with the next. Thus the first frame faces directly into the sun and the fourth frame faces almost directly away from it. The set was intended for interior decoration on either a flat, or curved, or corner wall.

Cedar Breaks is a region of southern Utah between Zion and Bryce National Parks and set at about 9,000 ft above sea level. In late September to early October the area is a scintillation of colour and bright light – a little-known locality, but with some of the finest displays of autumn colour in the United States.

Linhof Technorama, Agfa Professional S, Frames: four vertical: 6³/₄ x 2¹/₄

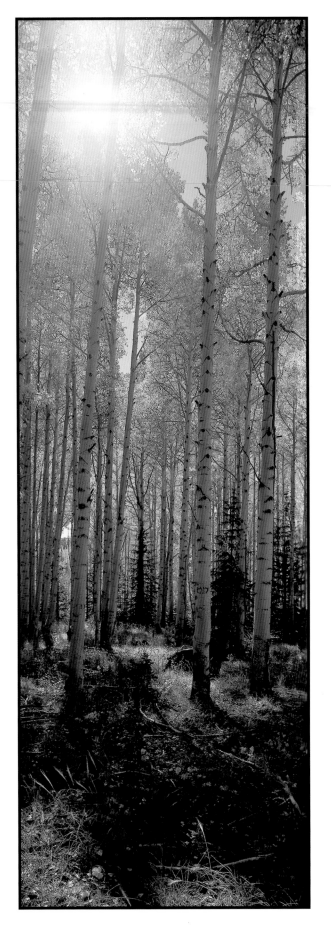
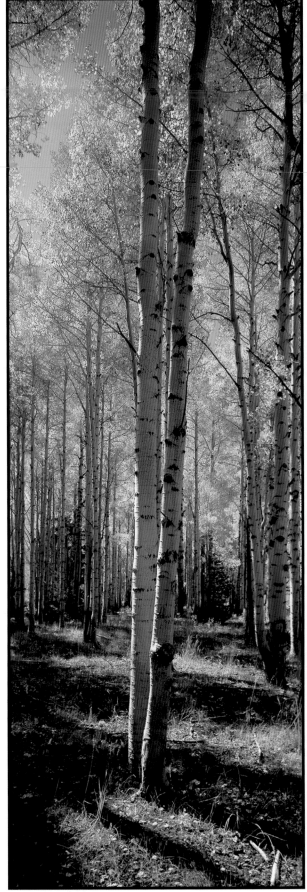

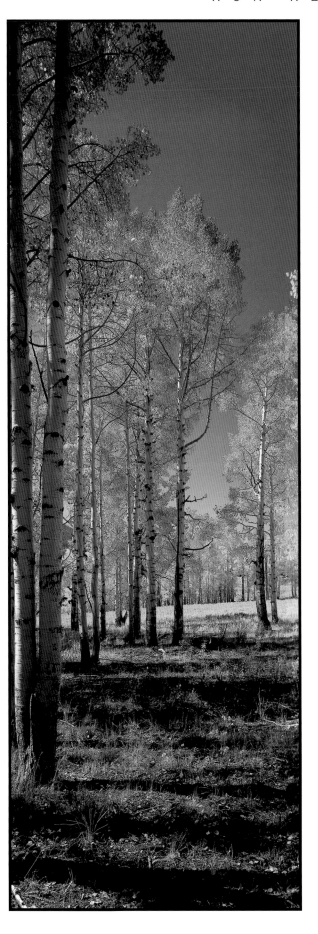
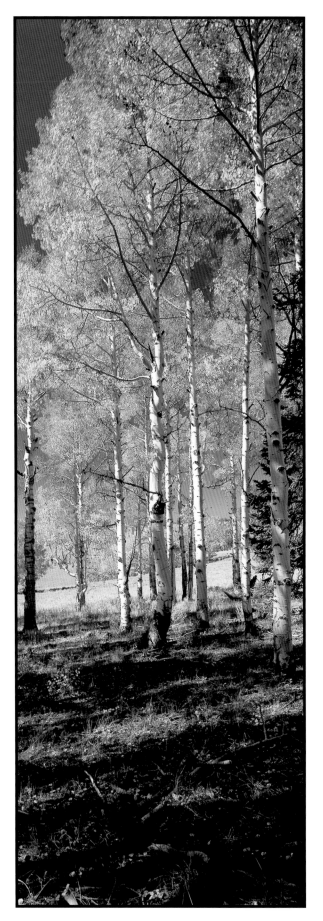

Jean-Daniel Lemoine

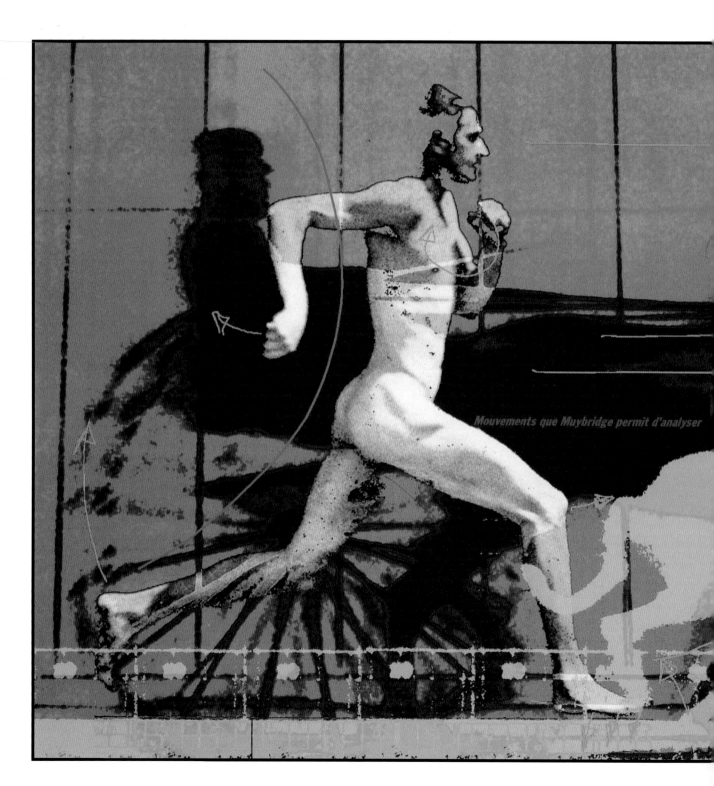

Mouvements que Muybridge permit d'analyser

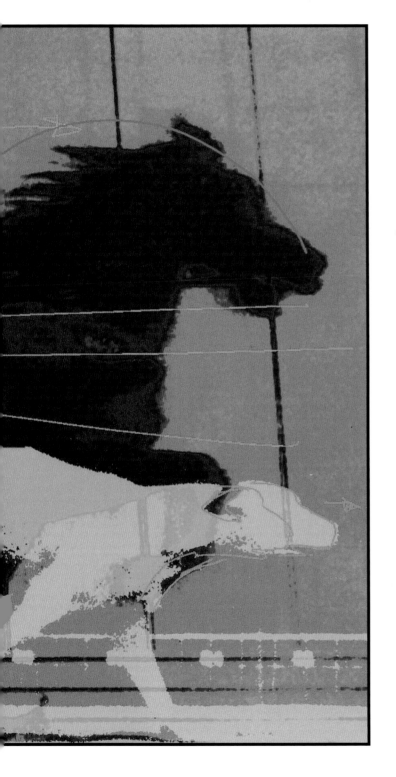

The French photographer Jean-Daniel Lemoine took his first photographs when he was ten years old and has had a passion for photography ever since. He is now retired after a career in the Space Industry and devotes most of his time to photography, particularly digital photography which he has been exploring for the past five years.

Jean-Daniel also studies alternative processes of photography principally photogravure a very complex process in which he is considered an expert. He produces signed limited edition prints using this printing process.

Throughout his years of photography Jean-Daniel has won more than 300 awards in national and international competitions. He is a member of the Photographic Federation of France and the International Federation of Photographic Art.

Many of Jean-Daniel's images have a strong surrealist atmosphere, he also acknowledges the influence of other artists and performers on his work, from Muybridge who we see here, to Picasso and cubism on page 68. He says "Anything that is laid down on a photographic support can be considered as a photograph, whatever the source. Initially photography is a technique that everyone exploits as they like. If the favoured domain is the representation of reality, it can become a tool of the imagination and an internal adventure. Then everything becomes possible, provided one accepts the rules of Art, where work and thought are of great importance!" His final message is that "Making or creating gives inner calm and brings each of us nearer to infinite wisdom".

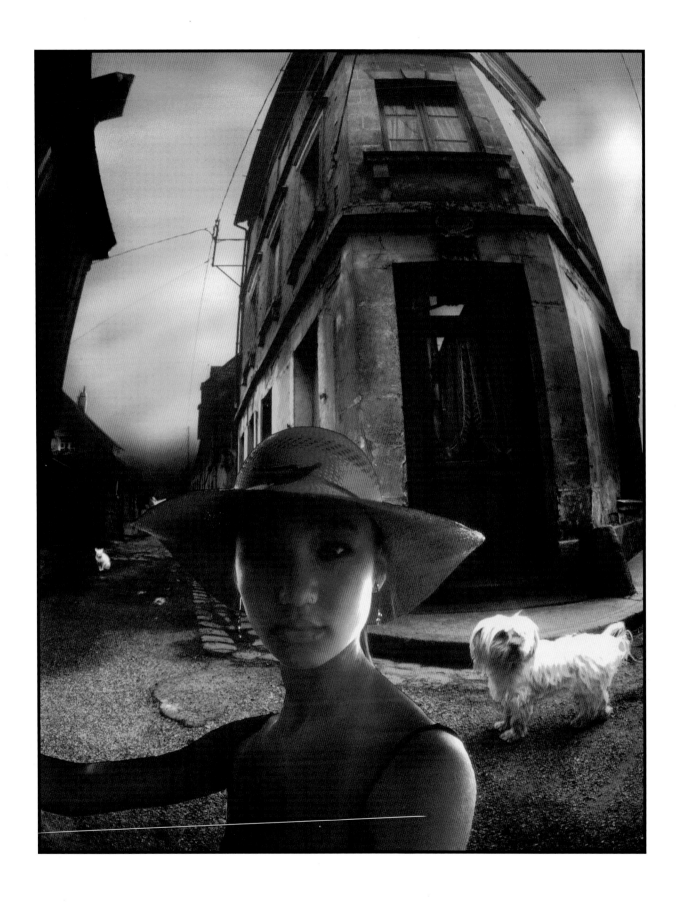

JEAN-DANIEL LEMOINE

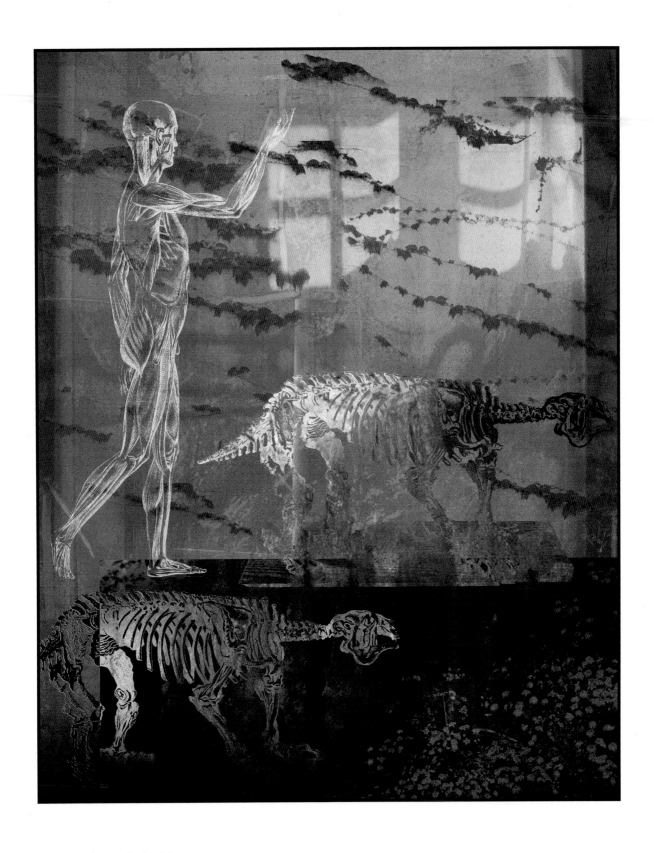

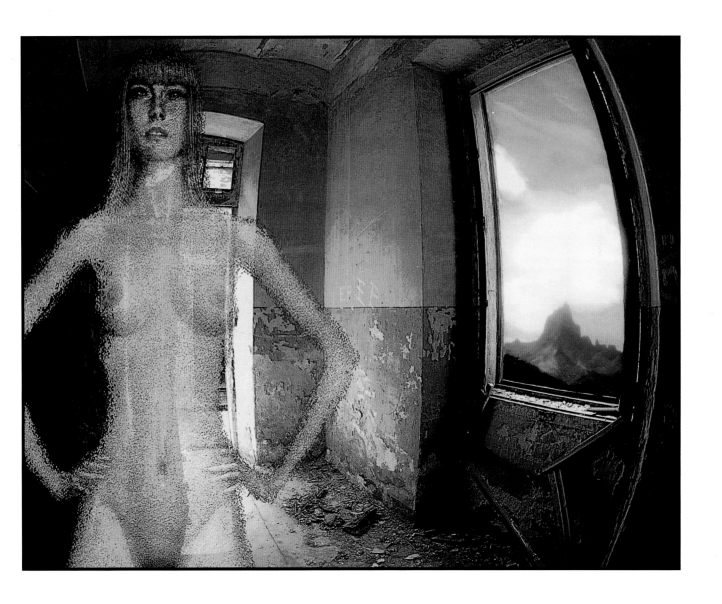

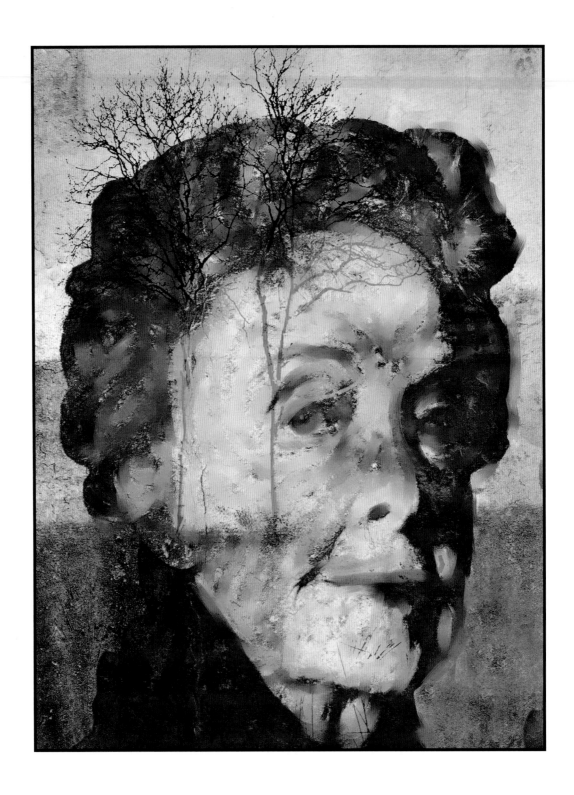

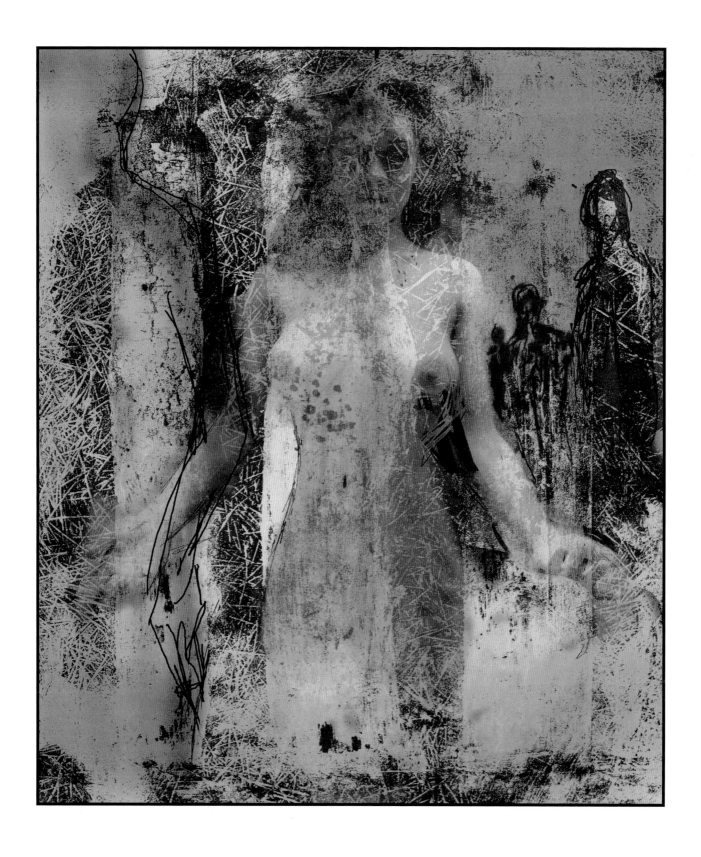

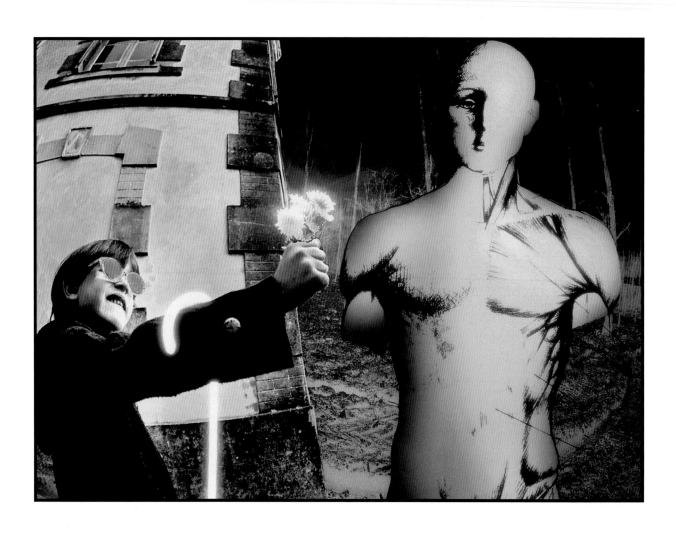

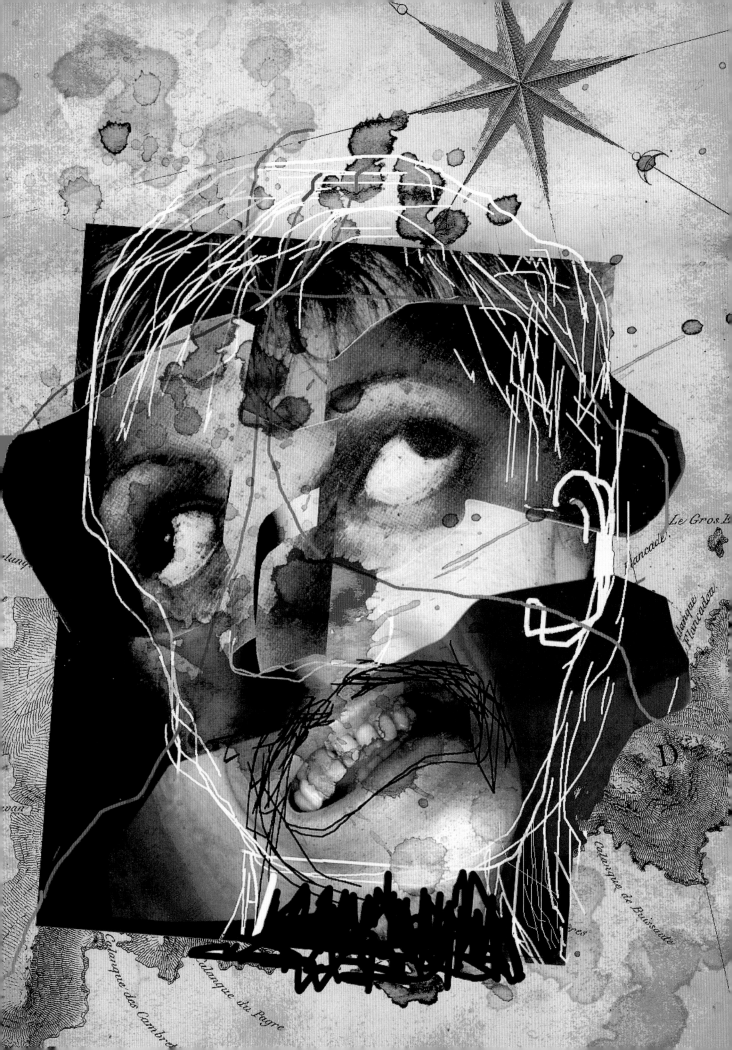

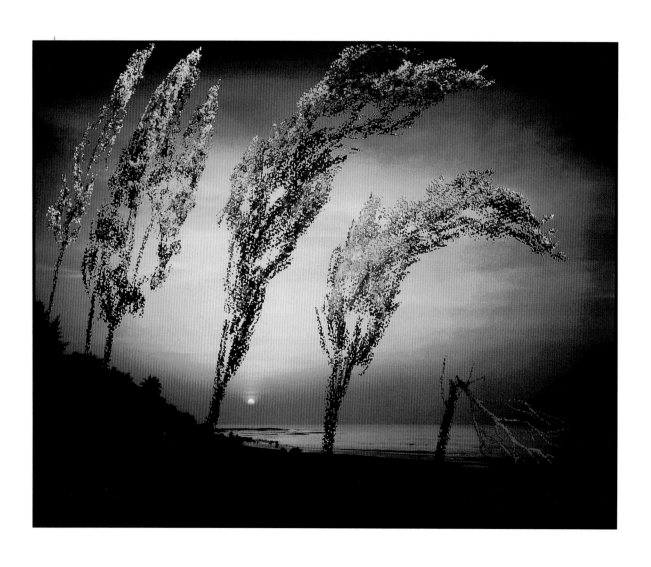

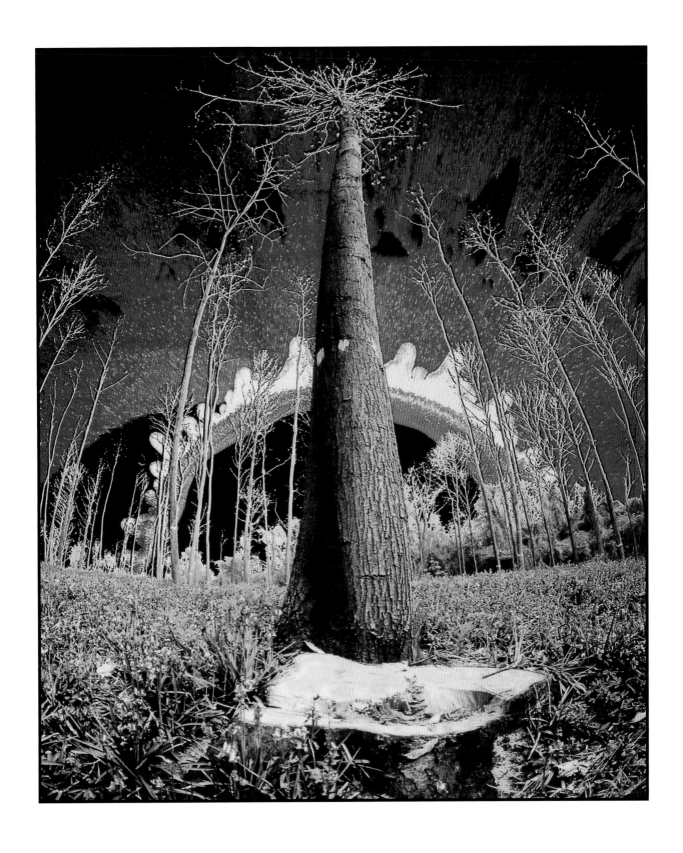

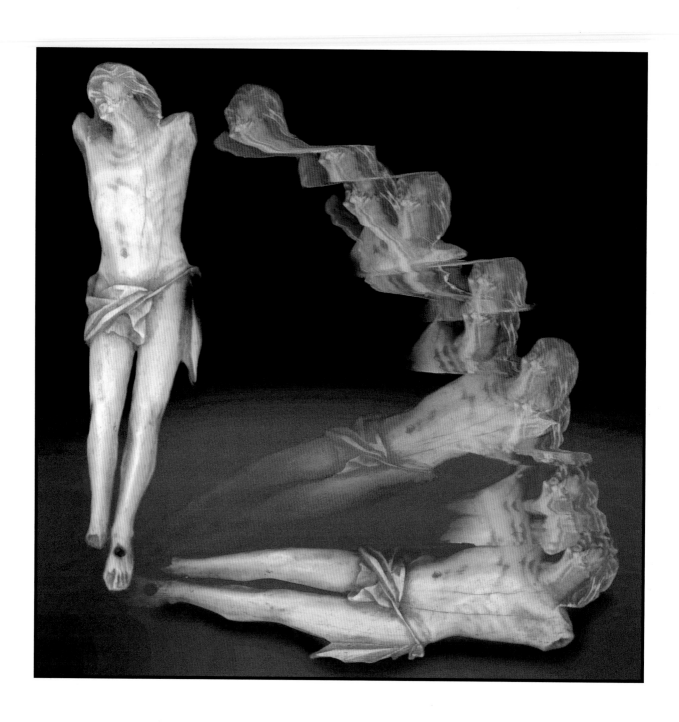

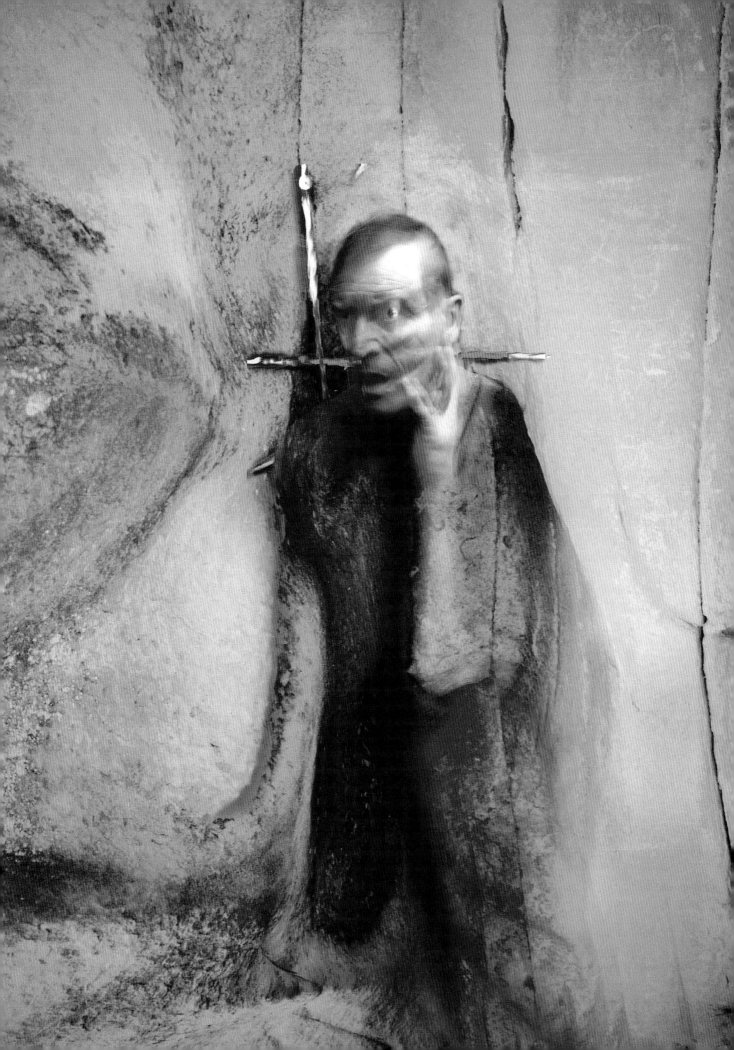

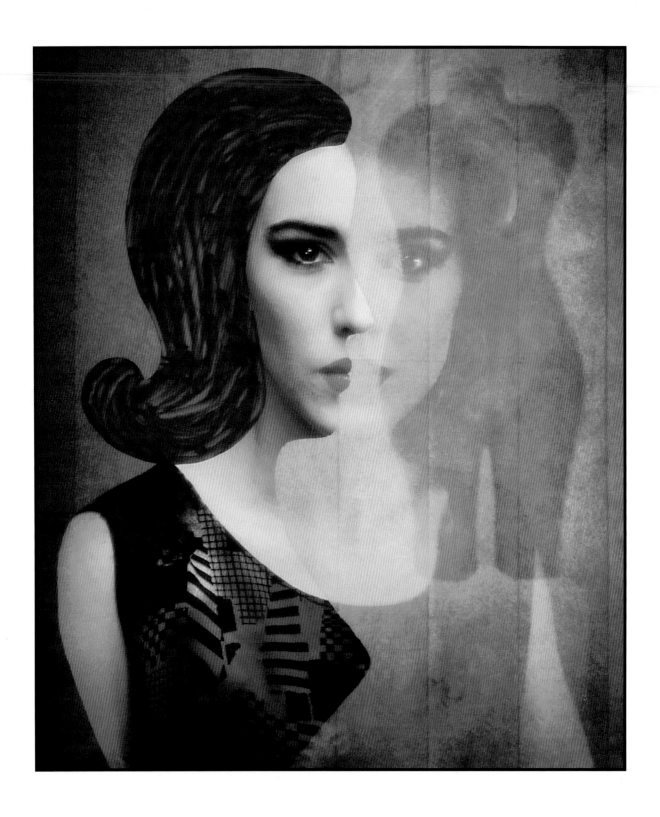

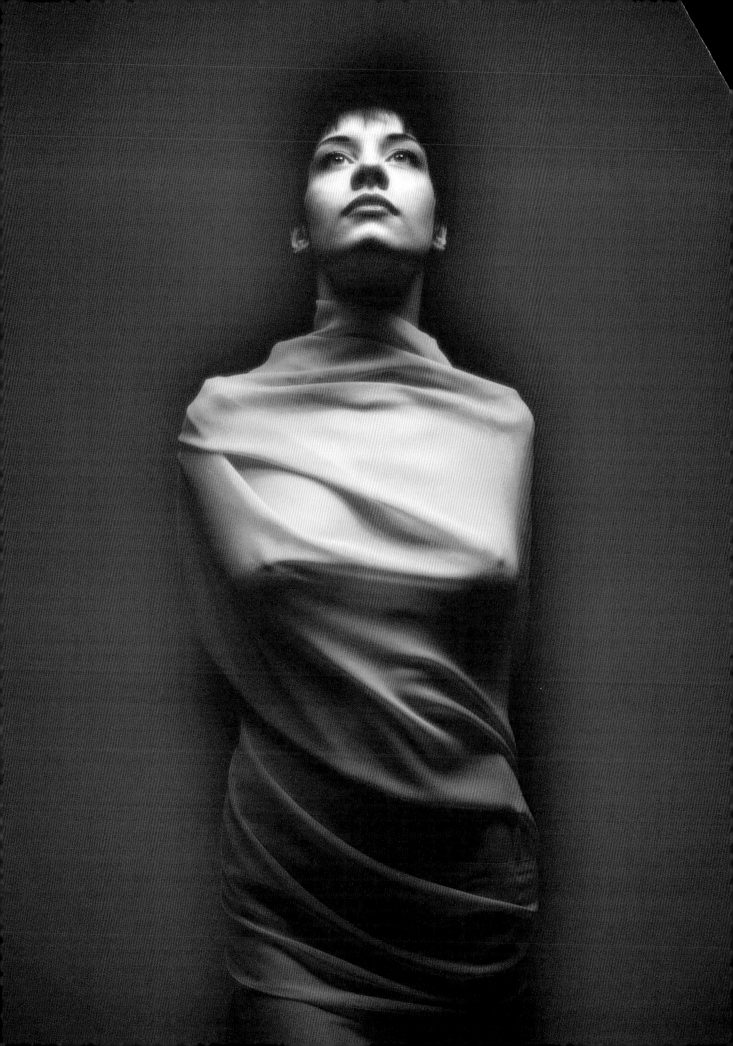

Francisco
HIDALGO

VISIONS OF THE CITY

Francisco Hidalgo is one of the legends of twentieth century photography. A true virtuoso of photography, his pictures have been exhibited internationally in galleries as well as published in thousands of books and magazines worldwide , this has made him one of the most famous photographers in the world.

Hidalgo studied at art schools in Barcelona and Madrid then at the Ecole des Beaux Arts in Paris. He became a celebrated illustrator working for the French television network. This led him to photography and the desire to travel the world to create his own unique images.

The city has been a focus for Hidalgo which captures his imagination as he probes beneath the surface to create a world of fragile poetic abstraction that is both vivid and direct as he says "It is the illustration of a subject that interests me more than anything else - indeed, in conceiving a picture I feel much like a painter. For a photograph to capture a particular atmosphere, I need a certain light, a subtle ambience. It gives me great pleasure to use the first light of day by rising early, as sometimes, filtering through the haze, the sun creates a strange, magical aura".

A major feature of Hidalgo's photographs is that he prefers to make his images in camera and by using multiple exposures and deliberate camera movement, he pushes 35mm equipment to produce ever more dramatic effects. He says "All my photographs are realised at the moment of taking, using only natural, available light."

Hidalgo is the author of a series of books on major cities of the world, he is currently preparing the next volume on Venice.

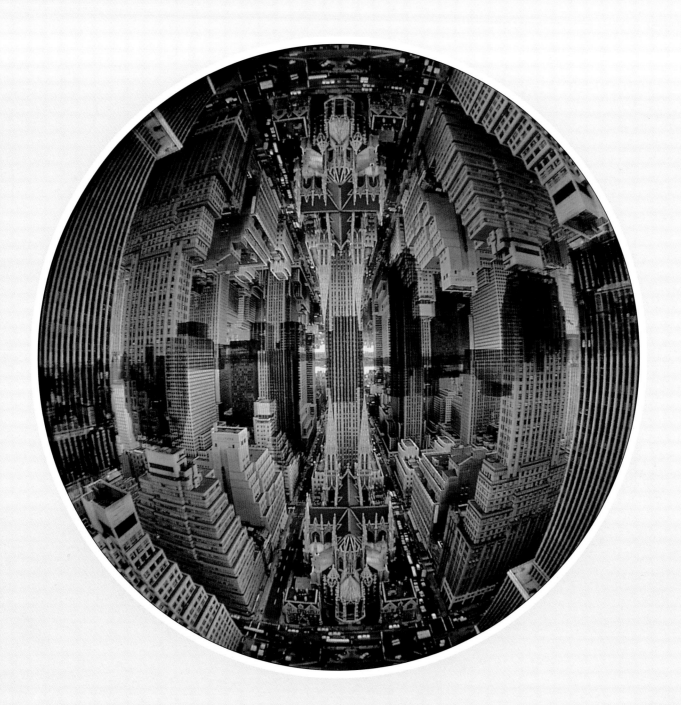

**Saint Patrick's Cathedral, New York,
surrounded by skyscrapers**

I dreamed of making a good picture with a Fish-eye lens, which
would symbolise New York. Looking at Saint Patrick's Cathedral
surrounded by those great skyscrapers I had an idea to reinforce
this effect, diminishing the blank sky by superimposing the
same subject twice. Using the lens cap which I had previously
cut in half, I masked half of each image, then I made a double
exposure in the same frame turning the camera 180°.

Nikon F, mirror blocked up, Nikon Fish-eye 7.5mm f8, 1/125 sec., Kodachrome 25

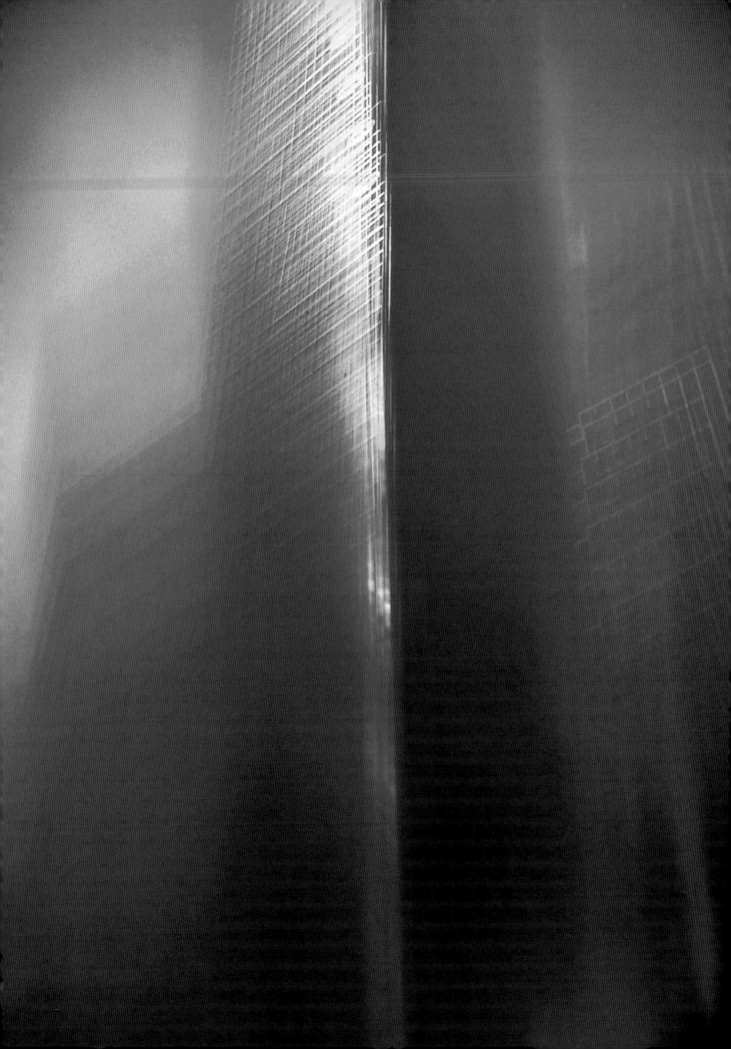

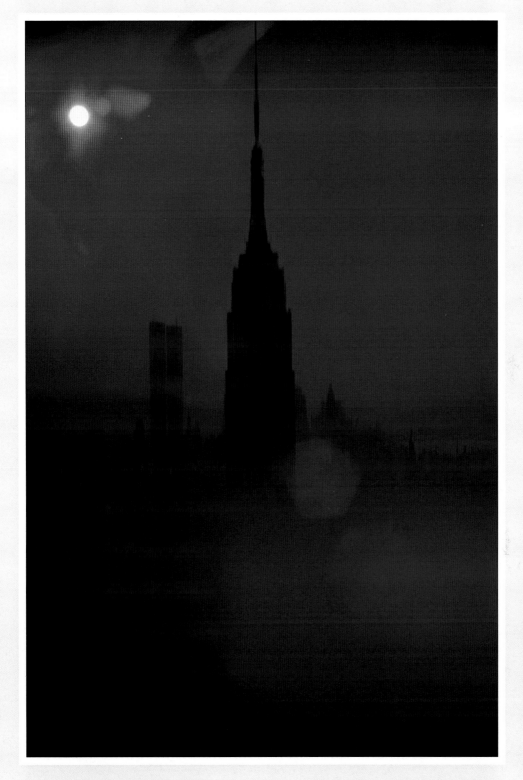

Avenue of the Americas, New York

I wanted a picture to capture the atmosphere of New York and not to describe a specific building. 8 exposures were taken in the same frame, I closed down 4 stops. Holding the rewind lever during shooting to stop the film advancing.

Nikon F2, MD-2 Motordrive, Nikon 20mm f4, 1/500 sec., Ektachrome Medical Film

Empire State Building and World Trade Centre, New York

I am a dreamer and sometimes I don't like reality, I prefer to suggest than to display. I don't care how a picture is made, what counts are the results. I hope that the viewer can imagine many things through my images.

Nikon F2, Nikon 105mm f2.5, 1/250 sec., Kodachrome 25, Wratten Gelatin Filter

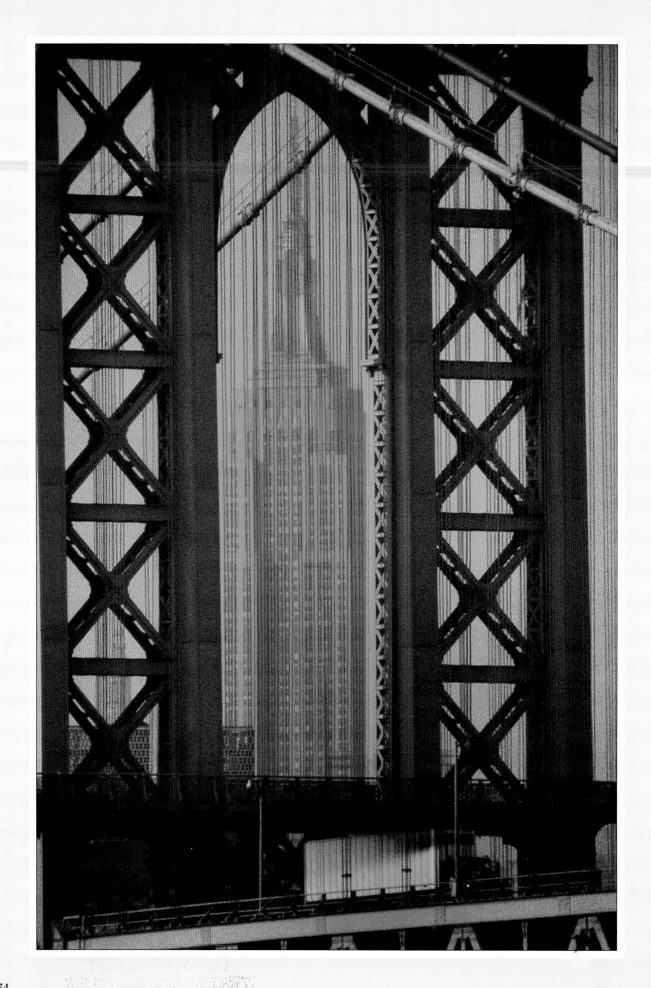

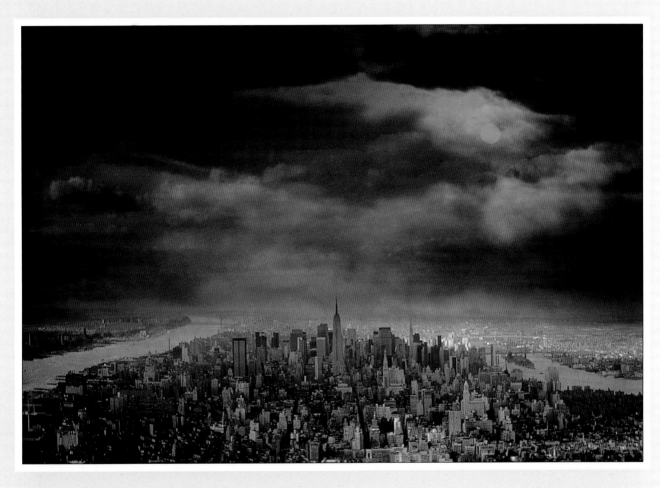

Lower Manhattan, New York, taken from the World Trade Centre

At the time I took this picture the twins were in the process of construction. I found this wonderful light.

Nikon F, Nikon 85mm f2, 1/250 sec., Kodachrome 25, Kodak Wratten Grey Gelatin Filter just in the sky

Manhattan Bridge and Empire State Building, New York, taken from Brooklyn Bridge

Most people think this picture is a montage. It is important to learn to look into the distance, it is amazing how many interesting subjects you can discover. I waited to get a truck in the picture to emphasise the perspective.

Nikon F2, Nikon Mirror lens 500mm f8, 1/250 sec., Kodachrome 64

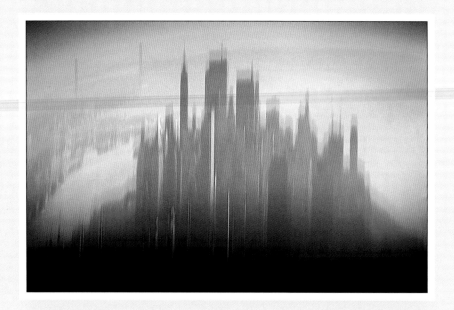

Downtown Manhattan, New York

This is my favourite picture, it enhanced the best of this city. Just the shape of buildings more graphic than reality. The photograph was taken through a piece of plastic which acted like a prism.

Nikon F2, Nikon Zoom 43-86mm f3.5, 1/500 sec., Kodachrome 25

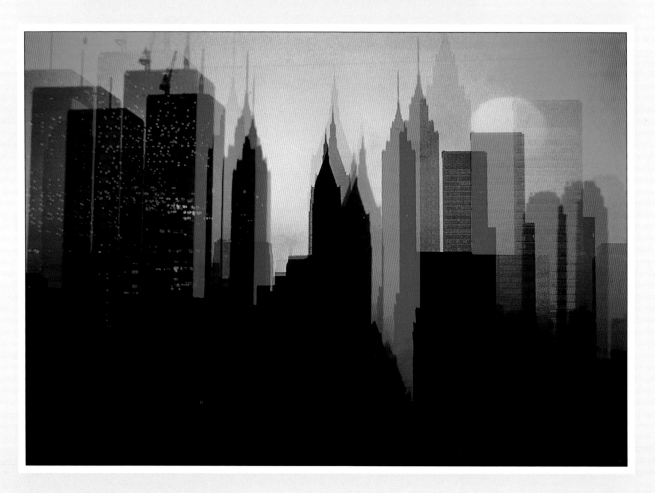

Downtown Manhattan, New York, taken from New Jersey at Hamilton Park

I think of New York like a painting more than a photograph. I took 3 exposures zooming during shooting. I closed down 1 stop.

Nikon F3, Nikon Zoom 80-200mm f4, 1/125 sec., Kodachrome 64, Kodak Wratten Gelatin Filters: blue, red, yellow

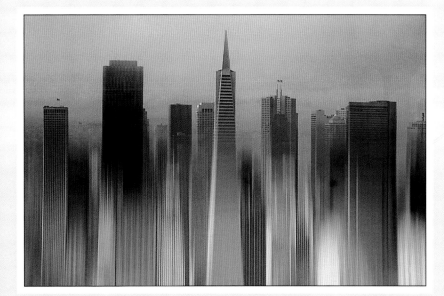

**Skyscrapers panorama
with Transamerica Pyramid,
San Francisco**

A small piece of plastic helped
me to realise this picture, held
across the bottom of the lens.
Once again I was more
interested in the atmosphere
of this picture than the reality.

Nikon F3, Nikon 135mm f2, 1/500 sec.,
Kodachrome 64

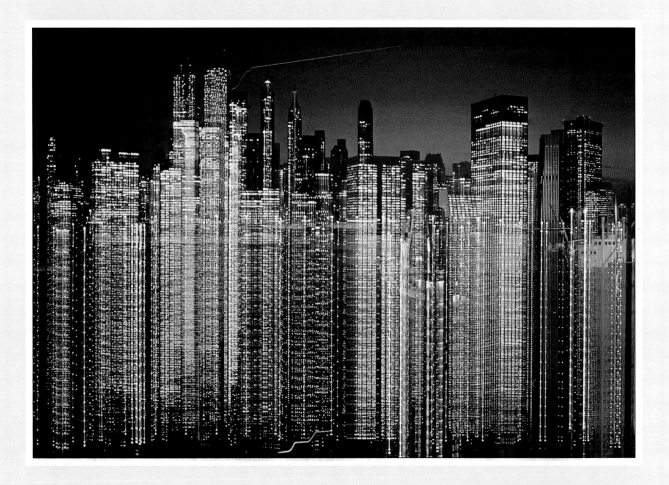

**Lower Manhattan, New York, taken from
Brooklyn Heights**

An exposure of 30 seconds was needed
for this shoot. I shifted the lens slowly
during the exposure.

Cullmann tripod, Nikon F3, Nikon P.C. 35mm f2.8,
Kodachrome 25

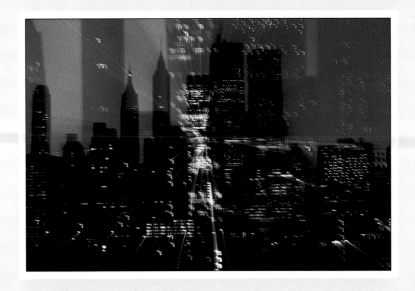

Manhattan, New York, taken near Brooklyn Bridge

The lens was zoomed for 10 seconds and then stopped zooming and exposed for 5 seconds more.

Nikon F3, Nikon Zoom 80-200mm f4, 15 sec., Ektachrome HS, Blue Wratten Gelatine Filter

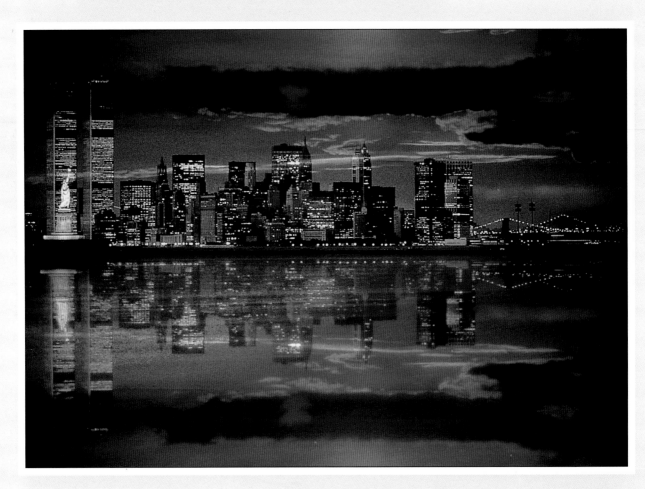

Down town New York and Governors Island

When in New York I am always looking for new angles. I think I know New York better than my own hand. The Statue of Liberty is one of the most remarkable subjects to photograph. I was searching for a way to take a picture including the World Trade Centre buildings with the panorama up to Brooklyn Bridge. I took a large map of Manhattan and discovered a place near New Jersey. The picture was taken from a locality called Bayonne. The subjects photographed were in the far distance, which accentuated the perspective giving to each element its real size.

Nikon F3, Nikon 80-200mm f4, 20 sec., Kodachrome 64

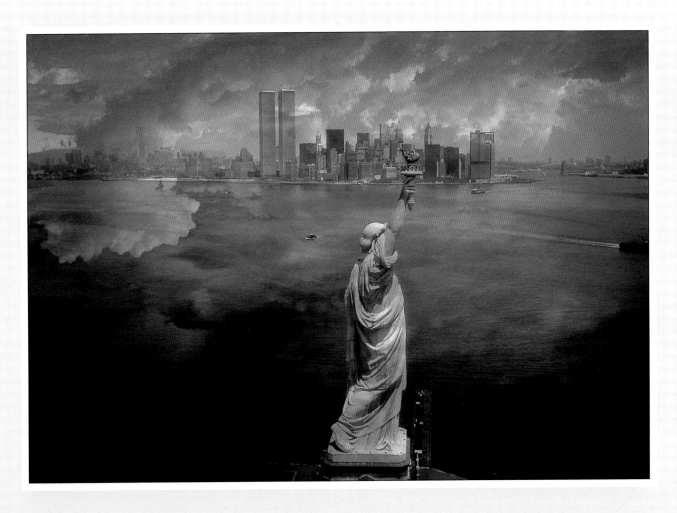

Statue of Liberty, New York

This picture was taken during an
assignment in New York City.
I made a round trip by helicopter
and decided this was a good angle
from which to shoot. I made a
double exposure, one with the
Statue of Liberty and Manhattan,
the other with a picture including
the sky. I closed down 1 stop.
I was very impressed by this
emotional view.

Nikon F4S, Nikon Zoom 35-135mm f3.5-4.5,
1/500 sec., Kodachrome 64

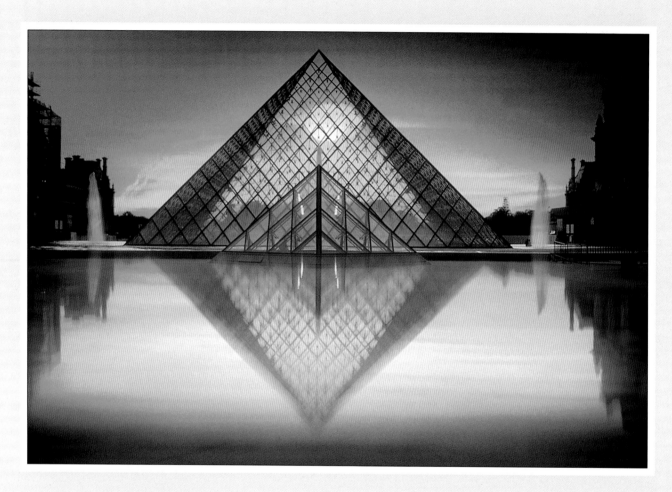

**Louvre and Pyramid, Square Napoleon,
Paris, by the architect Pei**

Ektachrome 200 rated at 320 ISO and
pushed 1 stop. This is a great film I have
discovered recently. Nearly the same
sharpness and grain as Kodachrome 64!
If you want to have the sun at this angle,
you have only one time each year,
the 1st of May at four minutes past seven
in the evening.

Nikon F5, Nikon AF Zoom 28-85mm F3.5-45
1/1000 sec.

Brooklyn Bridge, New York

Both parts of the bridge were framed
with this lens. The lens was pointed up
to the sky. There is no distortion in the
centre of the image when you use
a fish-eye lens. The orange filter was
incorporated in the lens. Learn to look
up when in New York!

Nikon F3, Nikon Fish-eye 16mm f2.8, 1/250 sec.,
Kodachrome 64

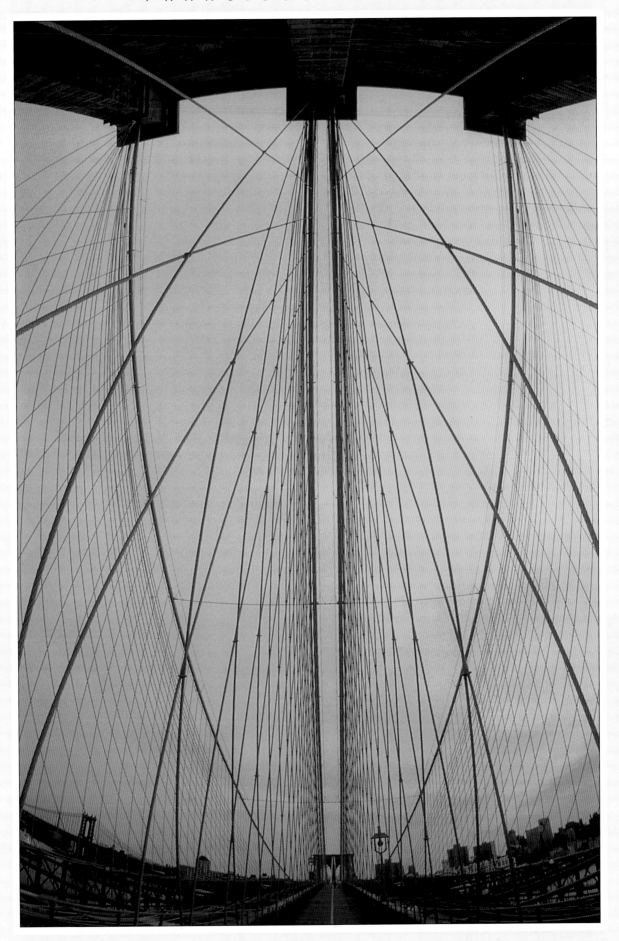

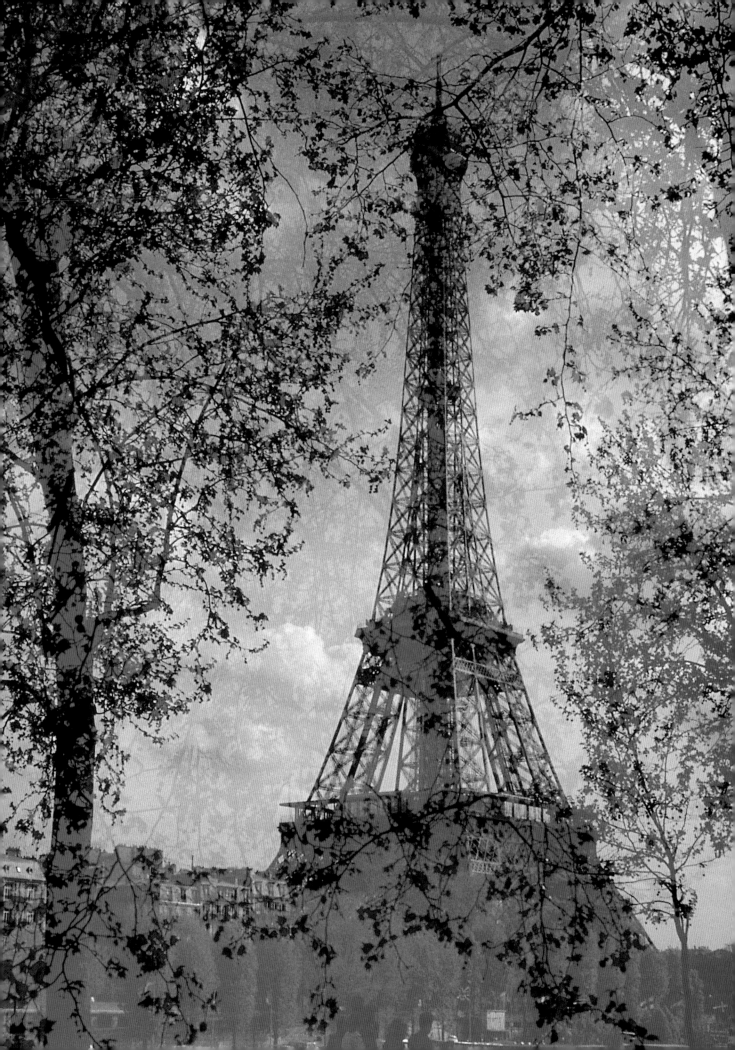

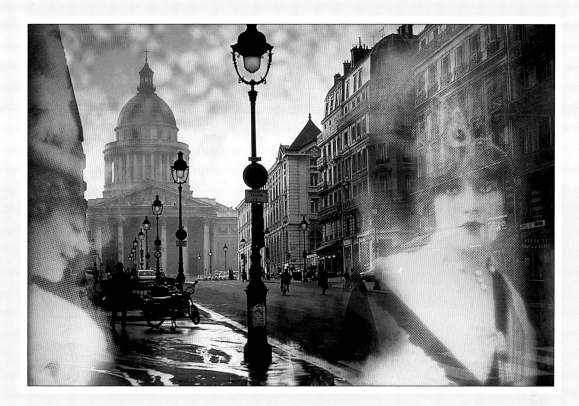

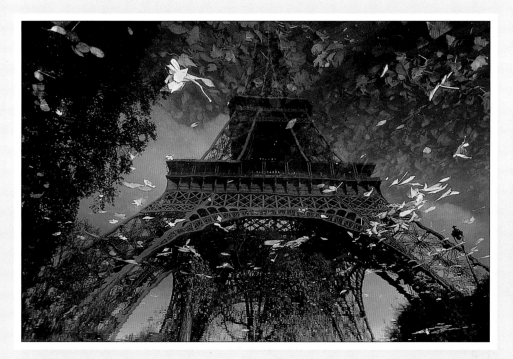

Above: **Latin Quarter, Rue Soufflot and Pantheon, Paris**

I took this picture early in the morning. The two ladies are a reflection in a shop window which I took as a double exposure. I closed down 1 stop. Get an idea first and then take the picture about 5 seconds later. I mean take your time when possible. I always say inspiration lasts only a few seconds. Never try to take the same picture later, the first time is always the best.

Nikon F4, Nikon 50mm f1.4, 1/250 sec., Kodachrome 64

Eiffel Tower, Paris

I wanted to find a really new picture of the Eiffel Tower when I saw it reflected in a puddle. Generally I never look for new subjects, I just look and find them all around me.

Nikon F4S, Nikon Fish-eye 16mm f2.8, 1/30 sec., Kodachrome 64

Eiffel Tower, Paris

Double exposure. First the Eiffel Tower, second leaves against the sky. This is an interpretation of reality. The blue colour was produced by the sky. Just a little detail can considerably change an image in a poetic view.

Nikon F4S, AF Nikon Zoom 35-105mm f3.5-4.5, 1/500 sec., Kodachrome 64

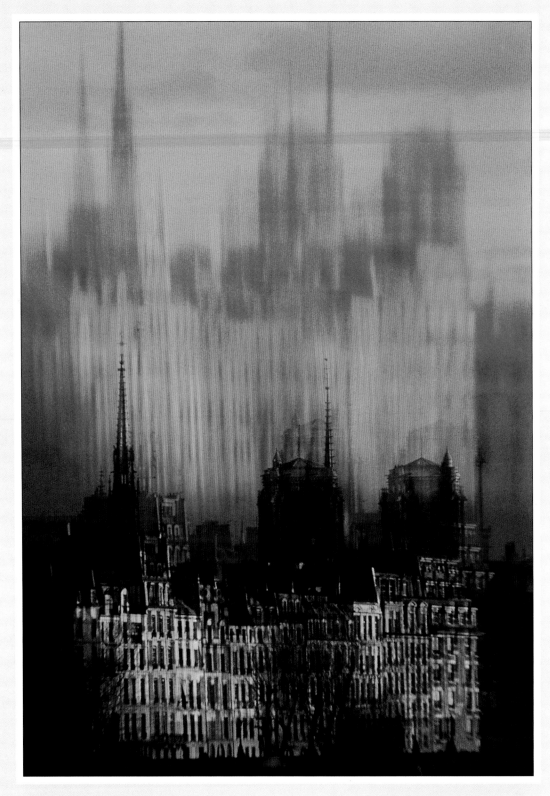

Notre Dame Cathedral, Paris

I think the most important thing in this picture is the light, but there is something more. I was inspired at that moment by the music of Bach which gives me the feeling that Notre Dame is ascending through the cosmos and constellations to a starry sky.

Double exposure, first exposure Notre Dame, second exposure Notre Dame through a prism. I closed down 1 stop.

Nikon F, Nikon 135mm f2.8, 1/125 sec., Kodachrome 25

Cologne Cathedral, Germany

I was on the 5th floor and saw through the window a magnificent view of the cathedral opposite. I made 3 exposures in the same frame moving the camera vertically during shooting. I closed down 1 stop and took just one picture.

The same applies for the other images in this portfolio, I have just one transparency of each. All the pictures were taken within the camera, once I shoot, the picture is finished.

Nikon F3, Nikon 20mm f4, 1/250 sec., Kodachrome 64

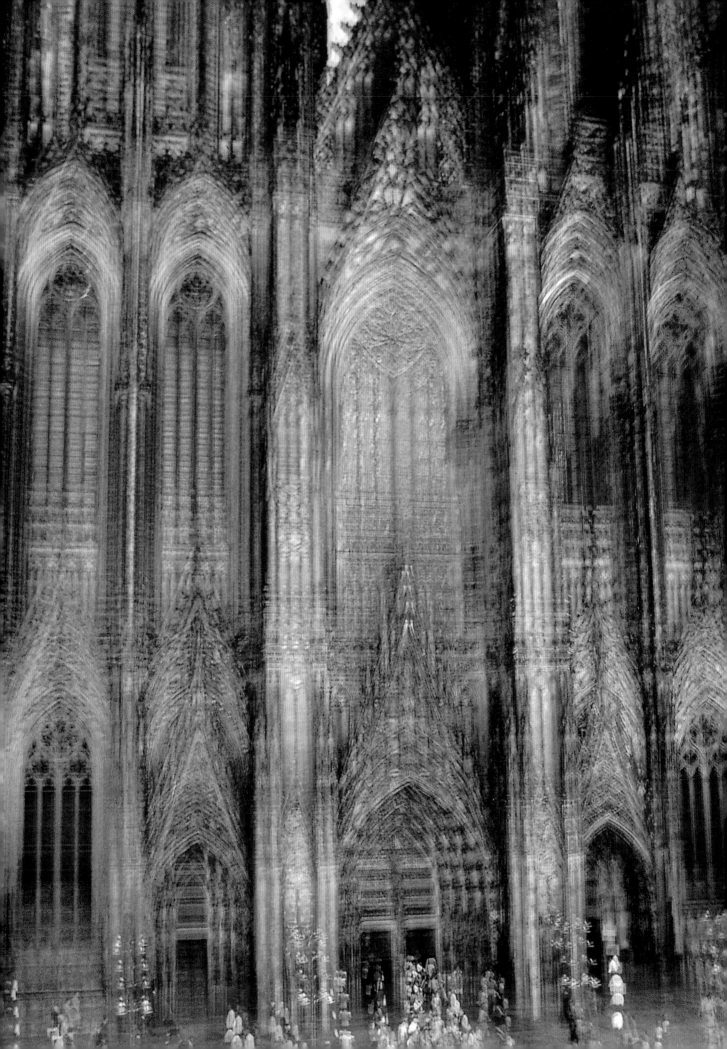

Lin Dung Leung

SPONTANEOUS REFLECTIONS

Lin Dun Leung was born in the province of Guangdong, China in 1928 and migrated to Hong Kong in 1937. He worked in the commercial sector until his retirement ten years ago. Lin is one of Hong Kong's most celebrated photographers. When reflecting on why he was drawn to photography "Early on I was minded to acquire a hobby which could sharpen my intellectual faculties, benefit the care of my mind and body, fill my leisure time meaningfully and serve as a kind of anchor for my retirement. Photography possesses all the attributes I desire".

He started by regularly visiting exhibitions of international photography in Hong Kong where he lingered for many hours. Learning from the successful became his means of study. In addition he read a large number of photographic publications searching for information.

After a steep learning curve and supported by field experiences and encouragement from his mentors in the Hong Kong photography scene, he gathered sufficient courage to send some of his photographs to international salons. He immediately gained wide acceptance for his work which boosted his confidence. Lin became a fellow of the Royal Photographic Society and is an Honourable Excellence of the Federation Internationale de l'Art Photographique. For twelve years he was listed in the 'Top Ten of Colour Photography' published annually by the Photographic Society of America.

Lin Dung Leung is a calm personality who enjoys travelling, an activity he combines with visiting a network of friends in the photographic community all over the world. In the future he would like to find a more innovative and enhanced style and concentrate on studio portraits. This is understandable as travel becomes more difficult and studio photography is less tiring. Whether studio or location – Lin Dung Leung's photography will still be a synonym for colour harmony and strong compositions.

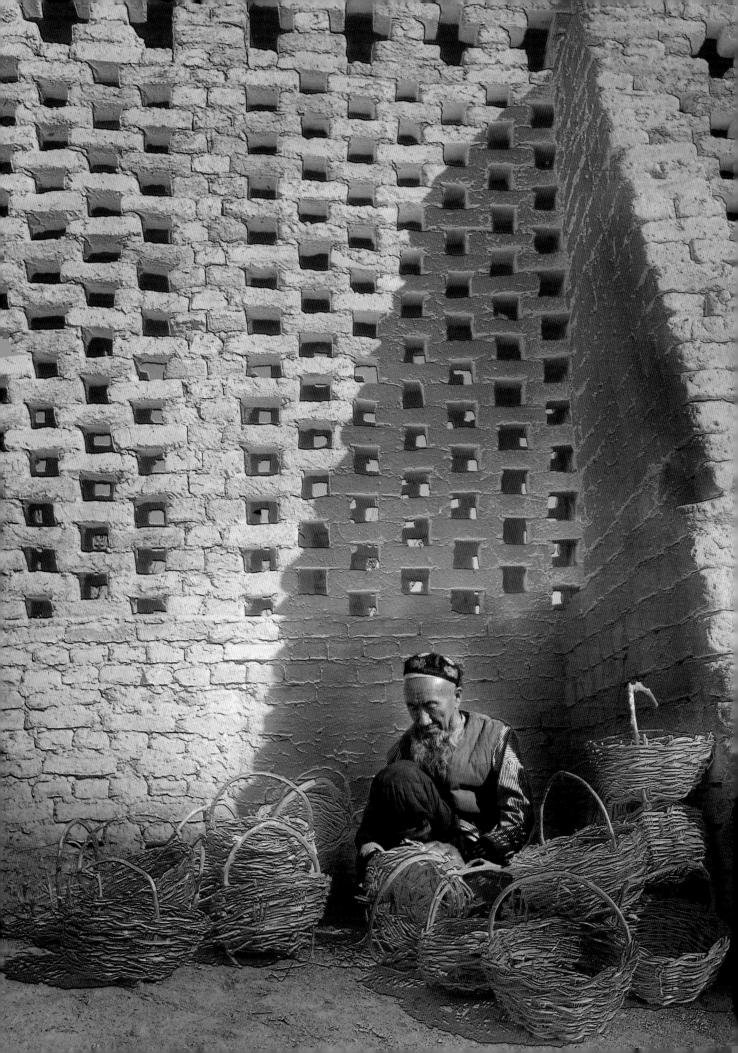

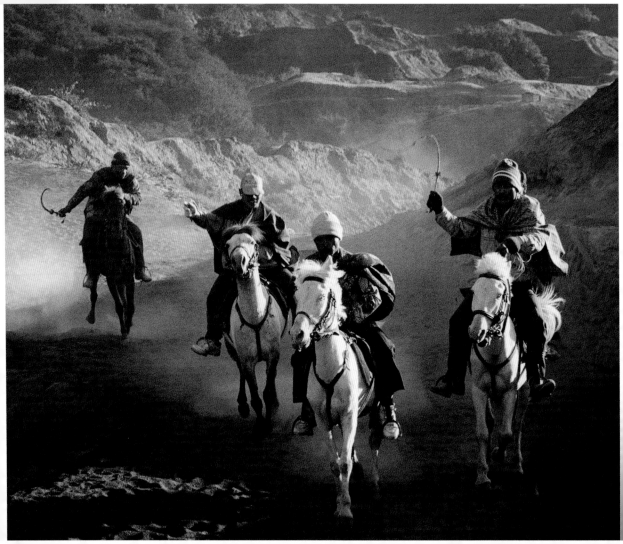

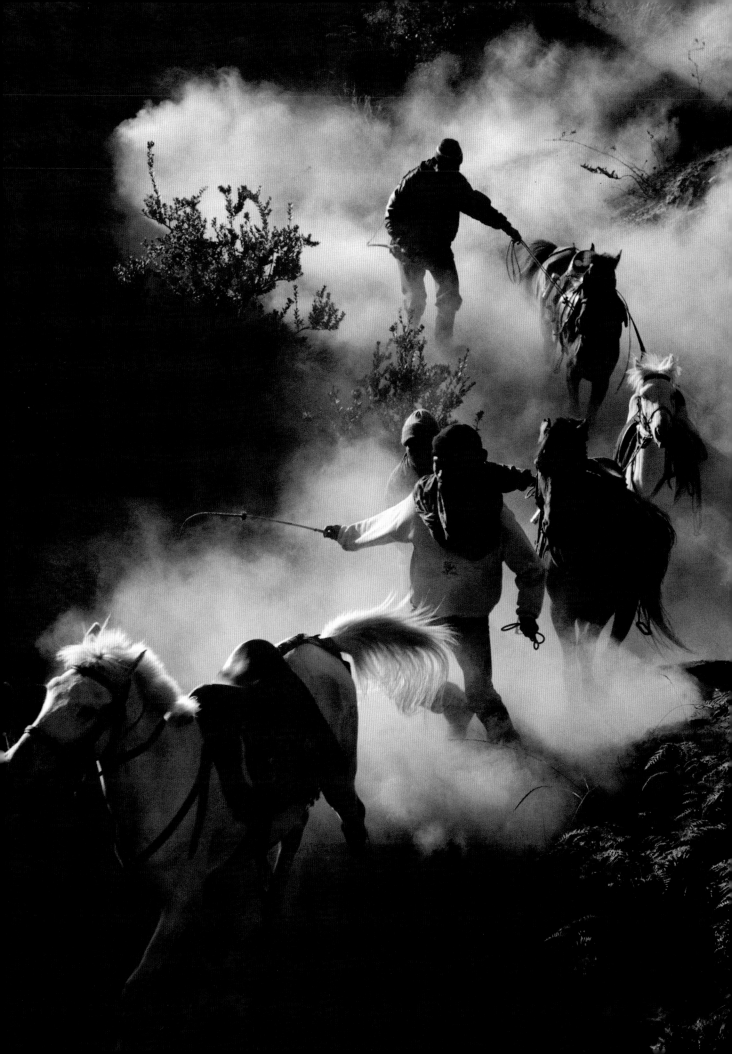

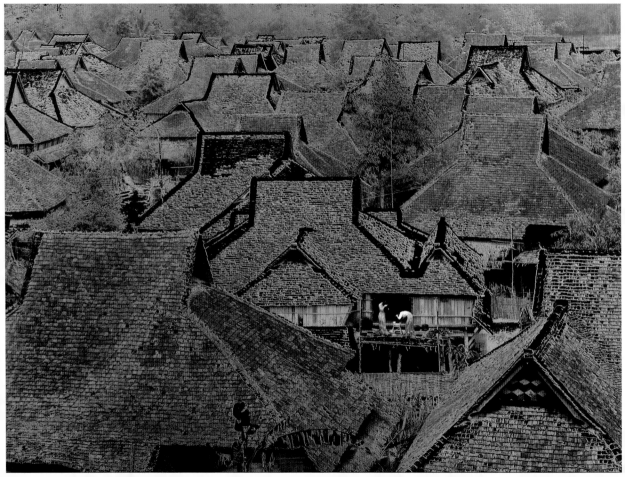

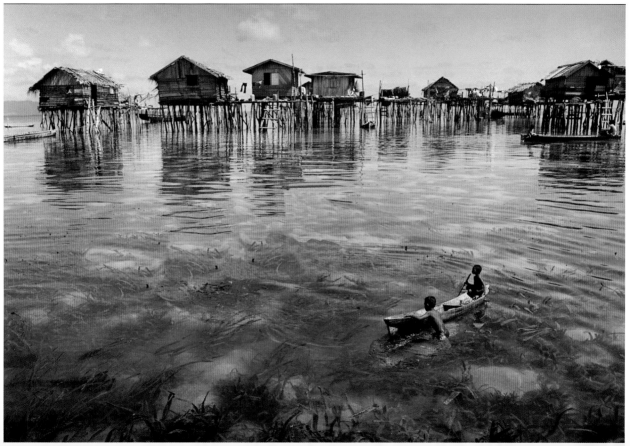

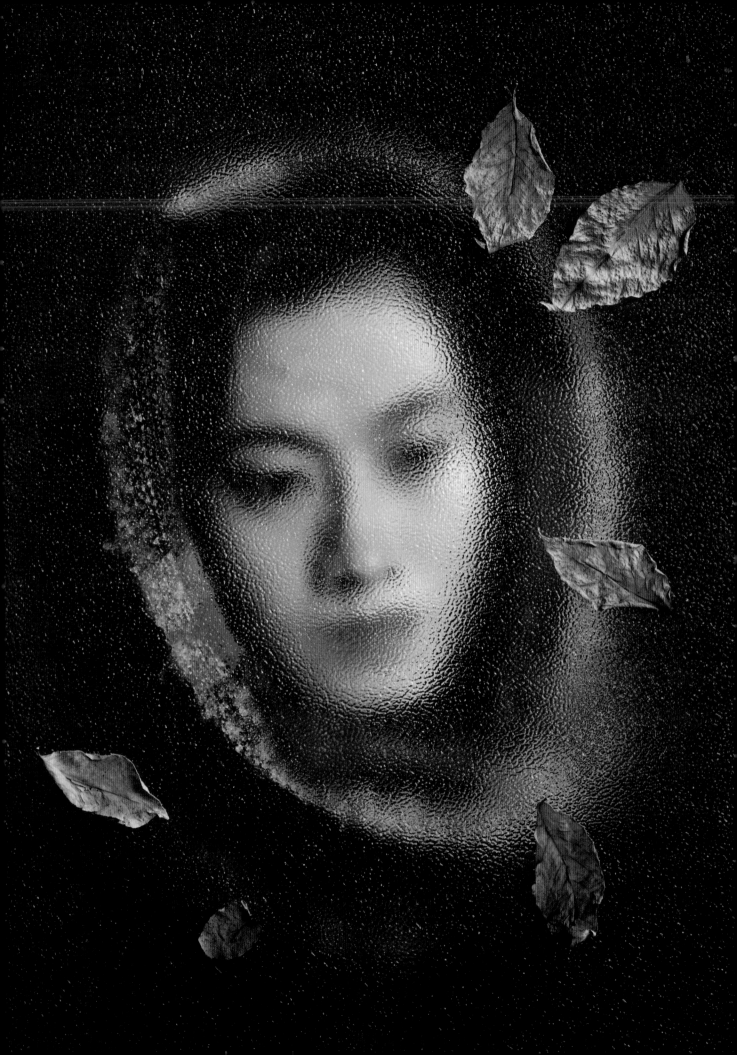

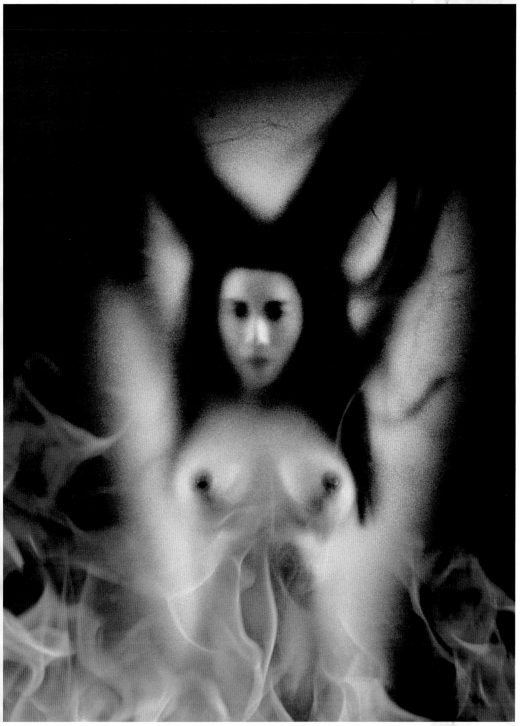

Time

INTERNATIONAL PORTFOLIO

TIME (Təim) time, good time, prosperity, Anglo Saxon - tima, Old Norse - timi, Germanic - timon. Also expressed by another derivative of the same base viz. TIDE which was superseded by time.

1. A limited stretch or space of continued existence as the interval between two successive events or acts.

2. A particular period in the existence or history of the world; an age, an era. TIMES Used as the name of a newspaper 1788. A period considered with ref. to one's personal experience. a. Period of existence or action; period of one's life.

The prescribed duration of the interval between two rounds in boxing, or the like, or the moment at which this begins or ends.

Military - the rate of marching, calculated on the number of paces taken per minute 1802.

Musical - the rate at which a piece is performed; hence the characteristic tempo, rhythm, form, and style of a particular class of compositions.

Speech - *You can fool all the people some of the time and some of the people all the time, but you cannot fool all the people all the time* (attributed to President Abraham Lincoln).

Colloquial. As times go, as things go in these times. Behind the times. *I went and had as a good a time as heart could wish* (Samuel Pepys).

One man in his time playes many parts (William Shakespeare).

It was the best of times ... (Charles Dickens).

Time when: a point of time; a space of time treated without reference to its duration. A point in time or of a period.

Modern English. What is the time, At what time, at the time that. A point or fixed part of the year, a season; also of a day. time of day, dinner-time, bed-time.

To know ... euery tyme of the nyht by the sterres fixe (Geoffrey Chaucer).

It was tyme to go to bed (William Caxton).

The devil bides his time (1722).

Four times fifty living men (Coleridge).

Men who had ten or twenty times less to remember (Gladstone).

Time waits for no man and your lifetime is over before it's begun (Entwistle).

Remember that time is money (Benjamin Franklin).

Time and tide wait for no man. Beat, happy stars, timing with things below (Tennyson).

Delay; spin out the time. To keep time. Time-honoured, Time-keeper, Timeless, Time-limit, Timetable, Time-server, Timepiece.

TIME - An international portfolio of images in Photography Yearbook 2000, individual interpretations on the theme of time at the end of the millennium.

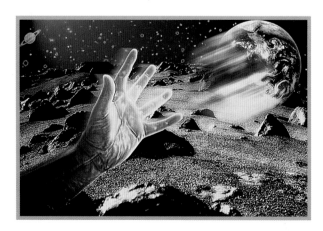

Elfi Kaut
AUSTRIA

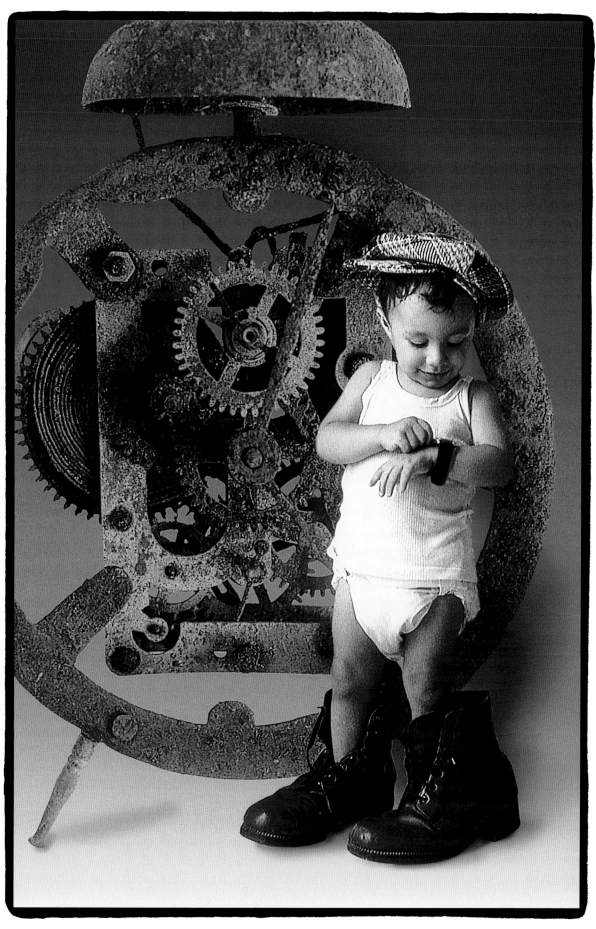

Anthony Xuereb
MALTA

95

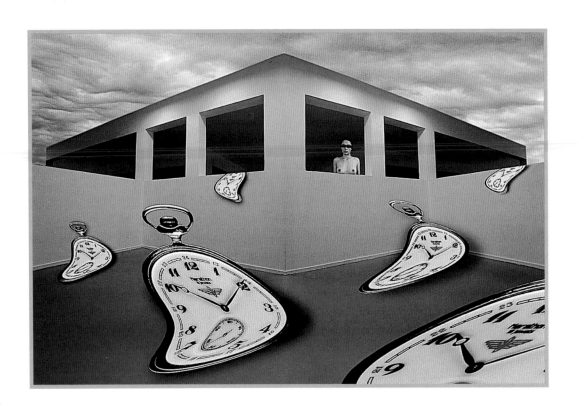

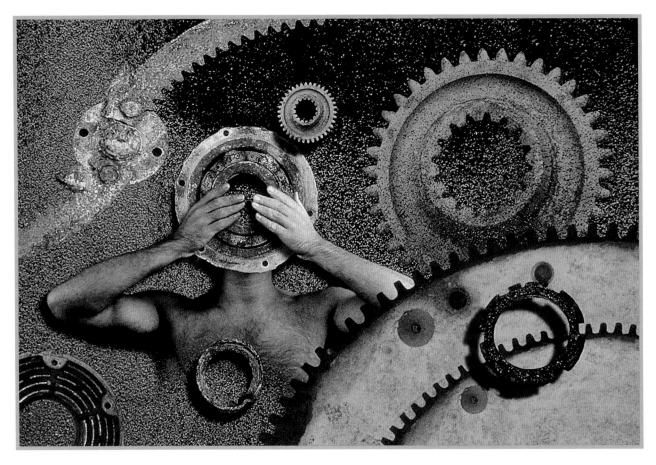

Manfred Kriegelstein
GERMANY

Siegfried Wallner
AUSTRIA

96

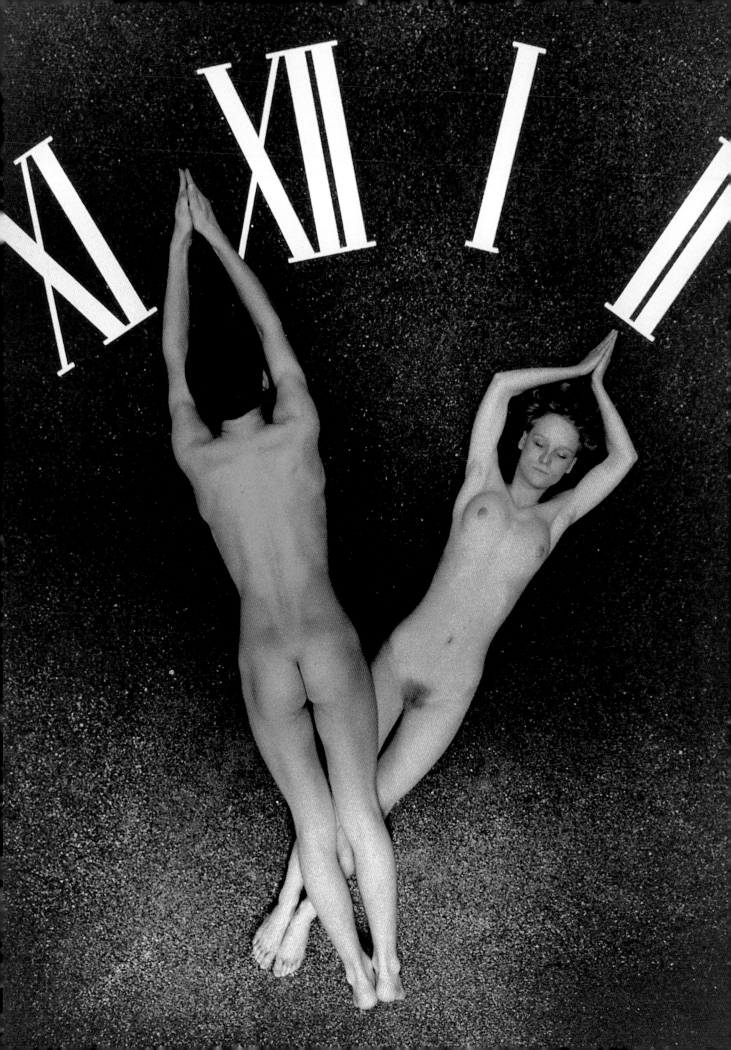

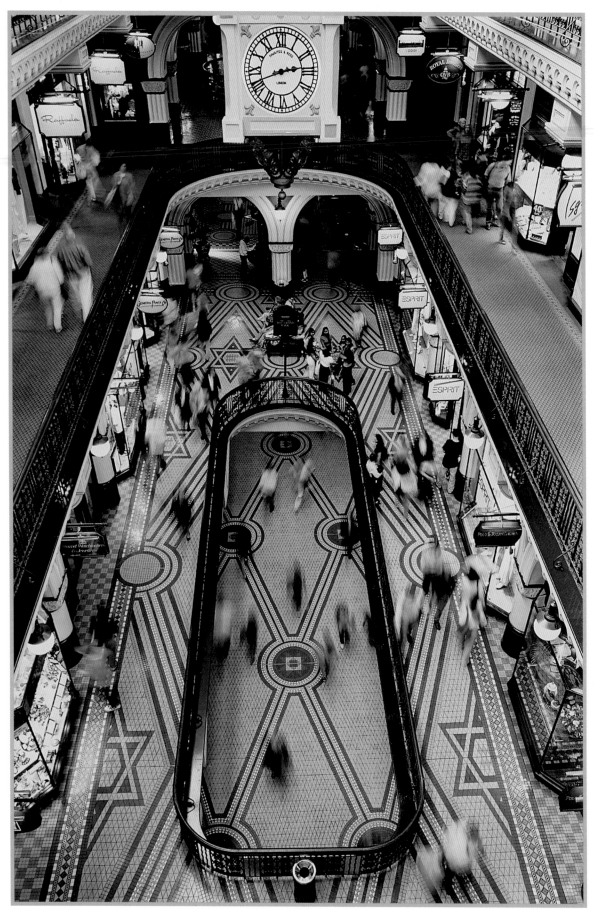

Frederick Hunt
AUSTRIA

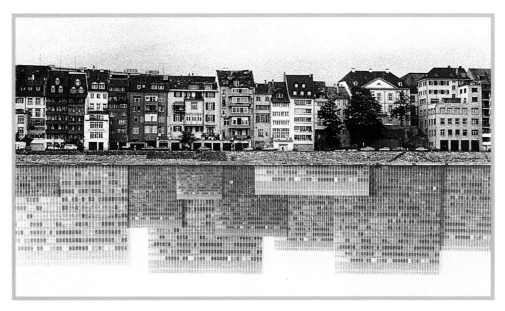

Walter Neiger
SWITZERLAND

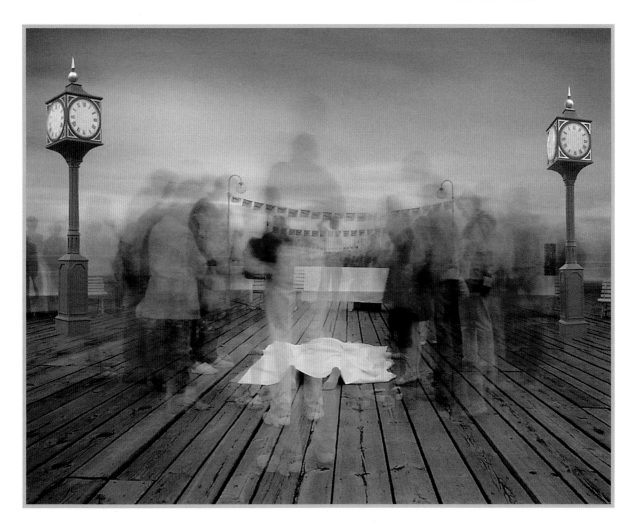

Piotr Powietrzynski
UNITED STATES

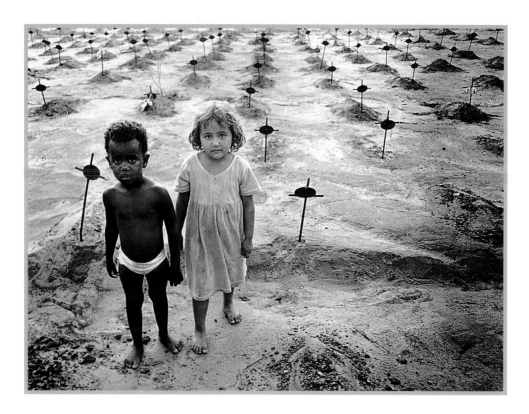

Alberto Vilas Boas
BRAZIL

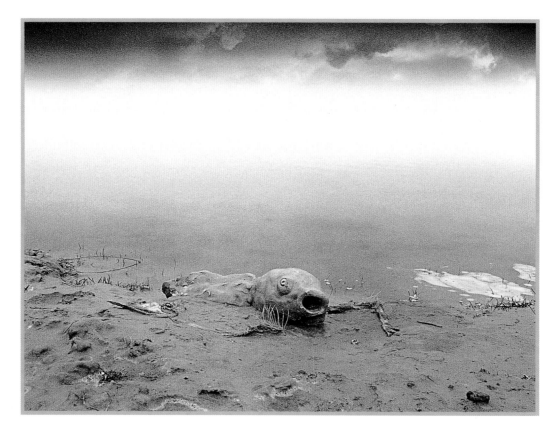

Jan Olichwier
POLAND

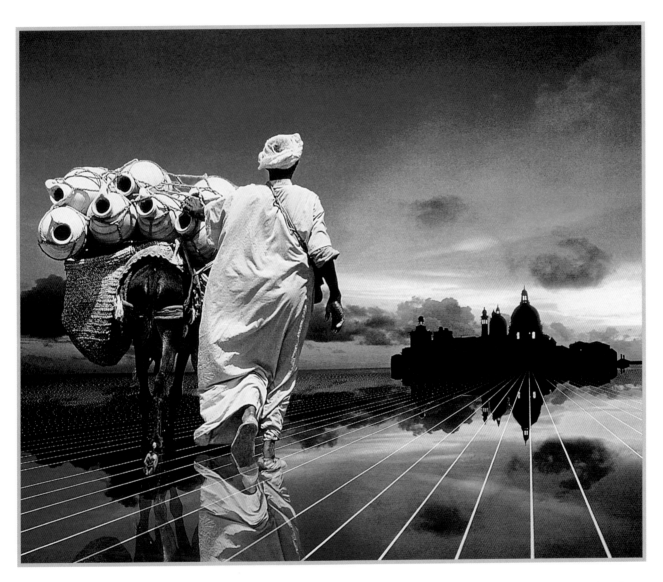

Toni Klocker
AUSTRIA

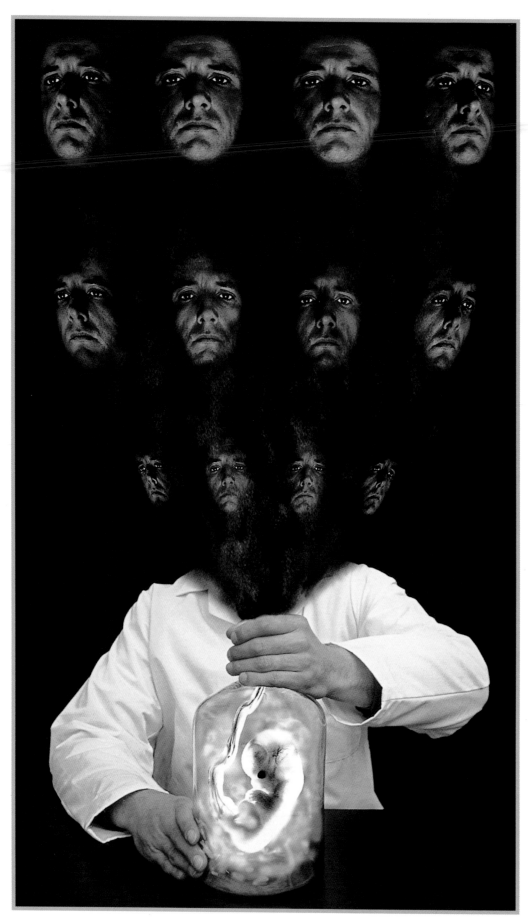

Manfred Holzer
AUSTRIA

102

Petras Katauskas
LITHUANIA

Delvin Stonehill
UNITED KINGDOM

103

Gunter Leidenfrost
AUSTRIA

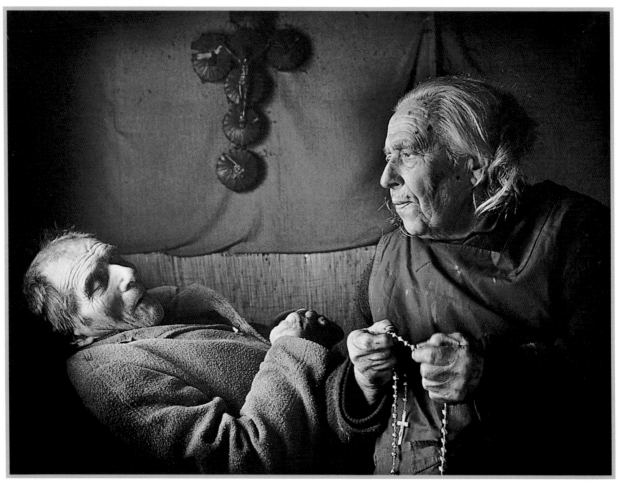

Gerardus van Mol
NETHERLANDS

104

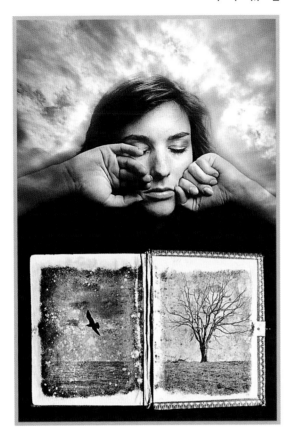

Jerry Uelsmann
UNITED STATES

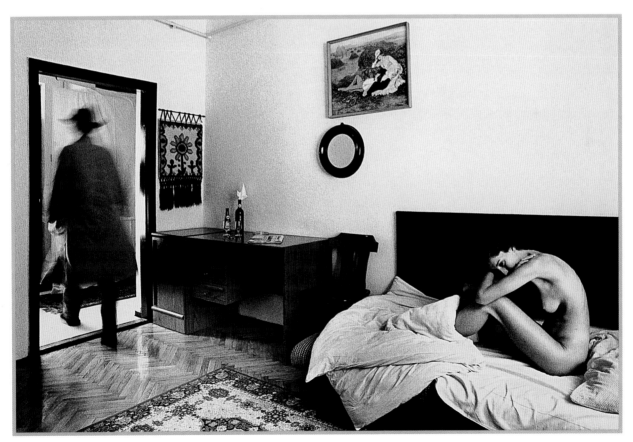

Eric Jorgensen
DENMARK

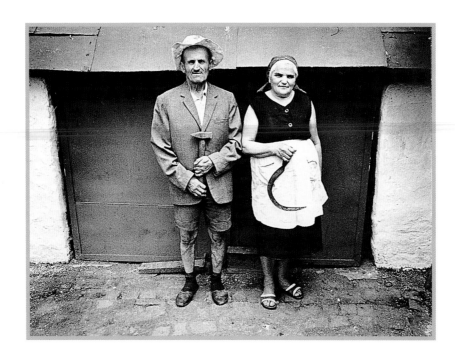

Aleksander Kelic
JUGOSLAVIA

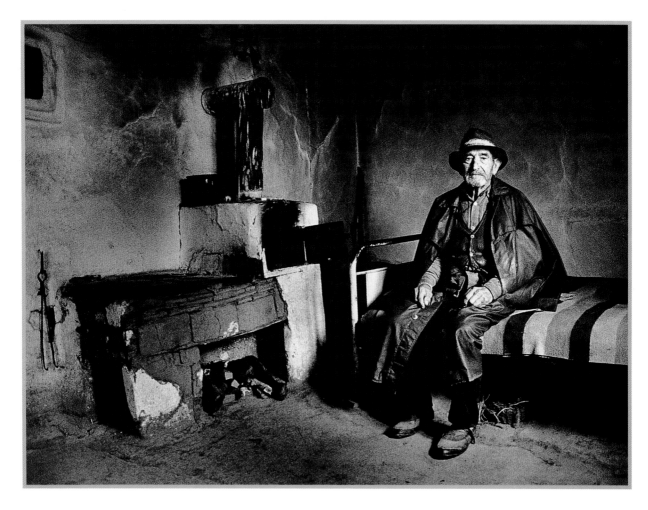

Dragan Ilic
JUGOSLAVIA

106

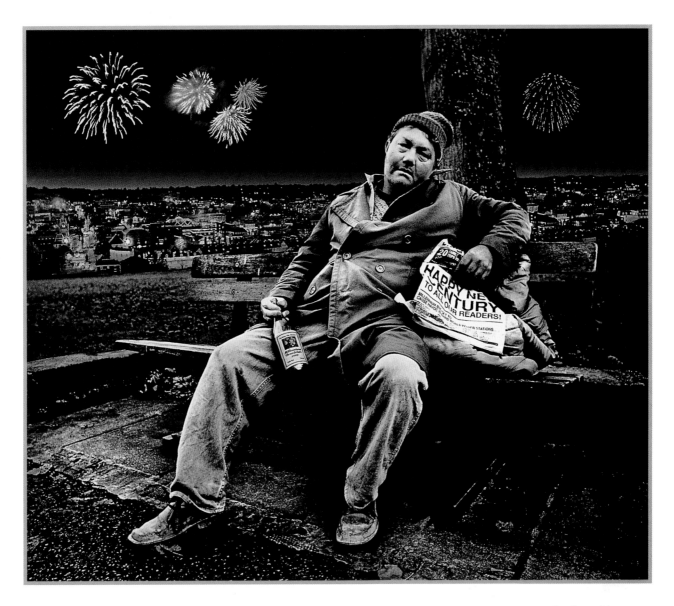

Anita Nutter
UNITED KINGDOM

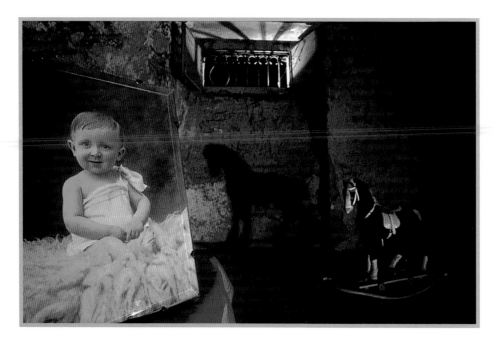

Giulio Montini
ITALY

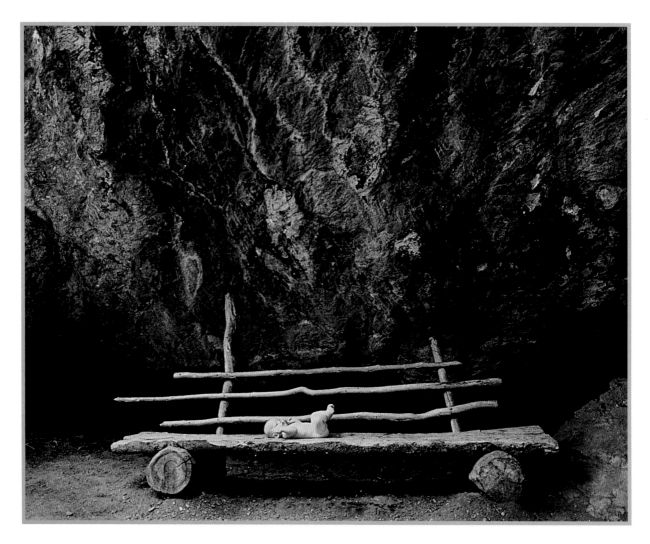

Siegfried Wallner
AUSTRIA

108

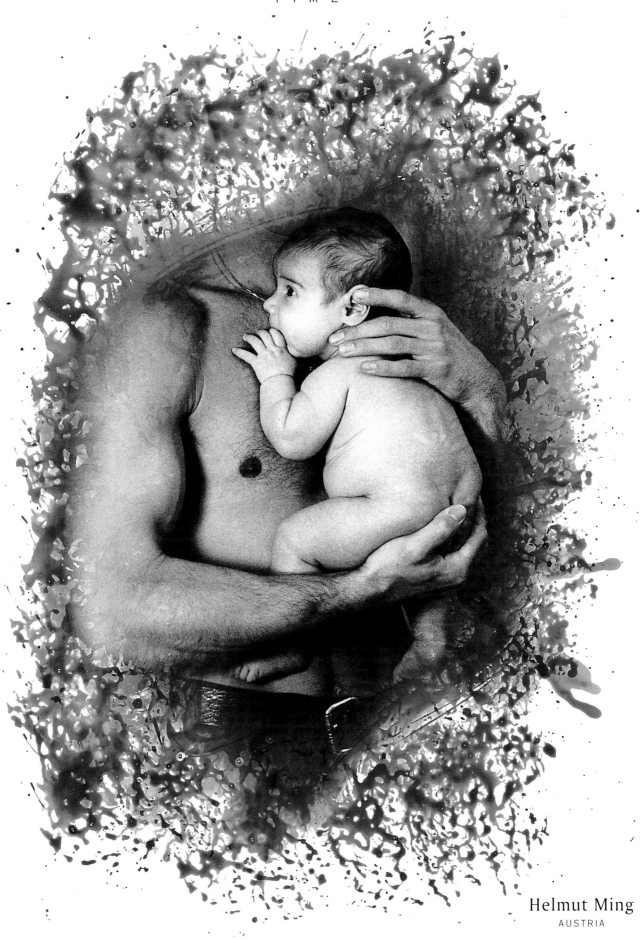

Helmut Ming
AUSTRIA

THE PHOTOGRAPHERS

Tien Chian Foong
SINGAPORE

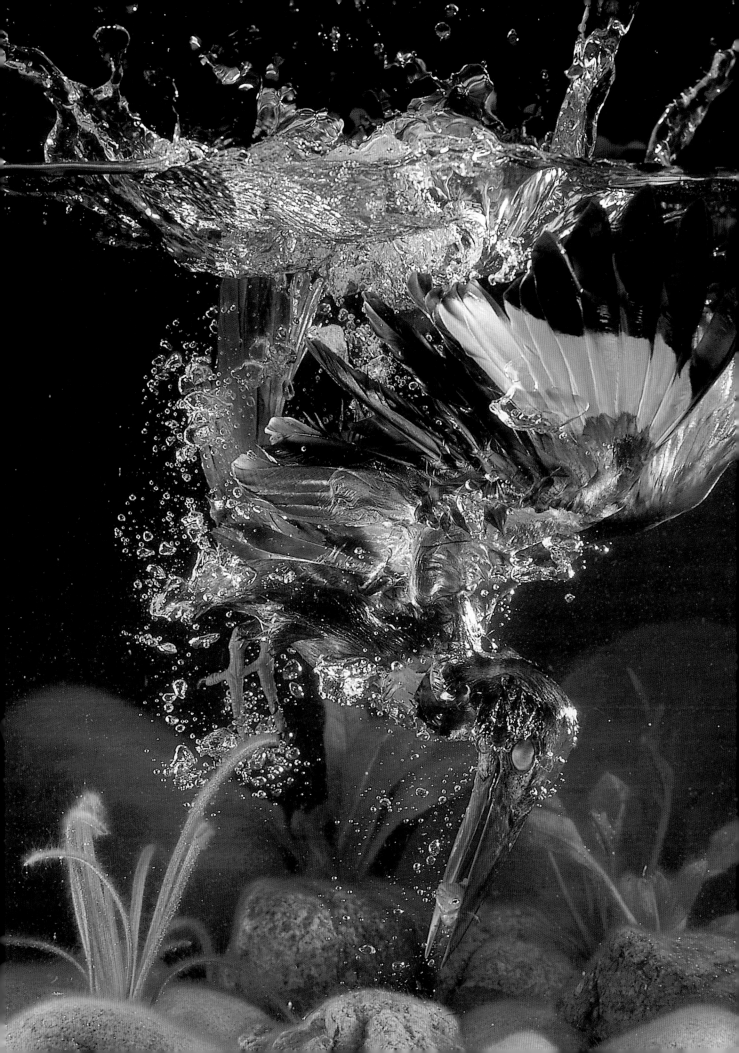

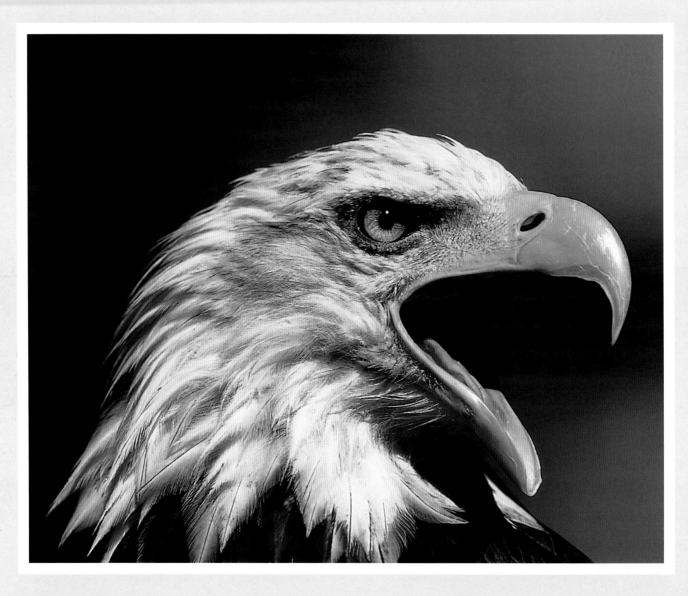

Norbert Baranski
GERMANY

Barbara Lewis-White
UNITED STATES

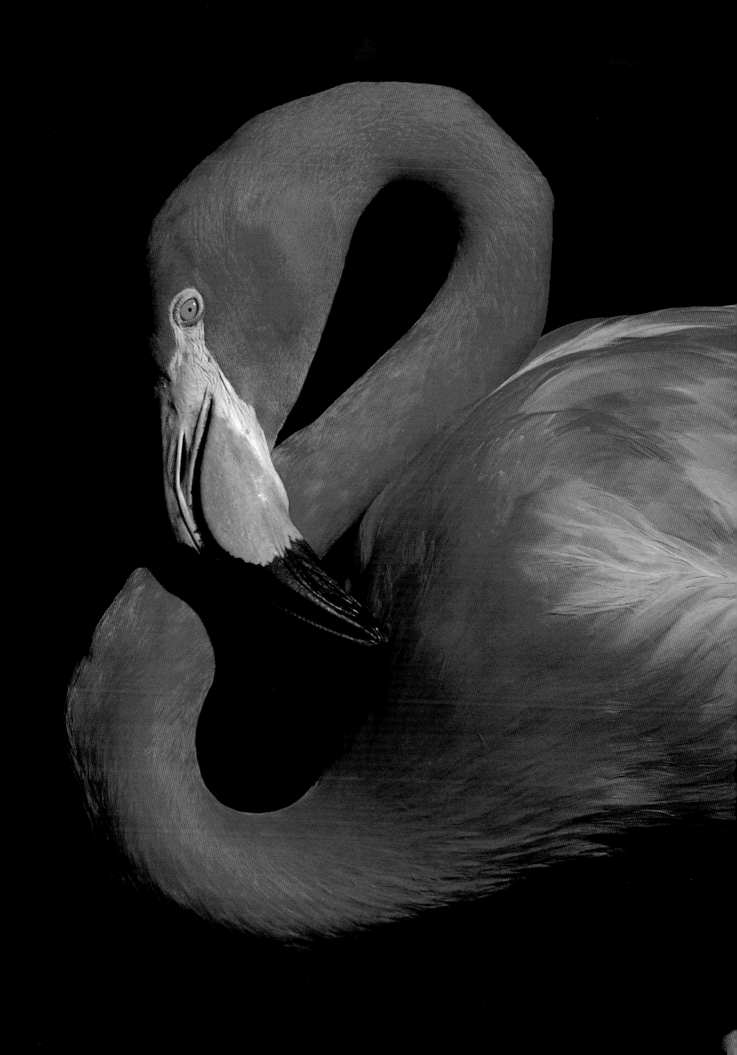

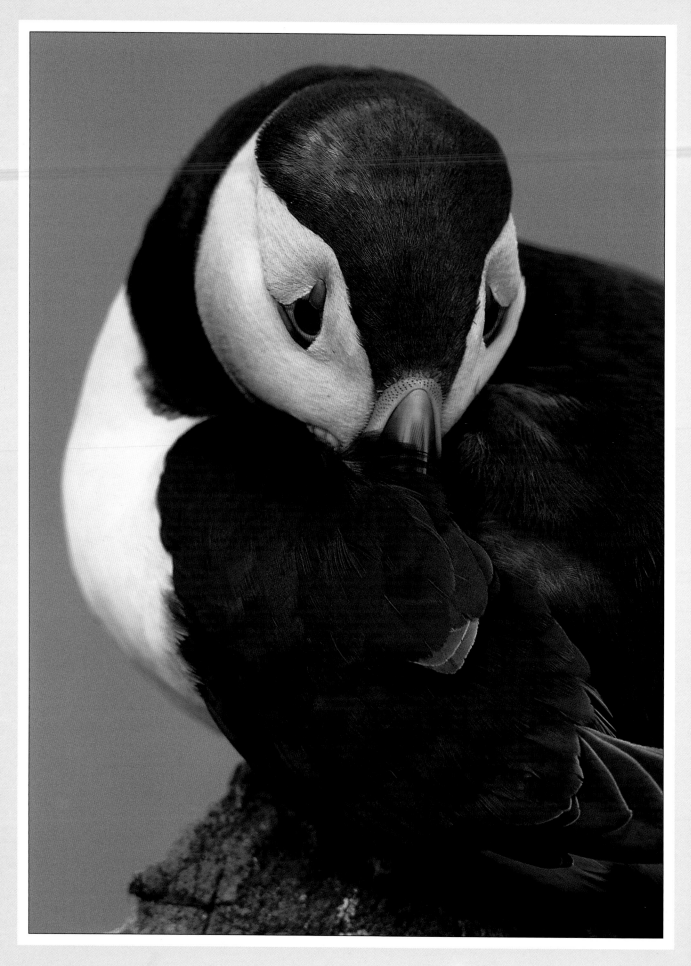

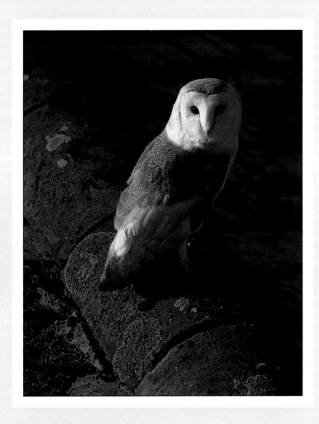

Malcolm Freeman
UNITED KINGDOM

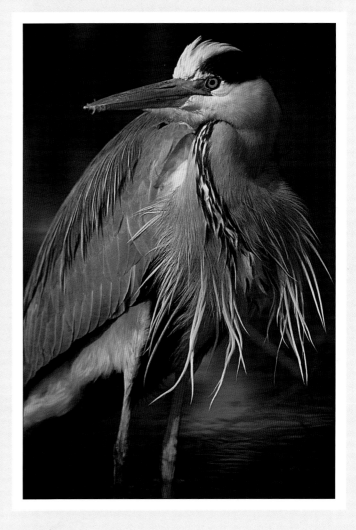

Paul Hicks Russell Hartwell
UNITED KINGDOM UNITED KINGDOM

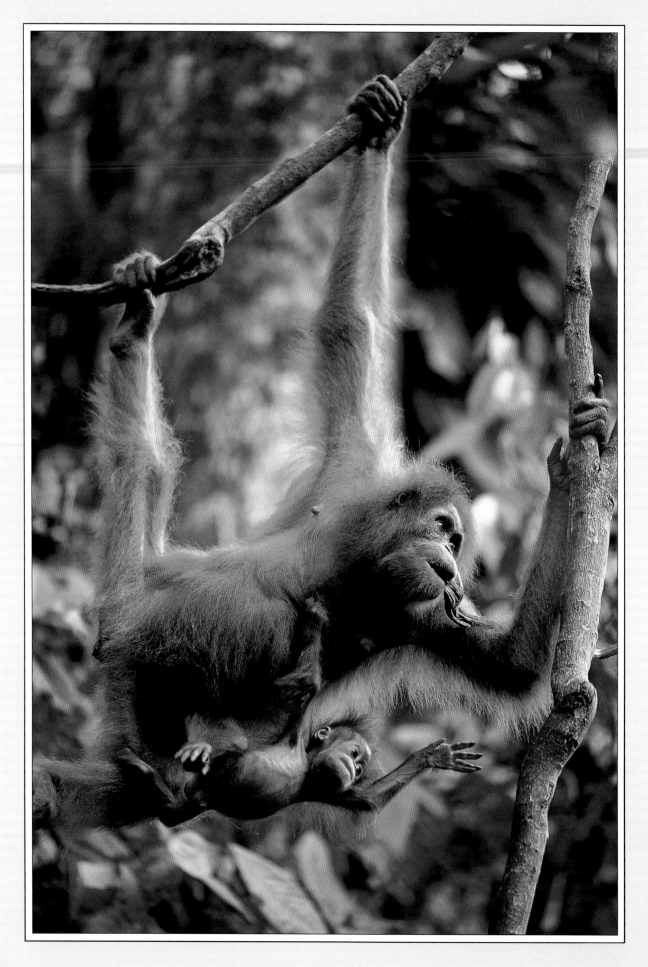

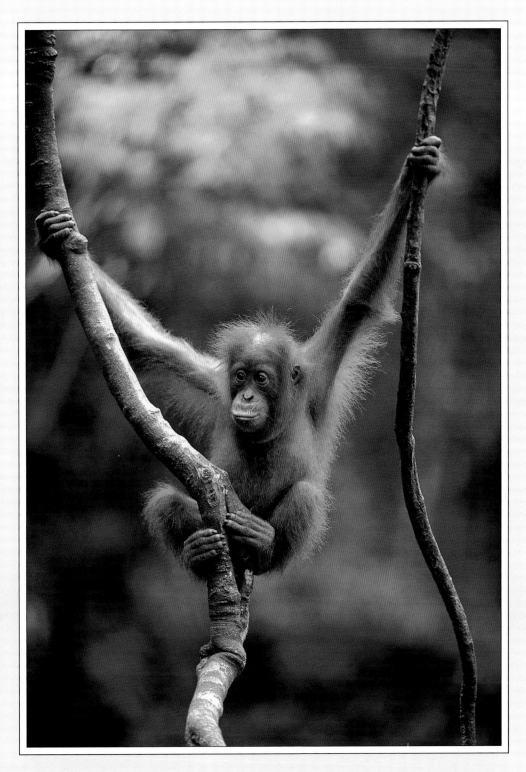

Anup & Manoj Shah
UNITED KINGDOM

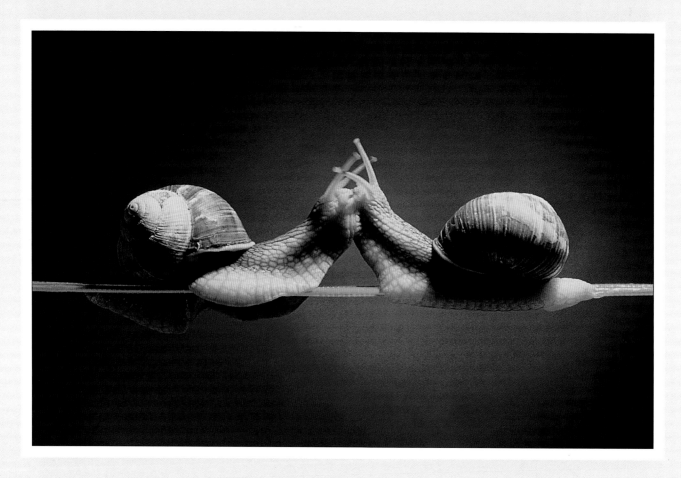

Cor Boers
NETHERLANDS

Manfred Zweimüller
AUSTRIA

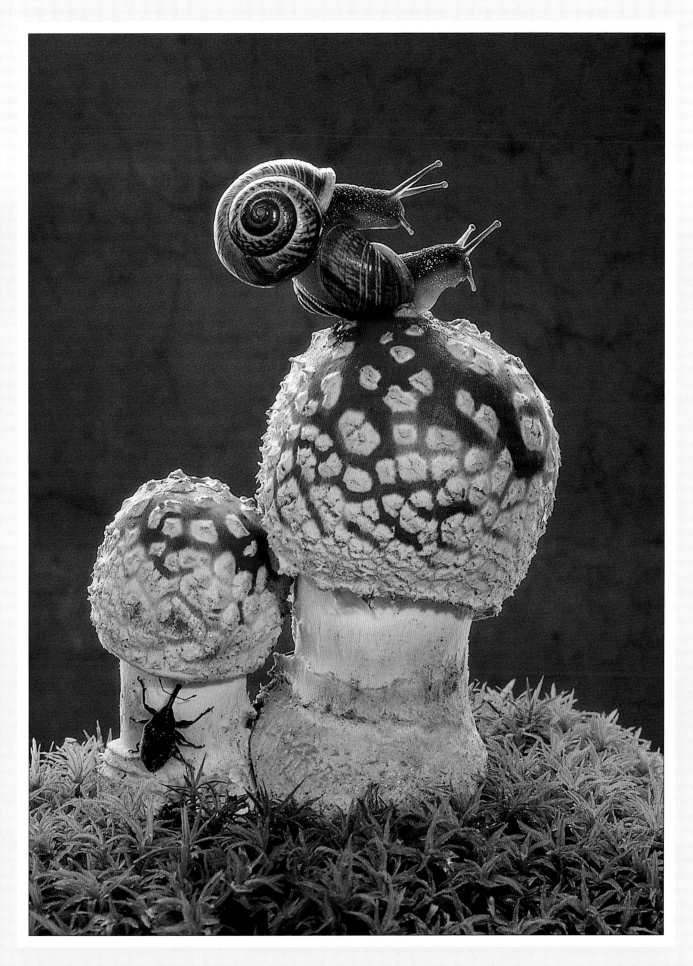

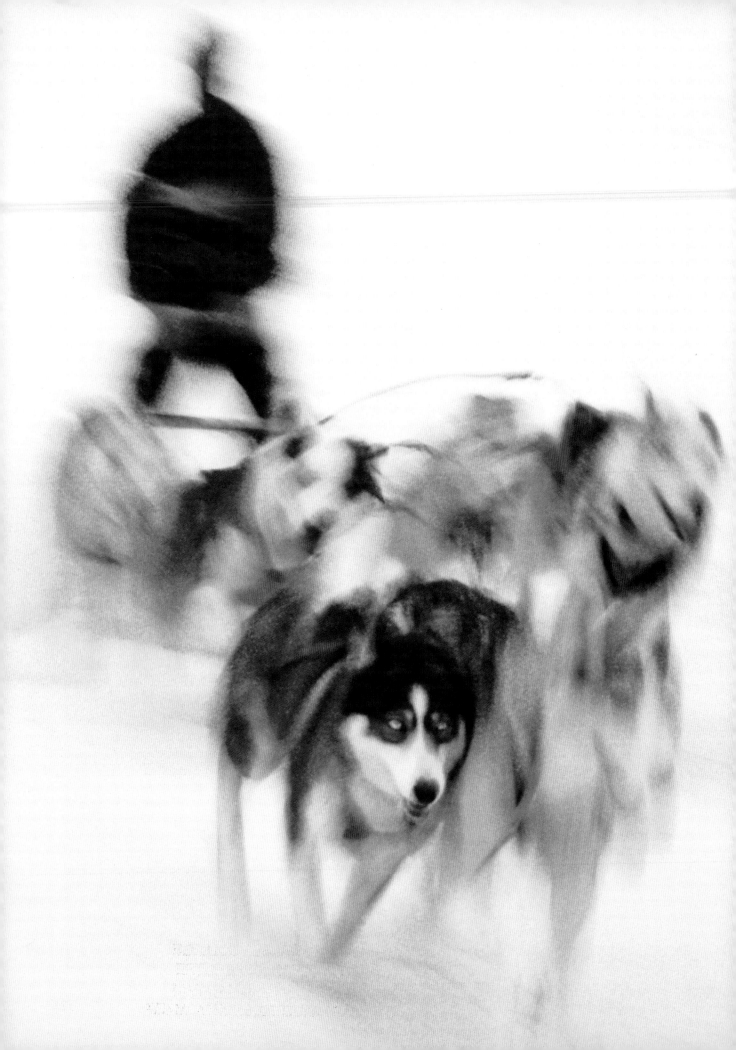

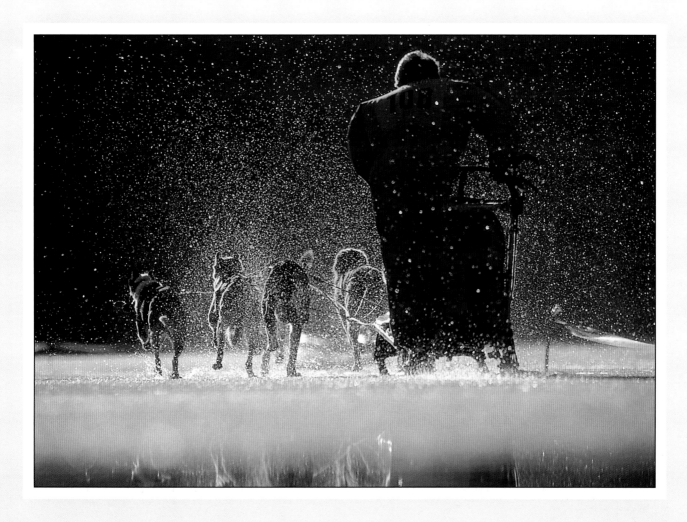

Hans Jörg Richter
GERMANY

Kenneth Cheng
CANADA

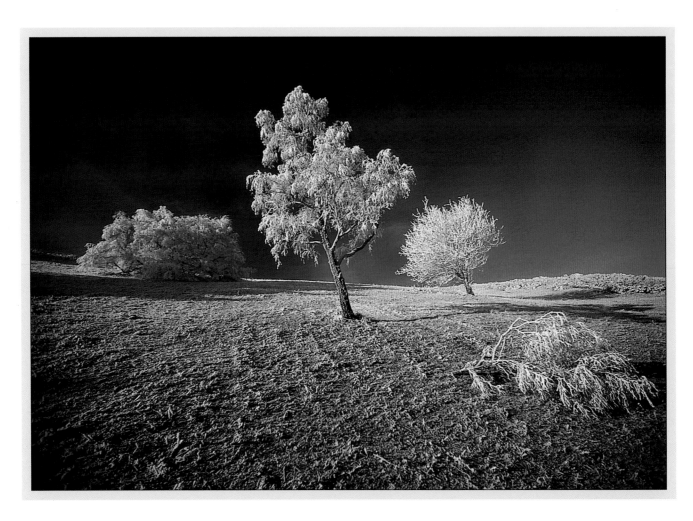

David Johnston
UNITED KINGDOM

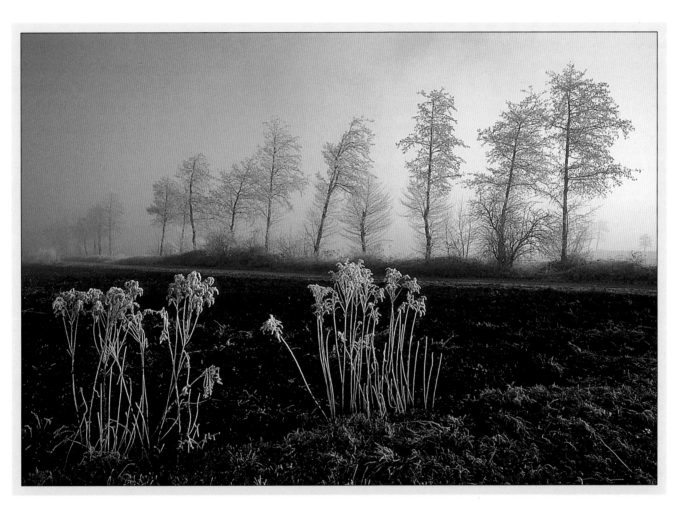

Dario Riva
ITALY

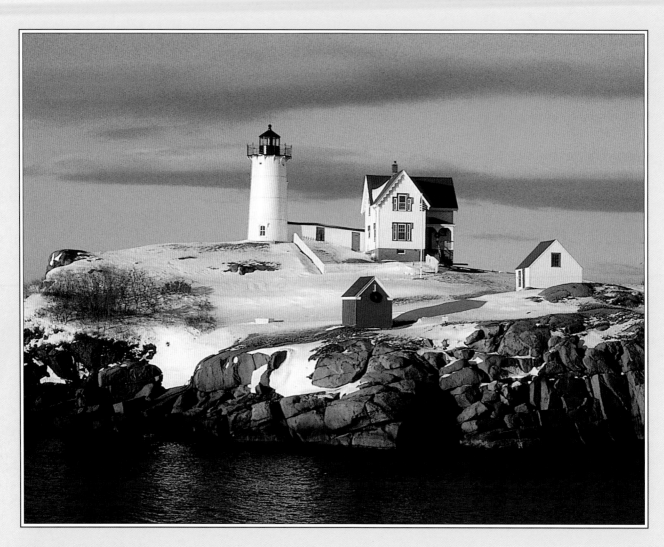

Phyllis Brandano
UNITED STATES

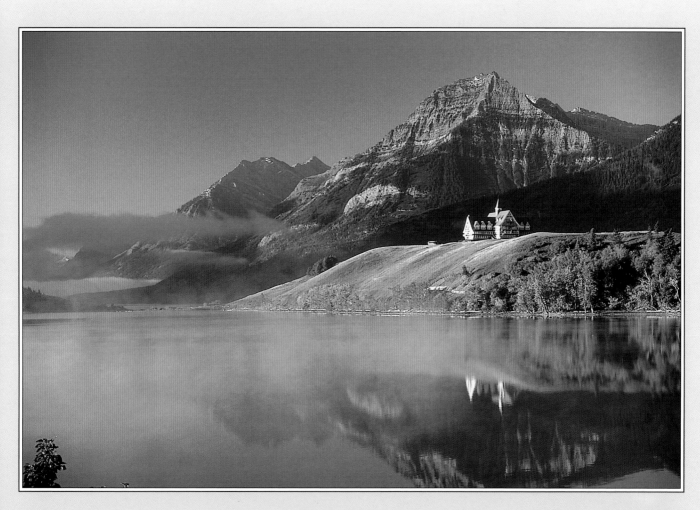

Arthur G Sticklor
UNITED STATES

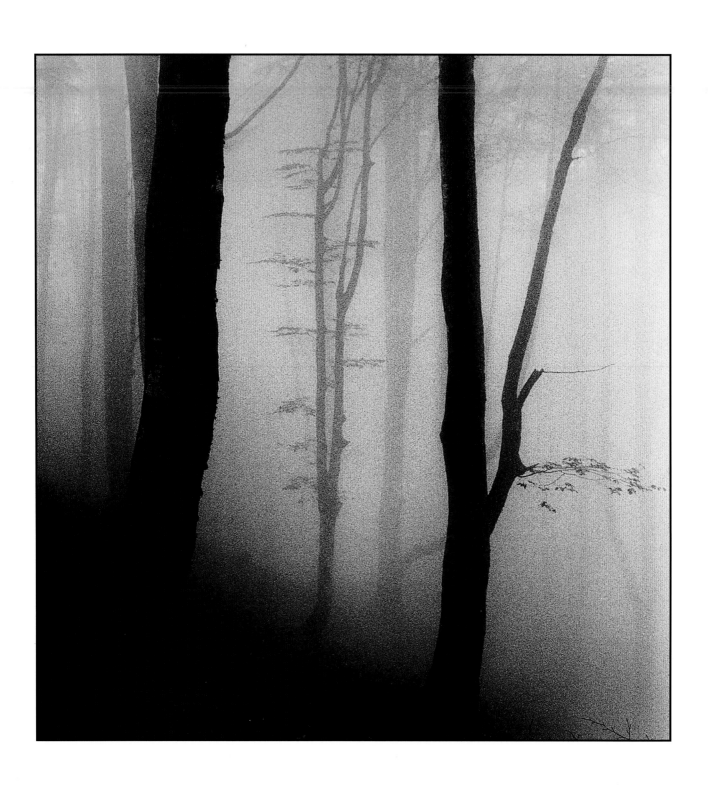

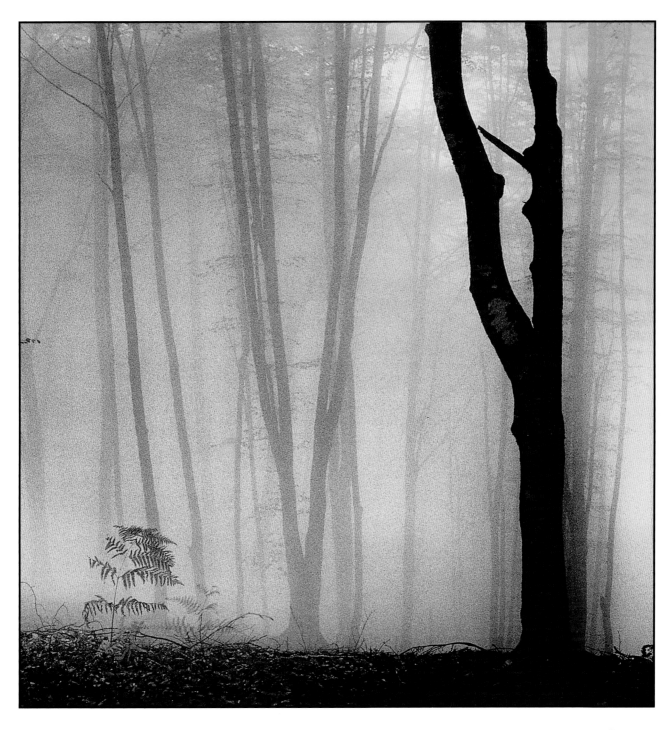

Agustin Zambrana
SPAIN

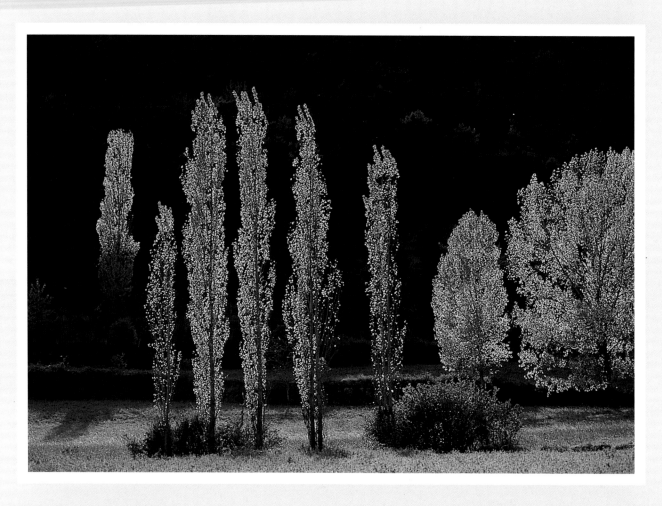

Dieudonne Andrien
BELGIUM

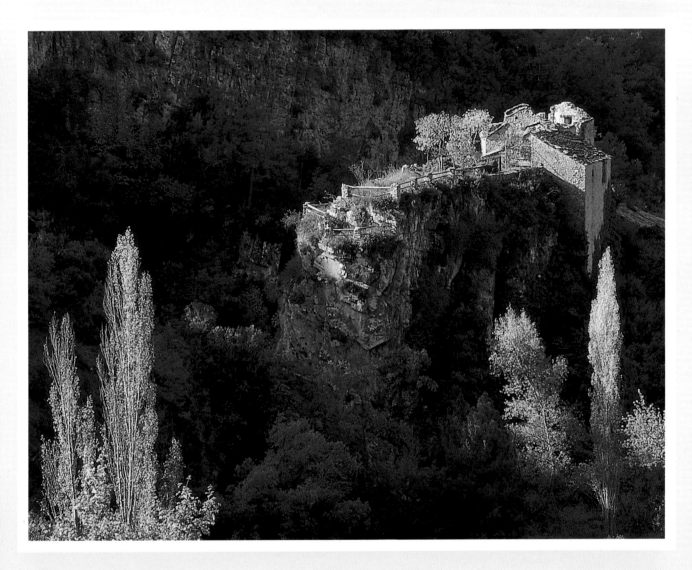

Andre Sangés
FRANCE

Alberto Goiorani
ITALY

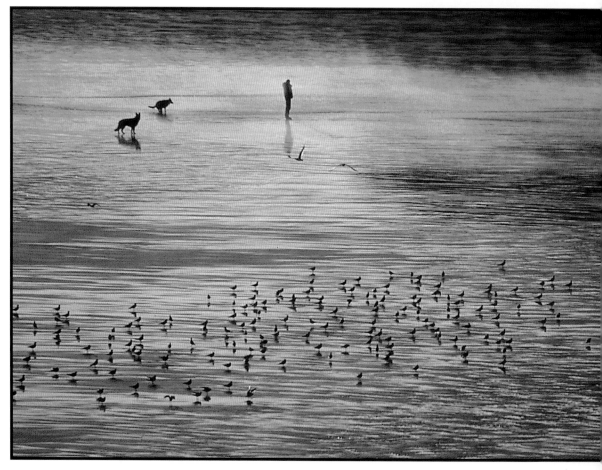

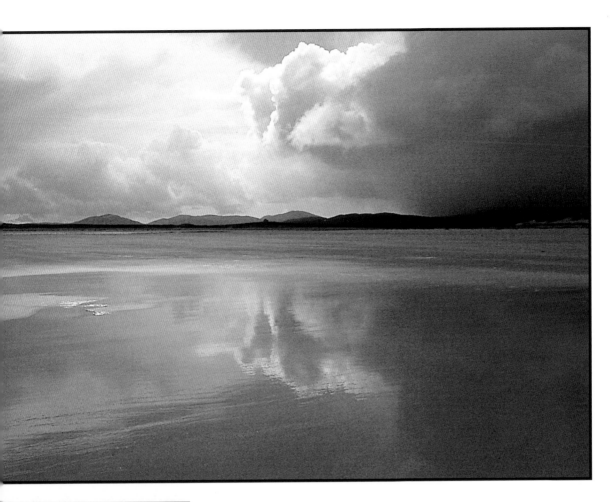

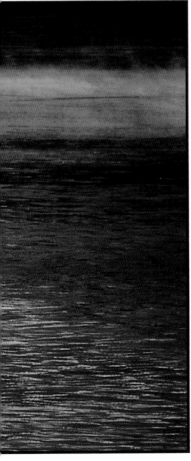

Maureen Toft
UNITED KINGDOM

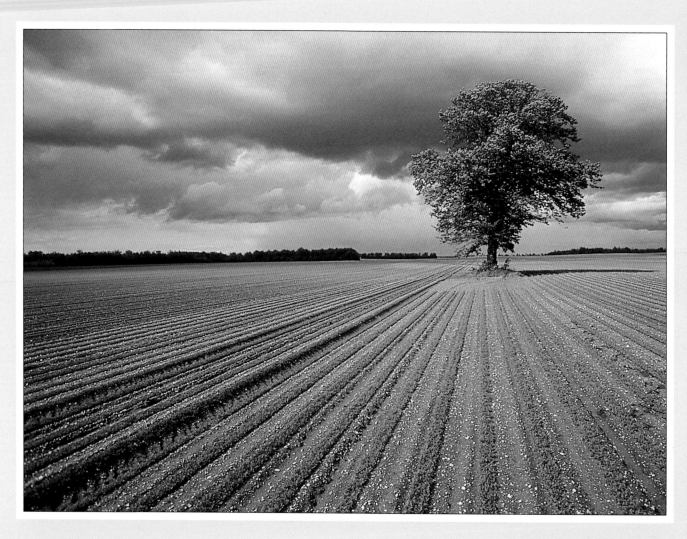

Pascal Tordeux
FRANCE

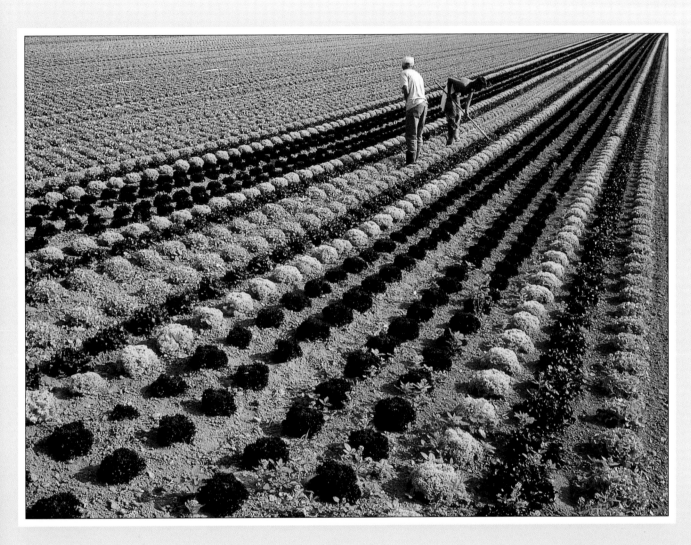

Alois Strasser
AUSTRIA

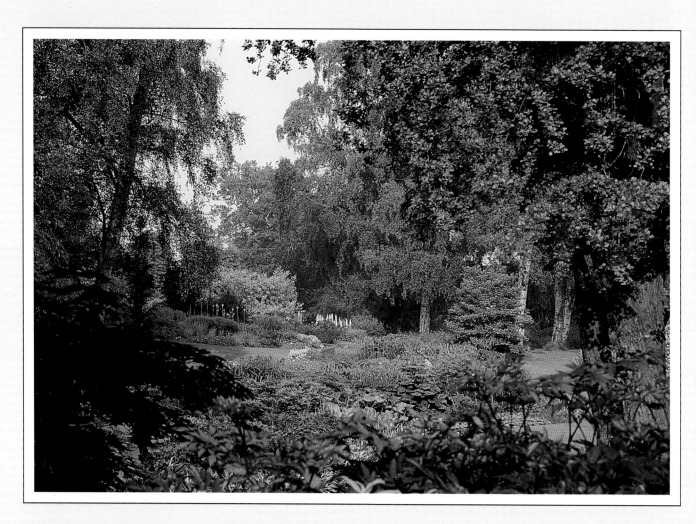

John Doornkamp
UNITED KINGDOM

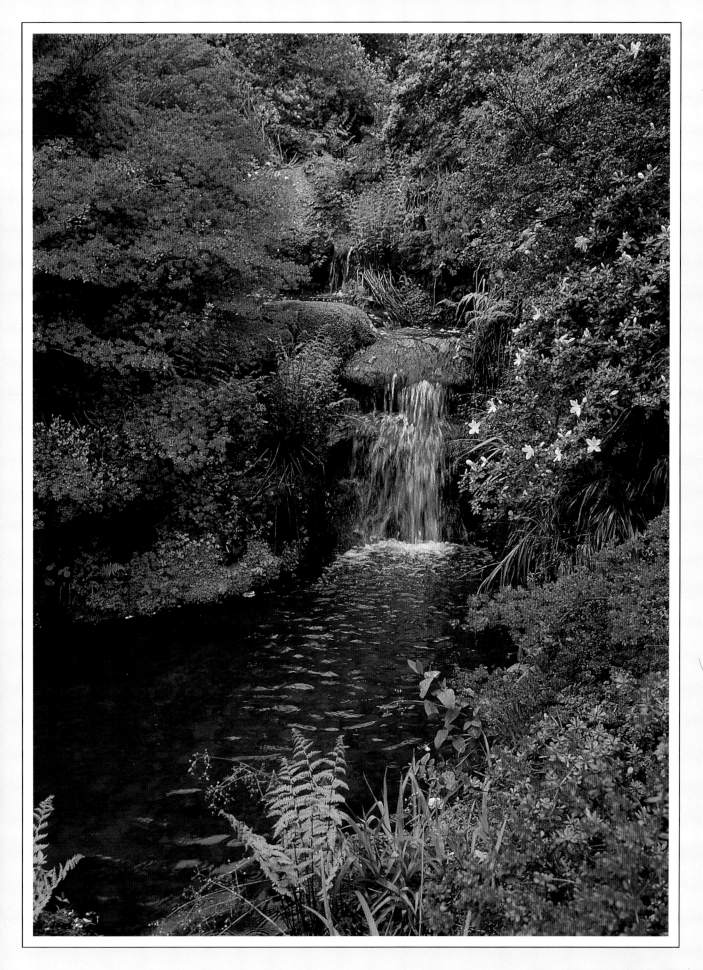

Derek Harris
UNITED KINGDOM

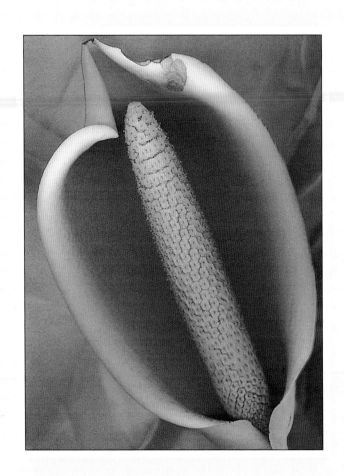

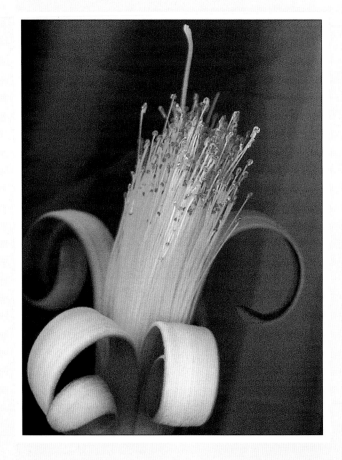

Ruth Adams
UNITED STATES

140

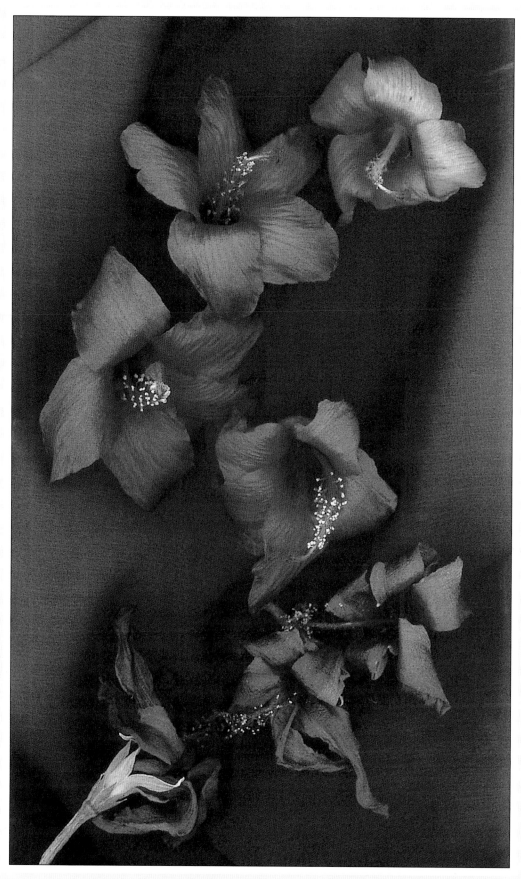

141

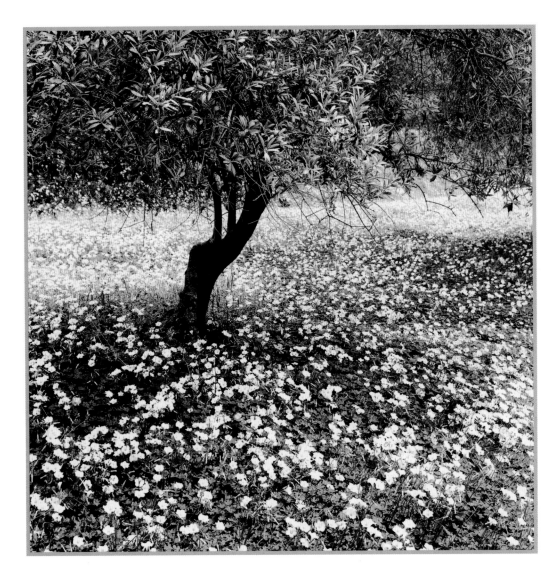

Tony Worobiec
UNITED KINGDOM

142

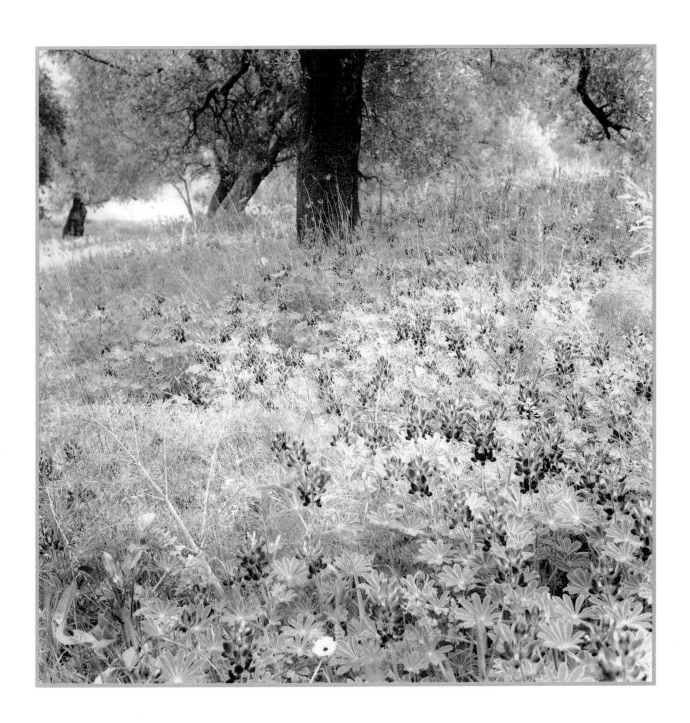

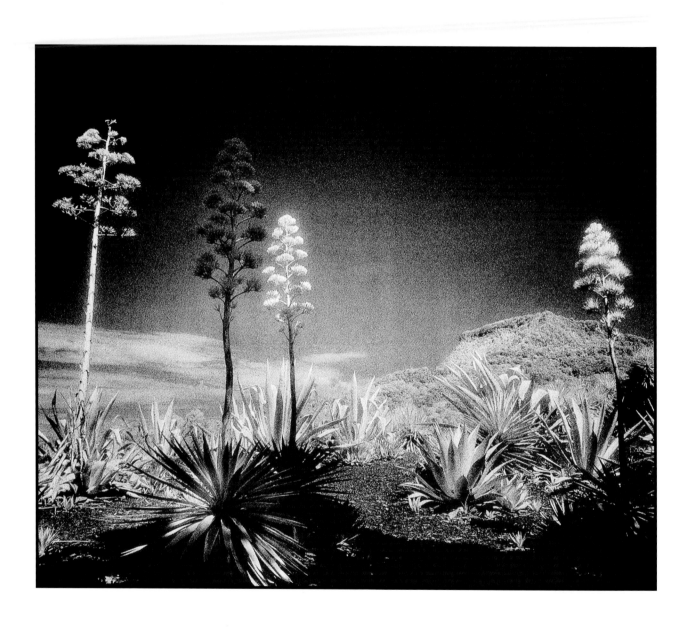

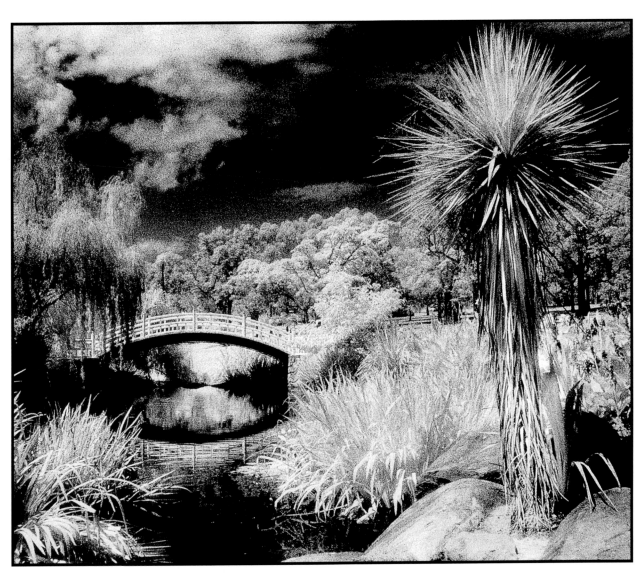

Joseph Horvat
AUSTRALIA

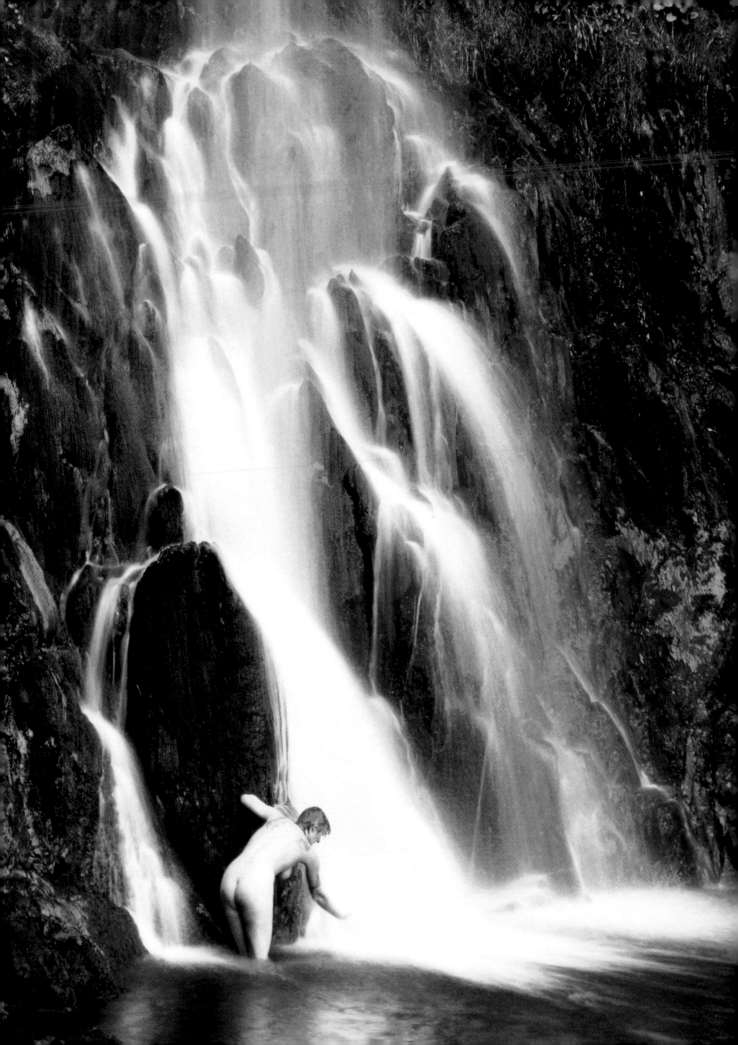

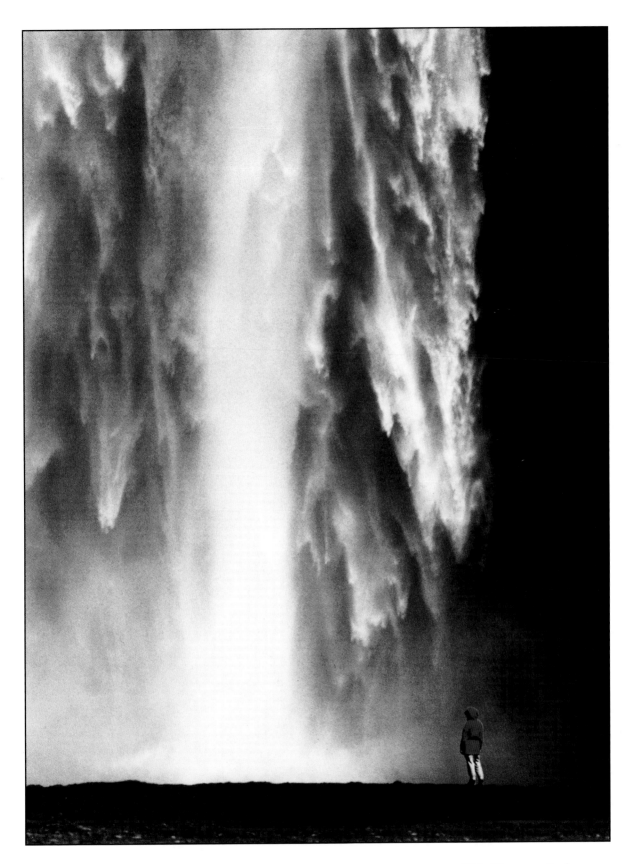

Wolfgang Scheuer
AUSTRIA

Roy Elwood
UNITED KINGDOM

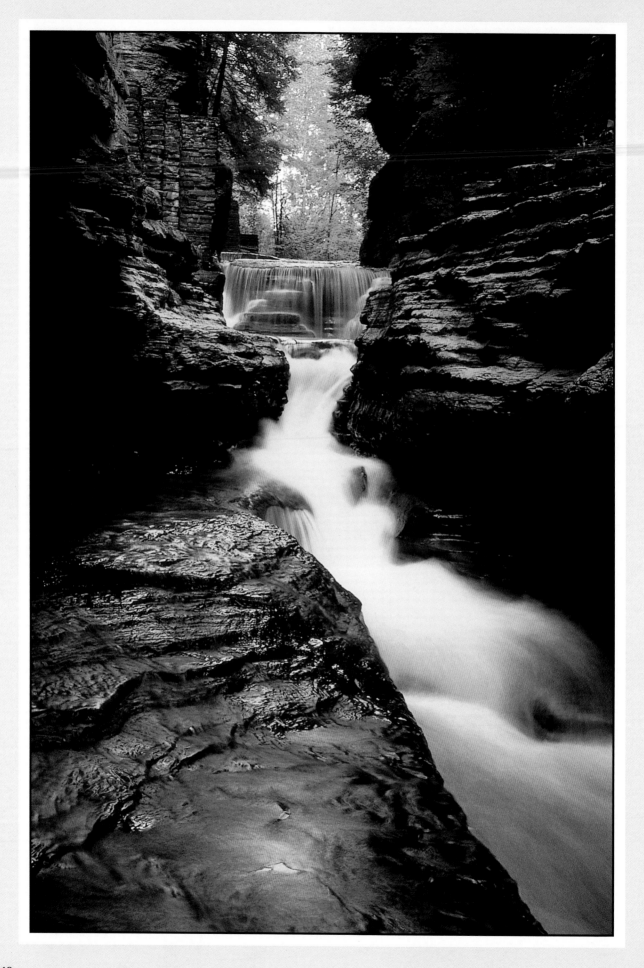

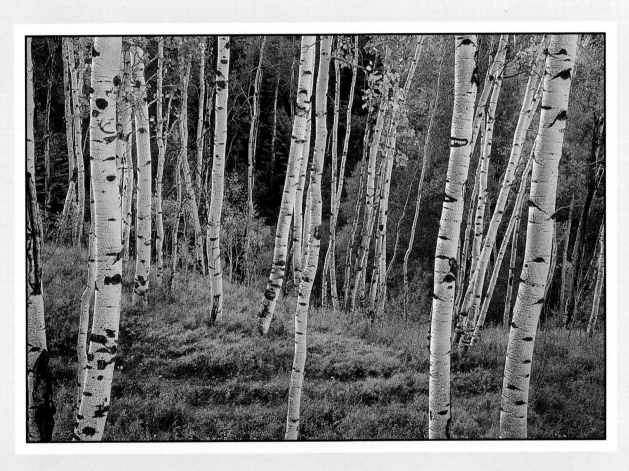

Rosemary Calvert
UNITED KINGDOM

Helmut Resch
AUSTRIA

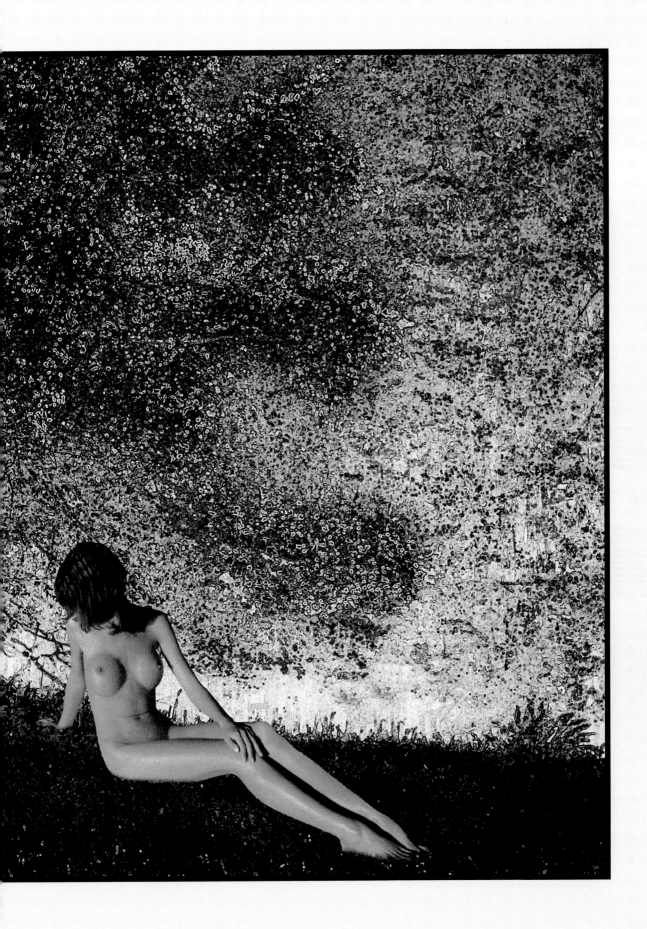

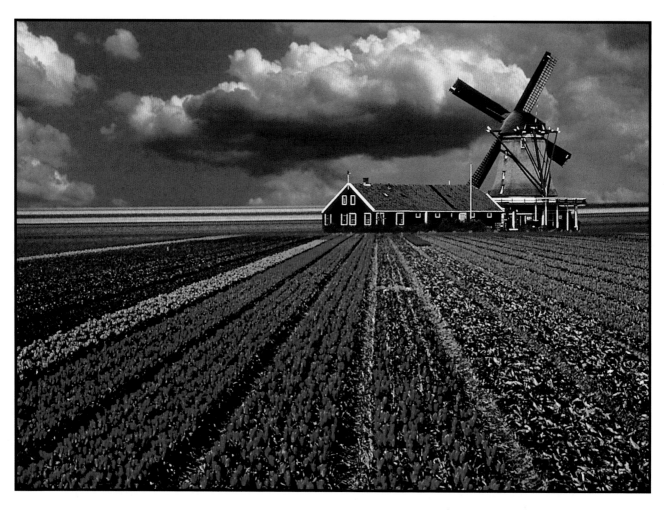

Alfons Vlaminckx
BELGIUM

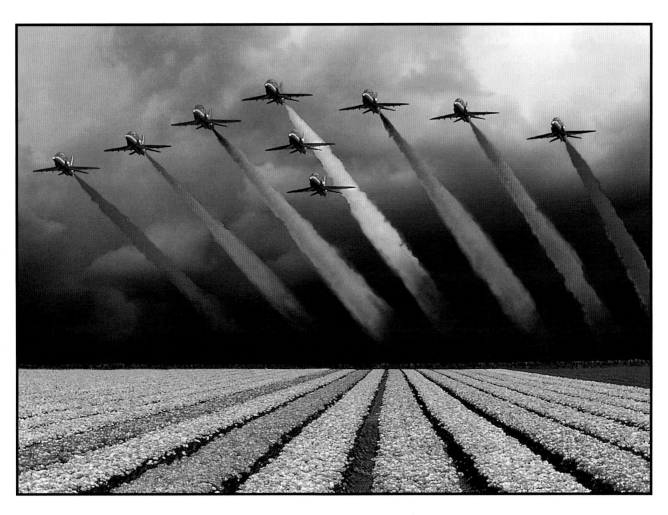

Anette Mortier
BELGIUM

Piotr Powietrzynski
UNITED STATES

Paavo Merikukka

FINLAND

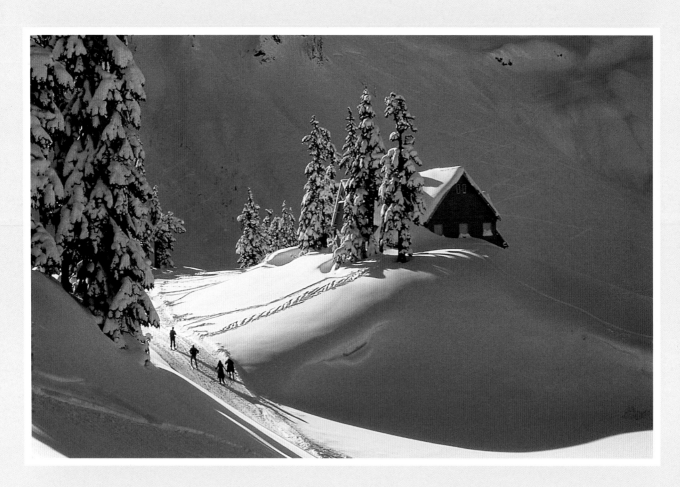

Robert L Morgan
UNITED STATES

Murphy M Hektner
UNITED STATES

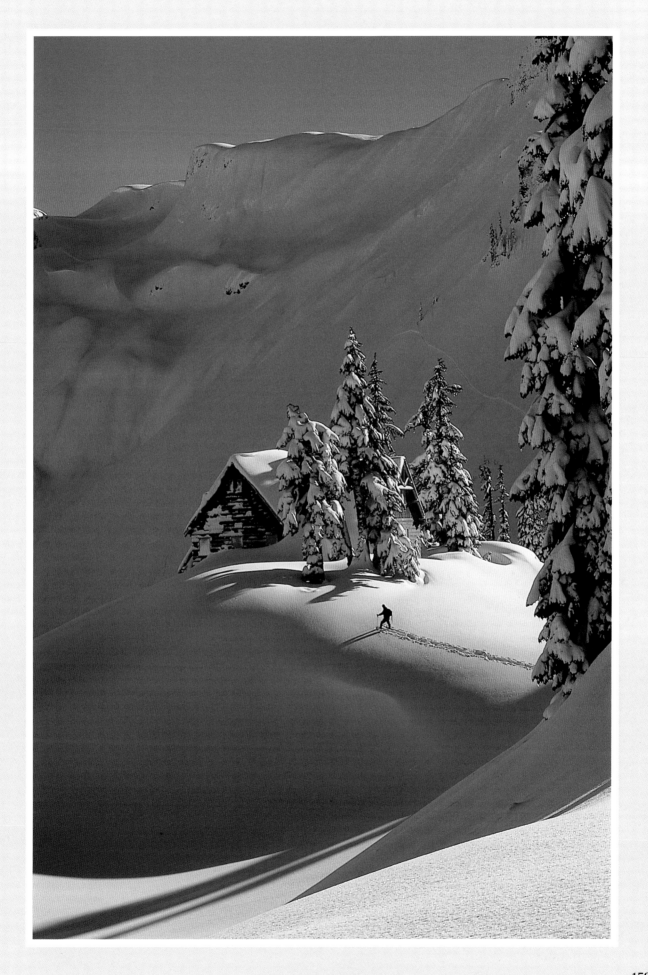

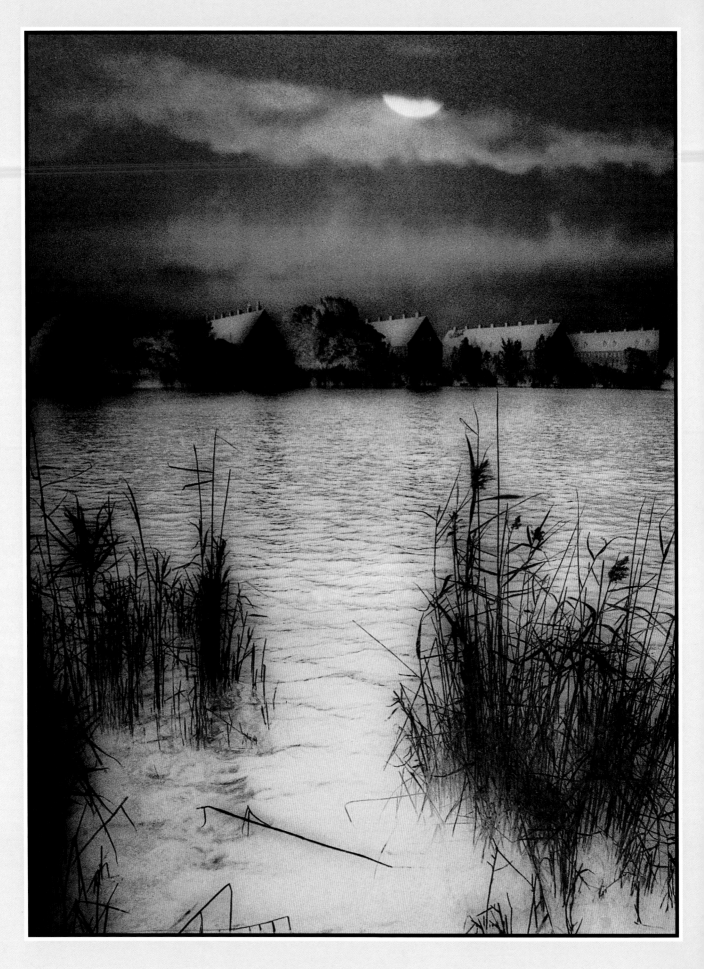

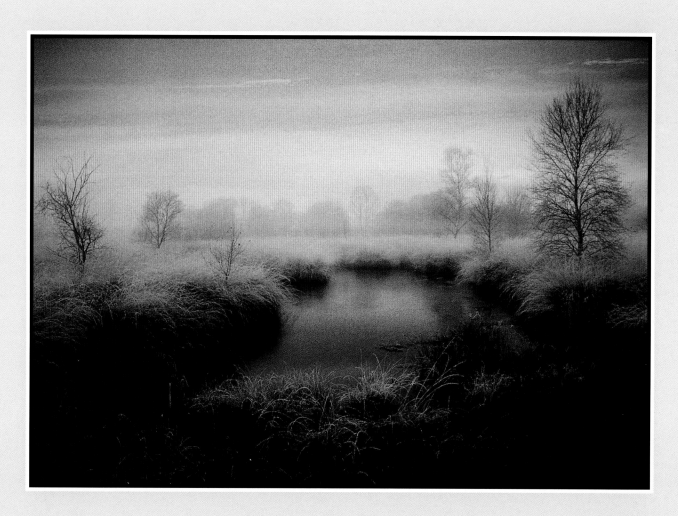

Cor Boers
NETHERLANDS

Manfred Baumgartner
AUSTRIA

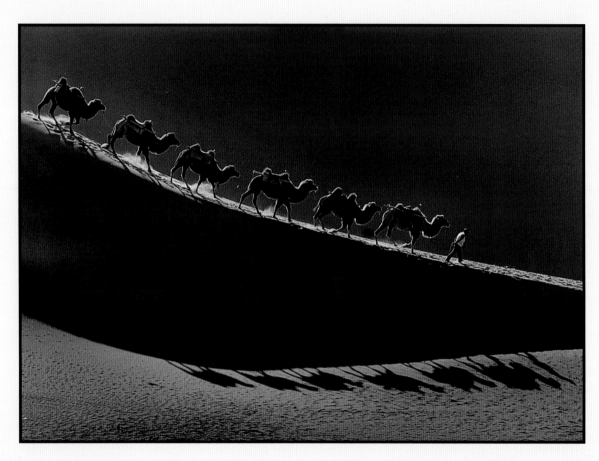

Tam Gim-Kou
HONG KONG

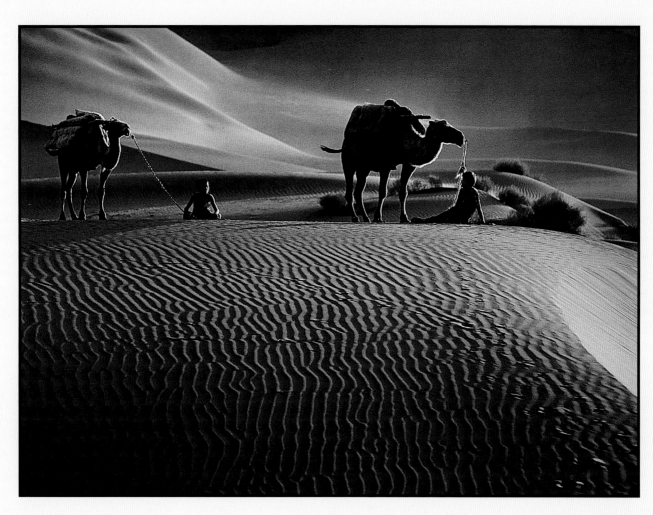

Ng Man-Kuen
HONG KONG

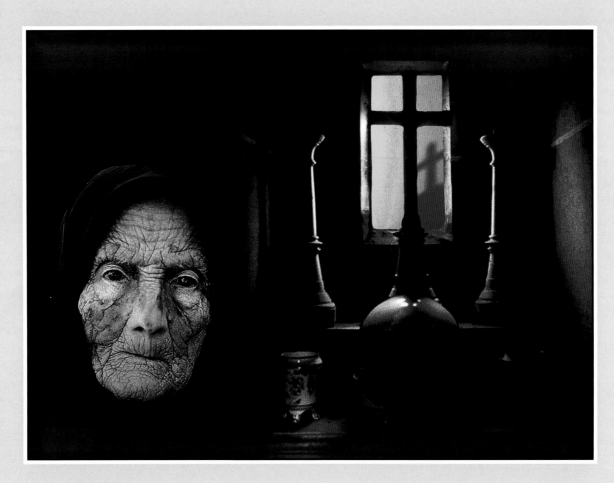

Manfred Kriegelstein
GERMANY

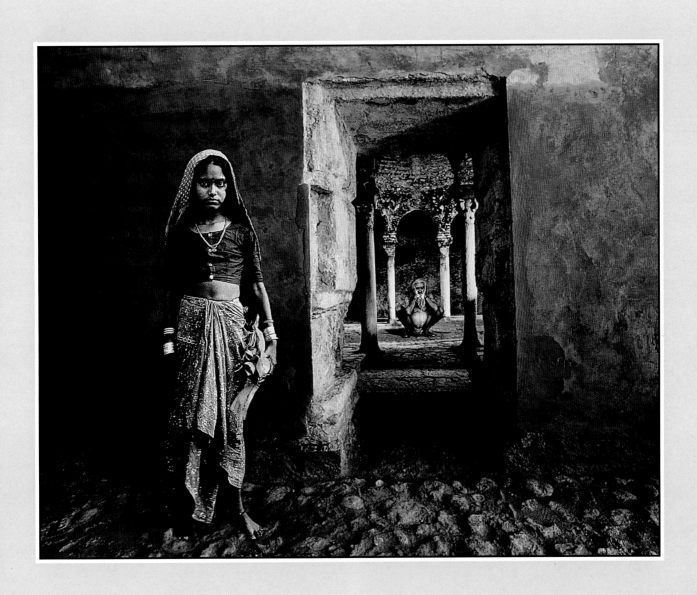

OVERLEAF
Shivji
INDIA

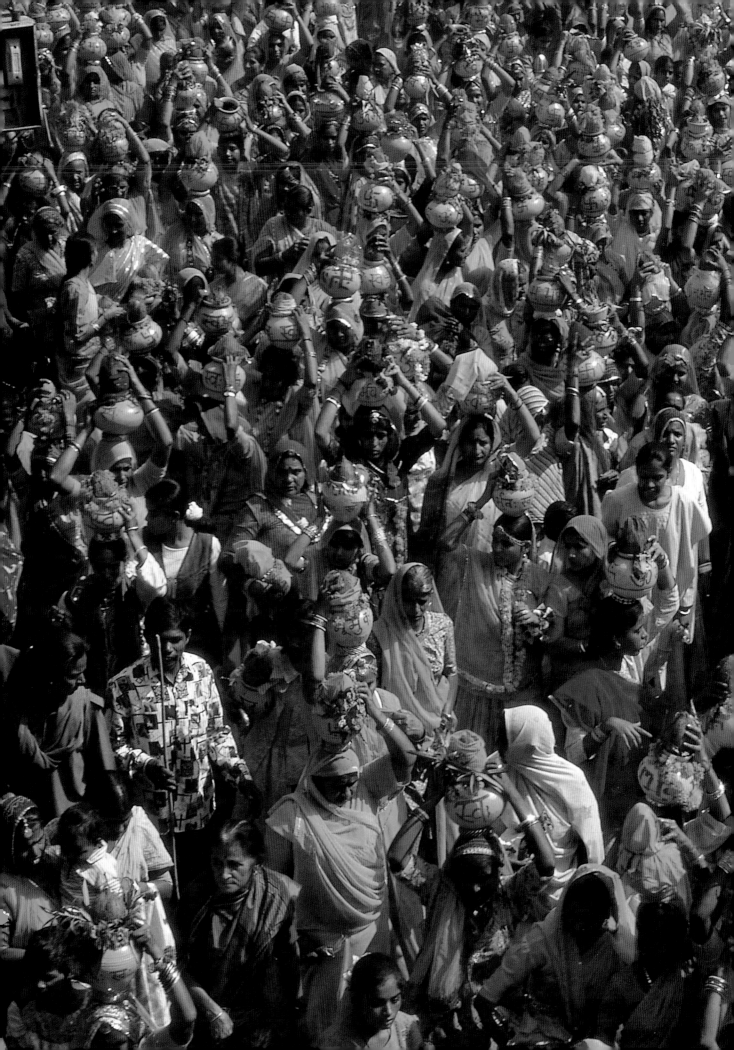

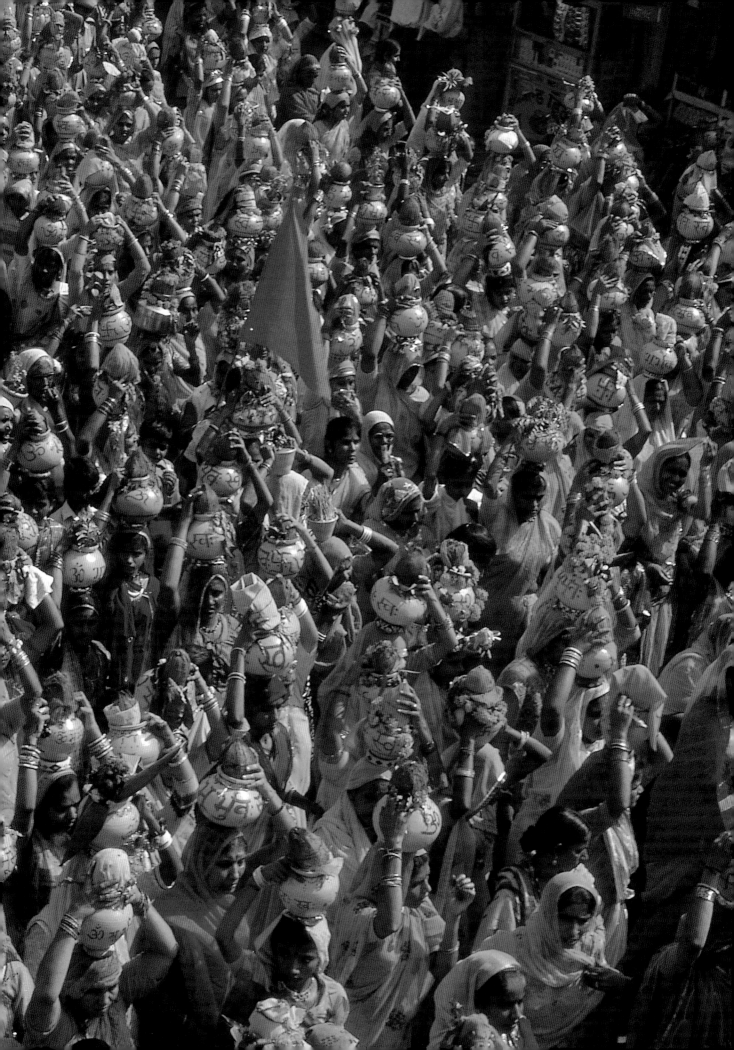

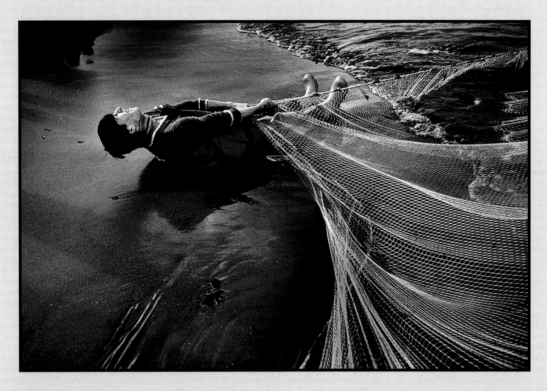

Italo di Fabio
ITALY

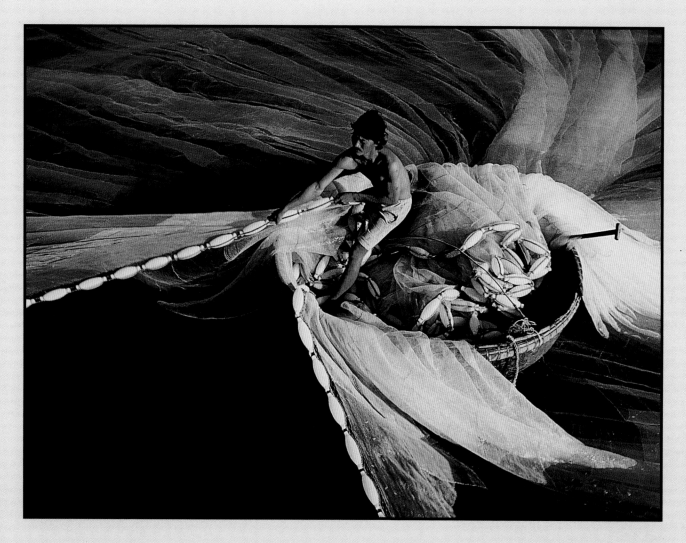

Rashid Un Nabi
BANGLADESH

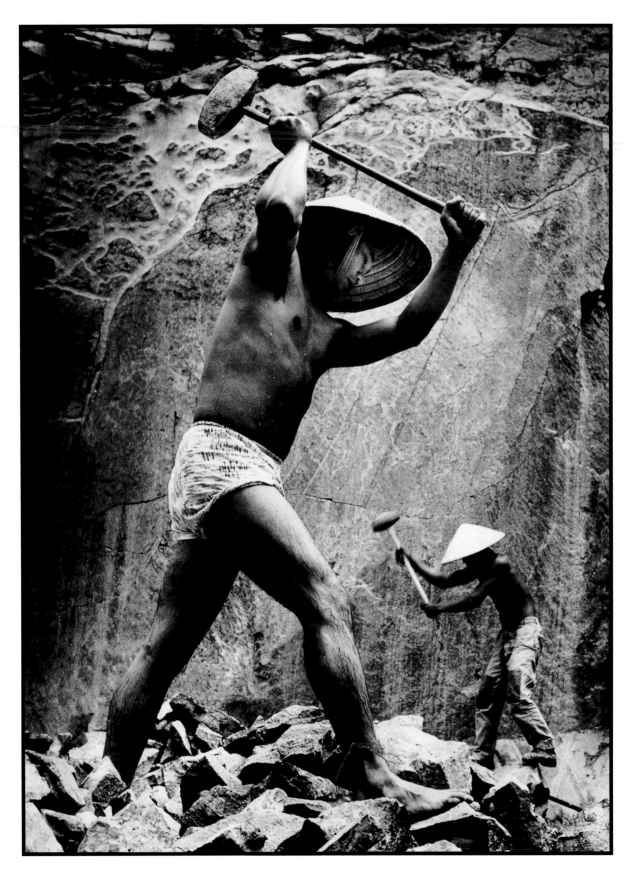

Lan Van Nguyen
UNITED STATES

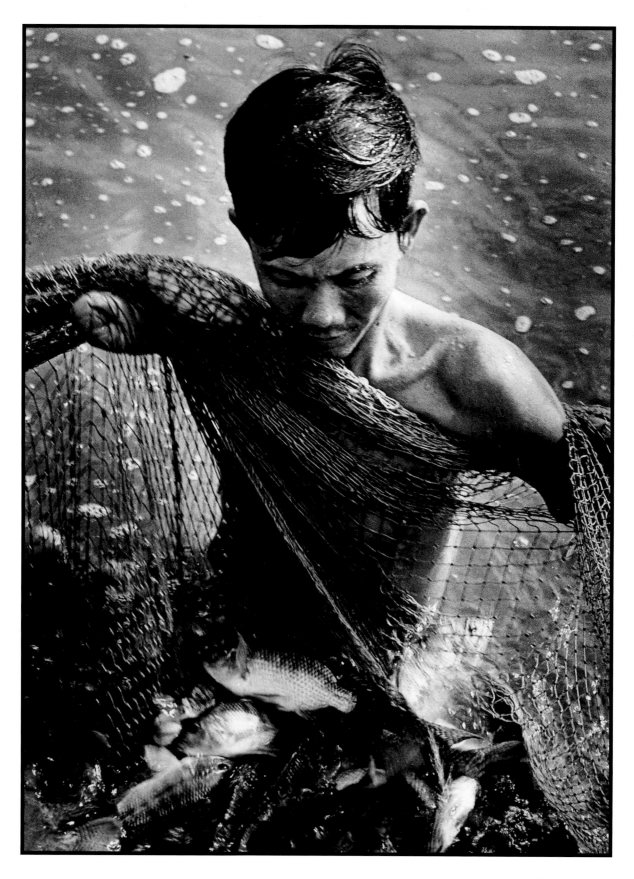

Le Hong Linh
VIETNAM

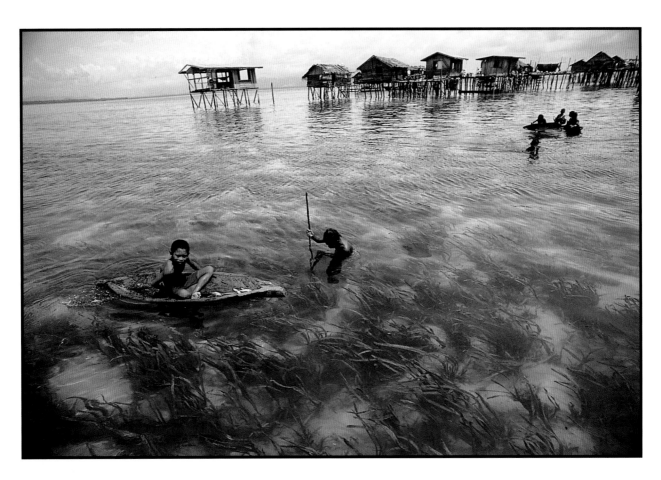

Tan Yam Heng
MALAYSIA

Leong Fook Hoe
MALAYSIA

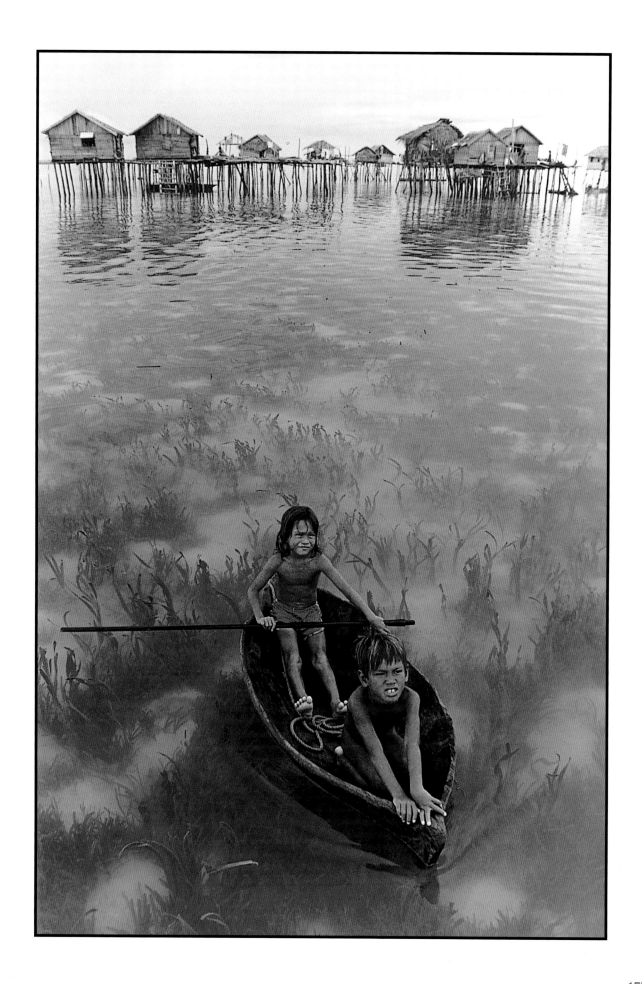

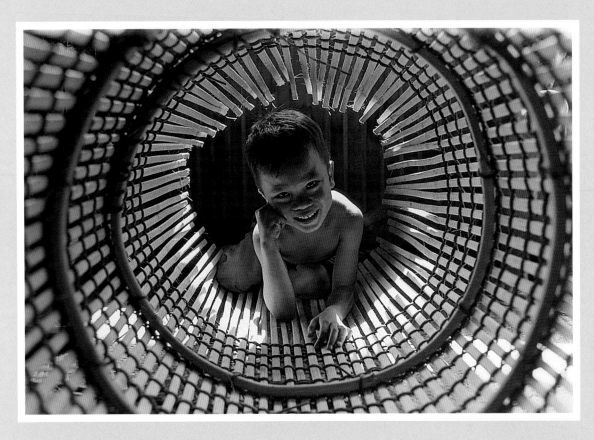

Leong Fook Hoe
MALAYSIA

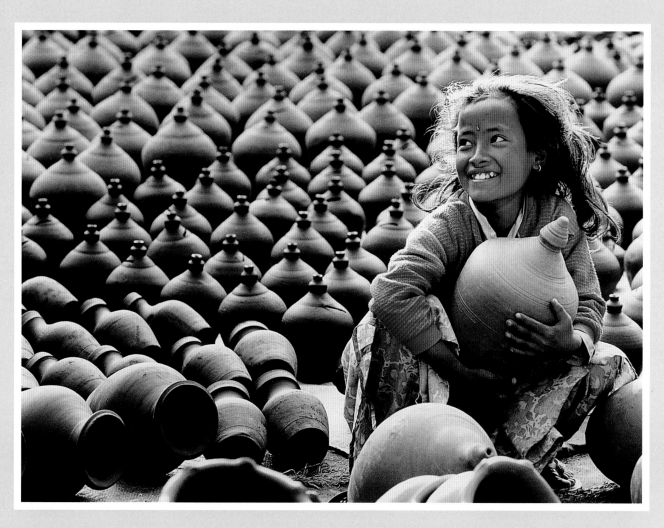

So Chung Shek
HONG KONG

175

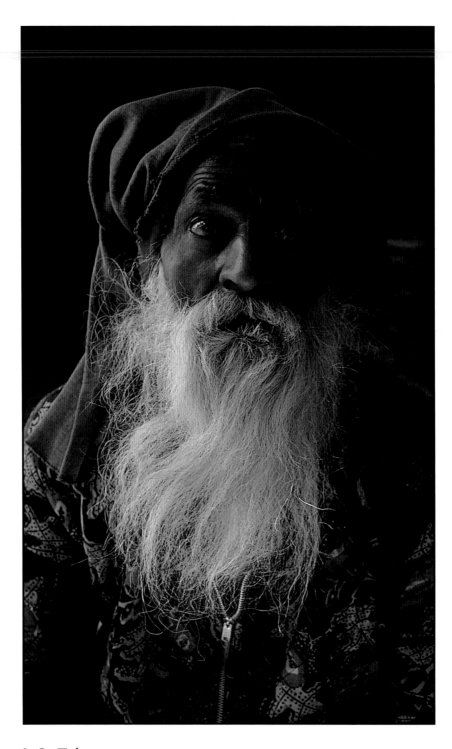

L.S. Tak

INDIA

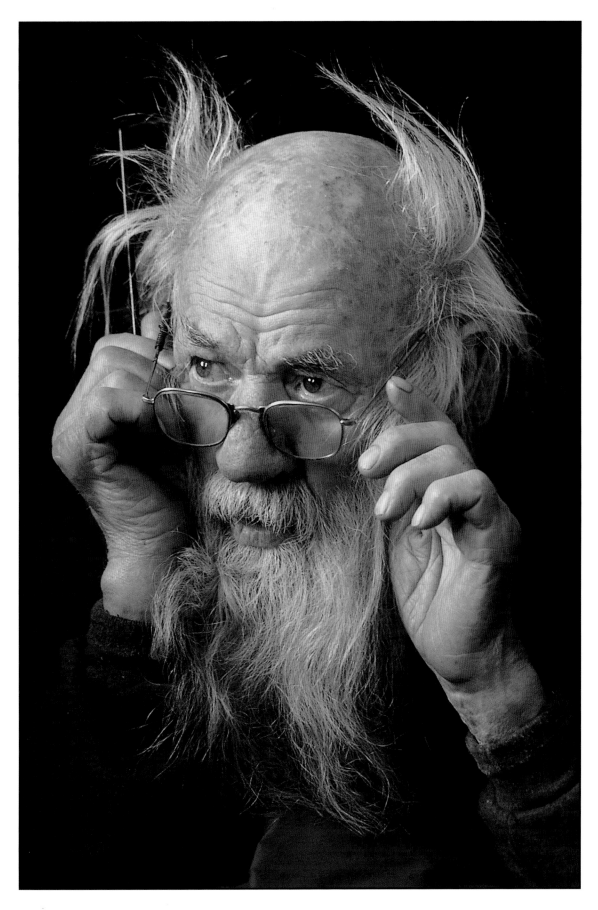

Gerardus van Mol
NETHERLANDS

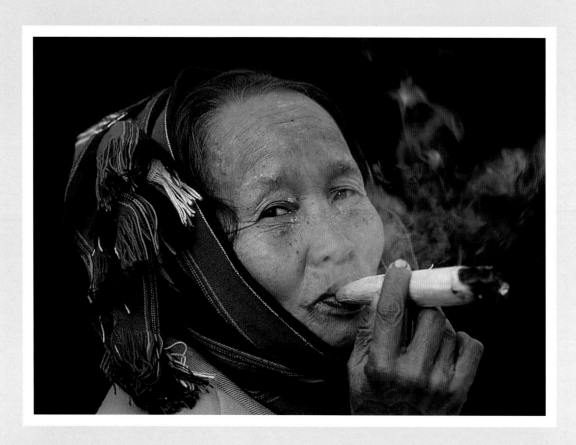

Karl-Heinz Papenhoff
GERMANY

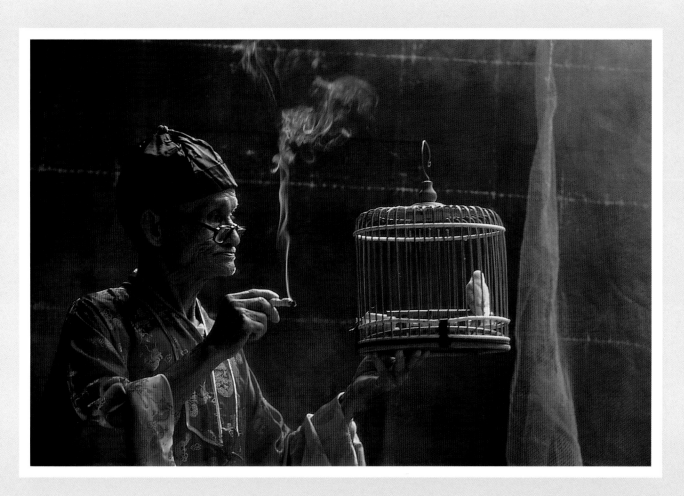

Junid B Osnam
SINGAPORE

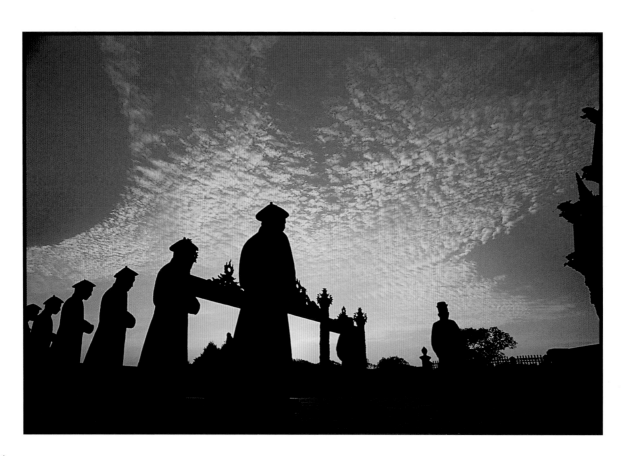

Huynh Ngoc Dan
VIETNAM

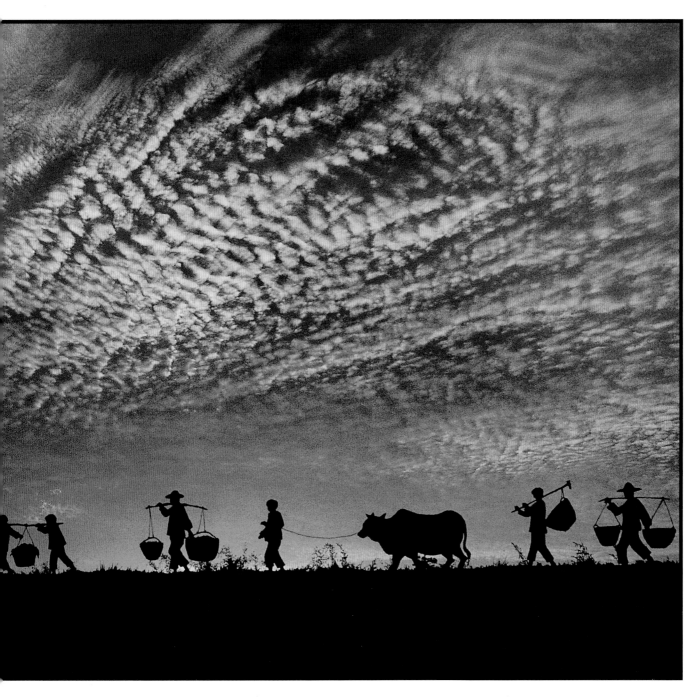

Lam Kin Cheong
MACAO

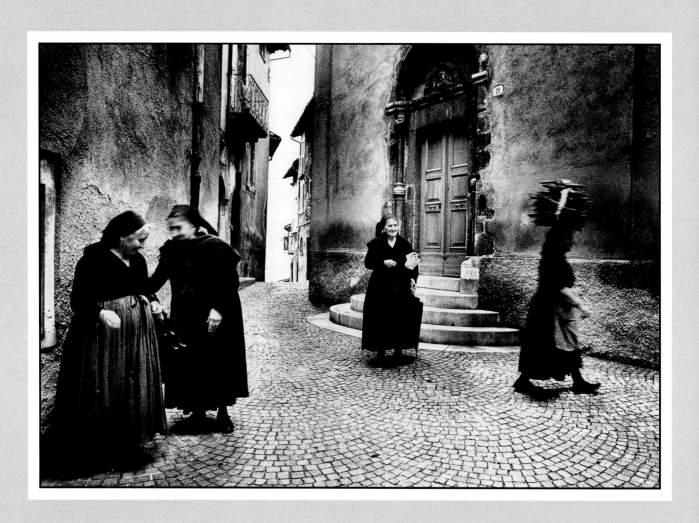

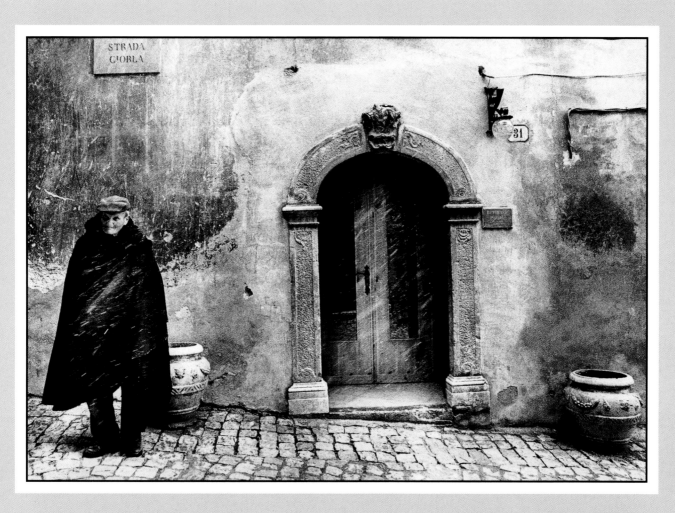

Omero Tinagli
ITALY

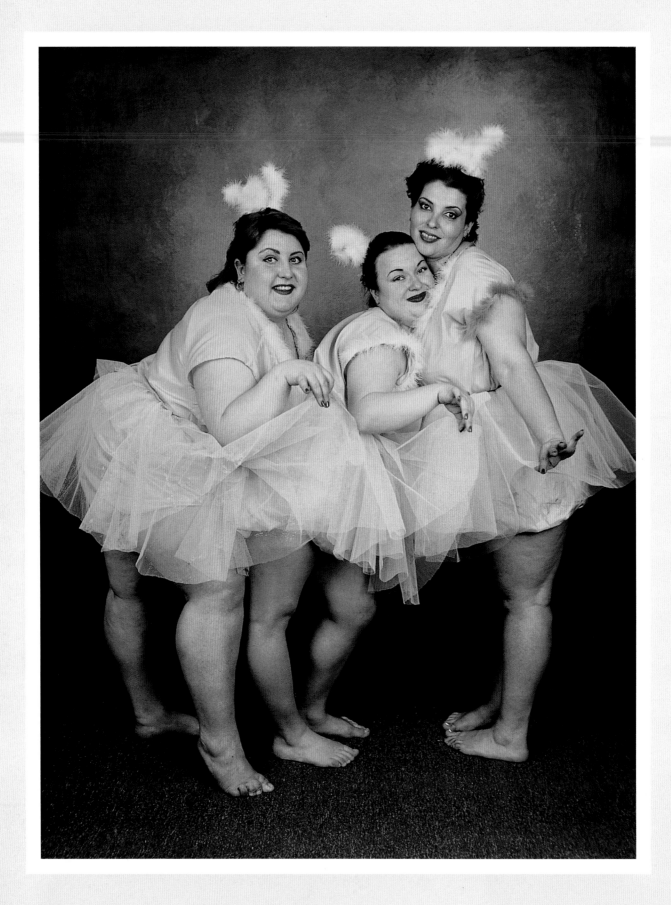

Sergey Buslenko
UKRAINE

Vladimir Vitow
RUSSIA

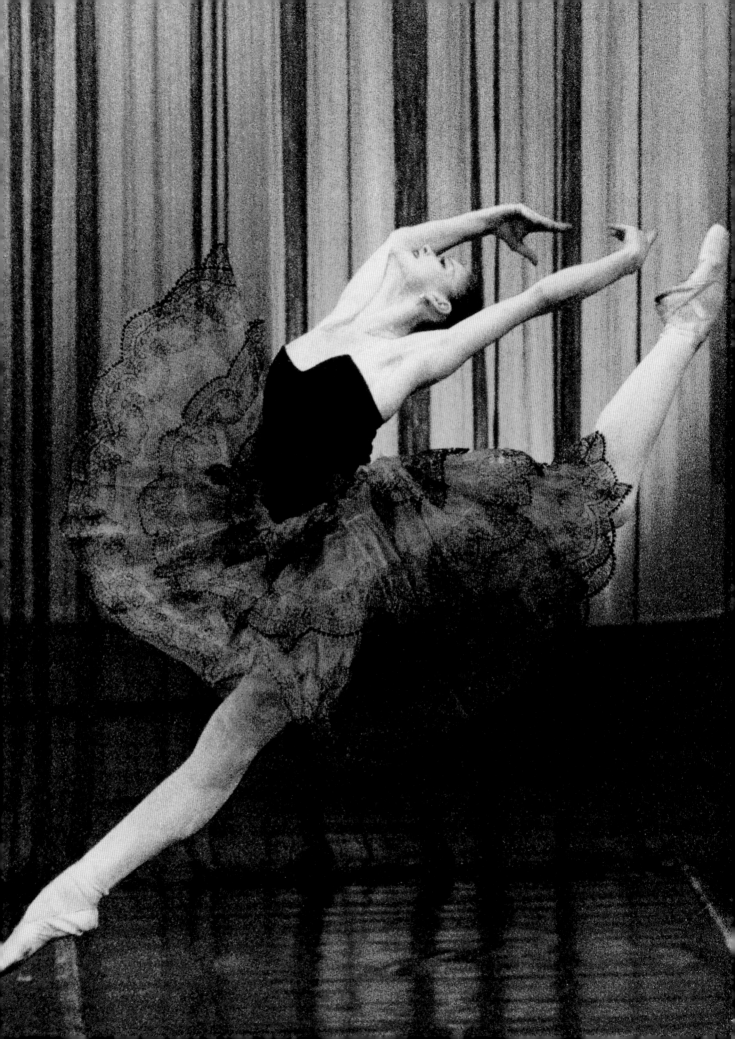

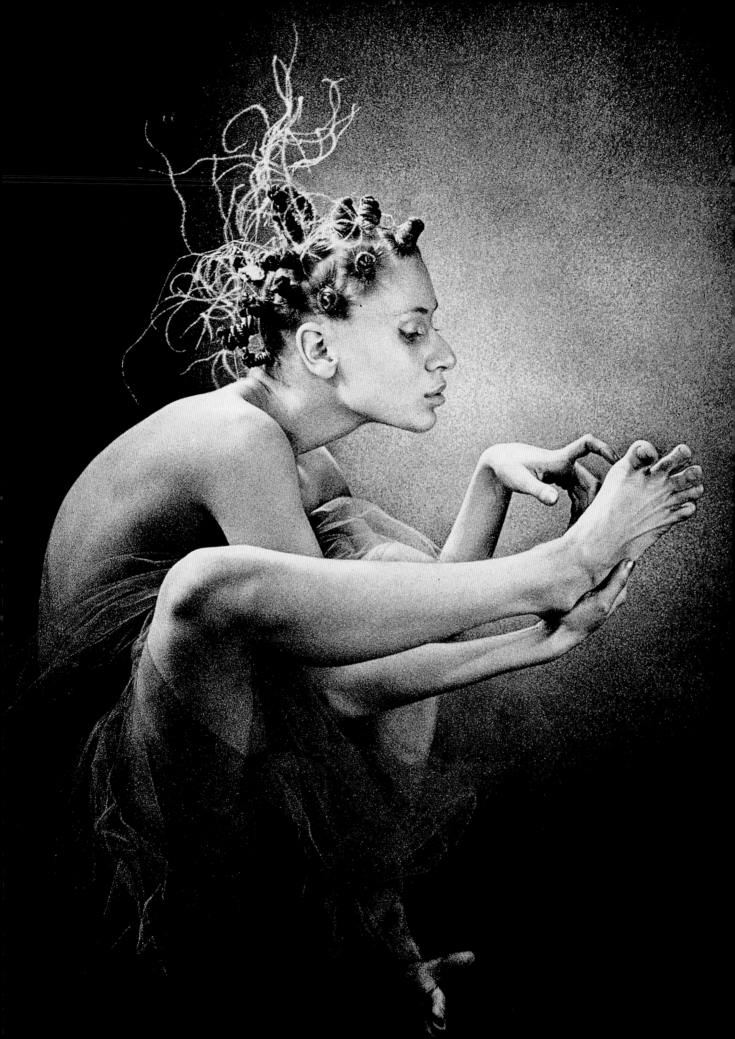

Elena Martynyuk
UKRAINE

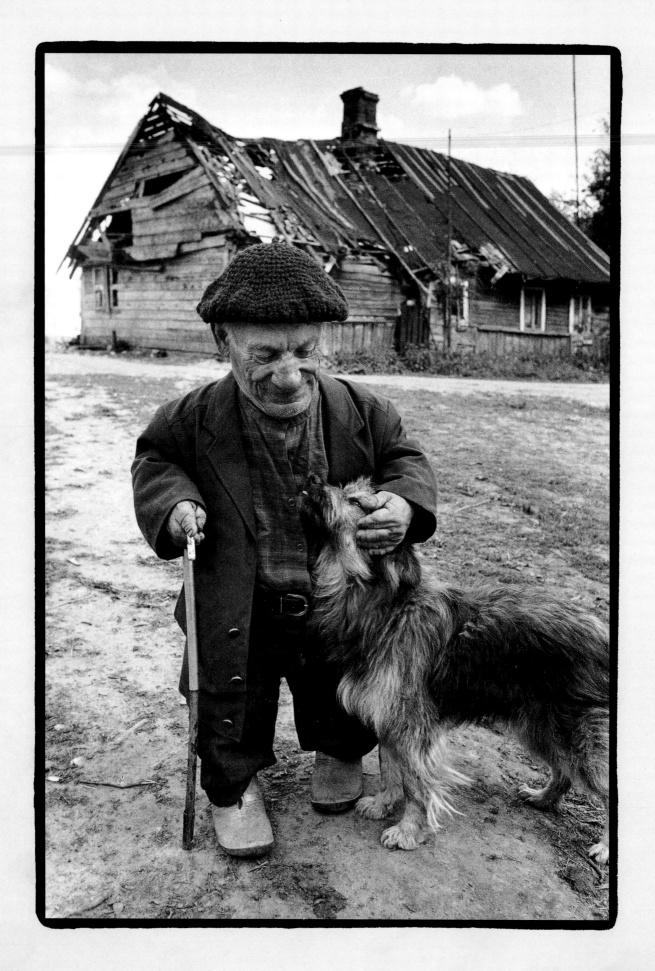

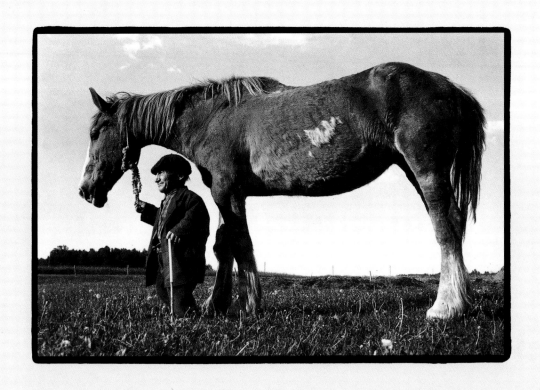

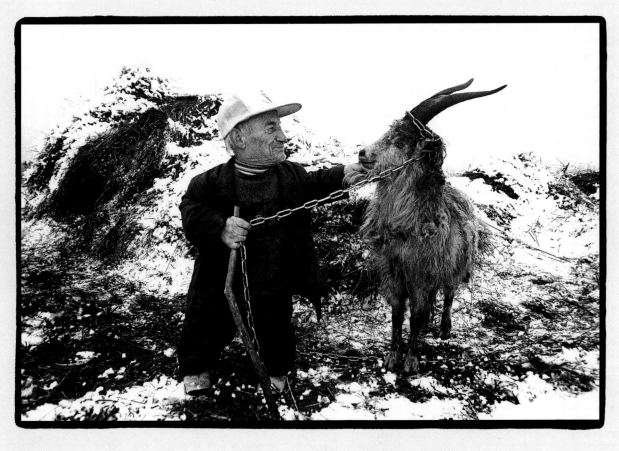

Romualdas Pozèrskis
LITHUANIA

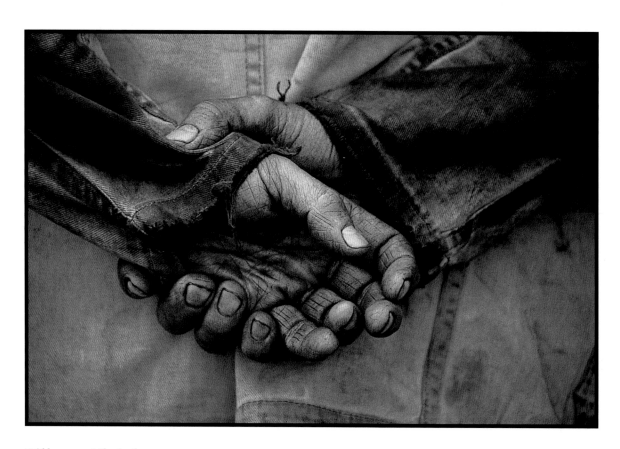

Tillman Kleinhans
UNITED KINGDOM

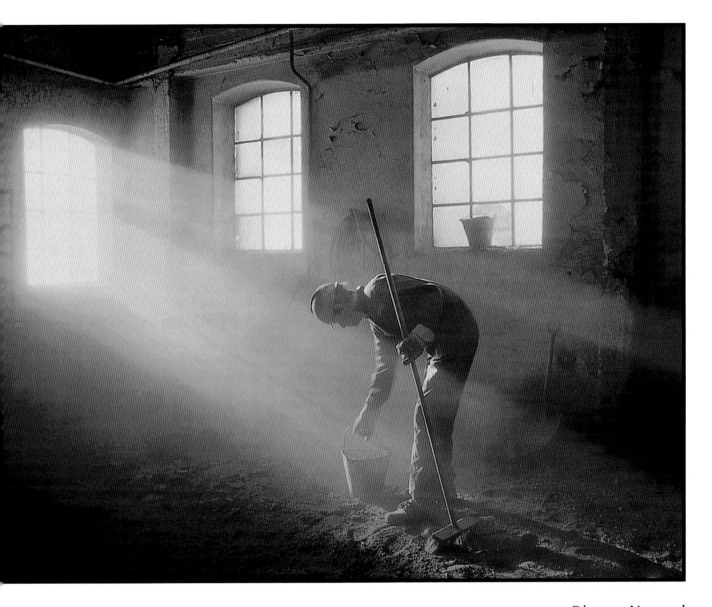

Bjarne Nygard
NORWAY

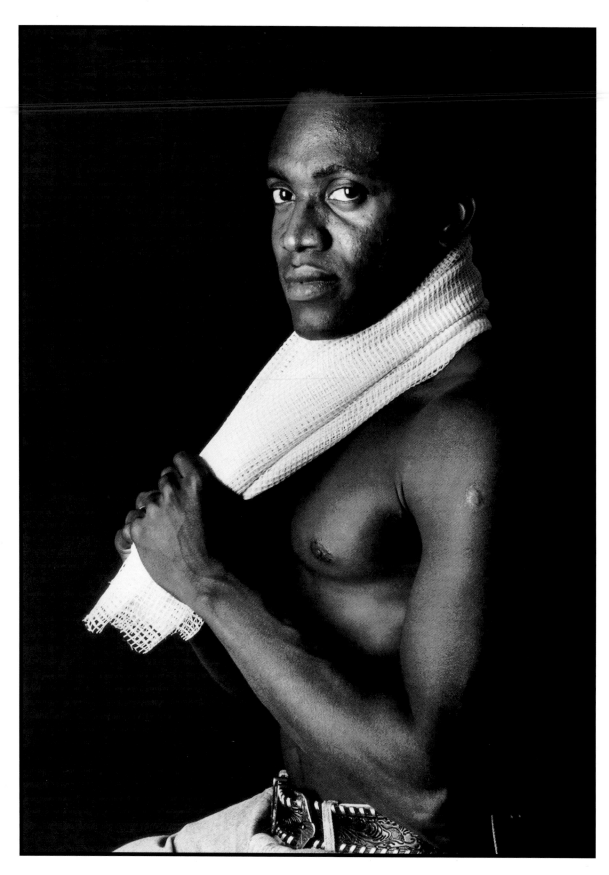

Karl Vock
AUSTRIA

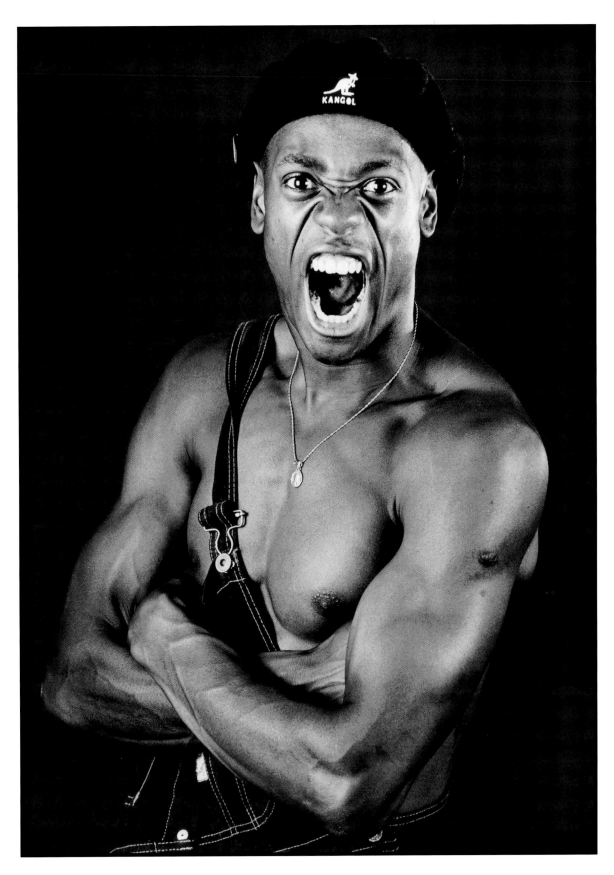

Didier Depoorter
FRANCE

193

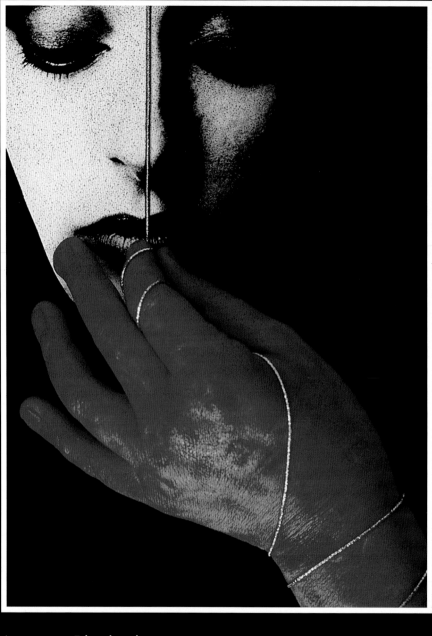

Augusto Biagioni
ITALY

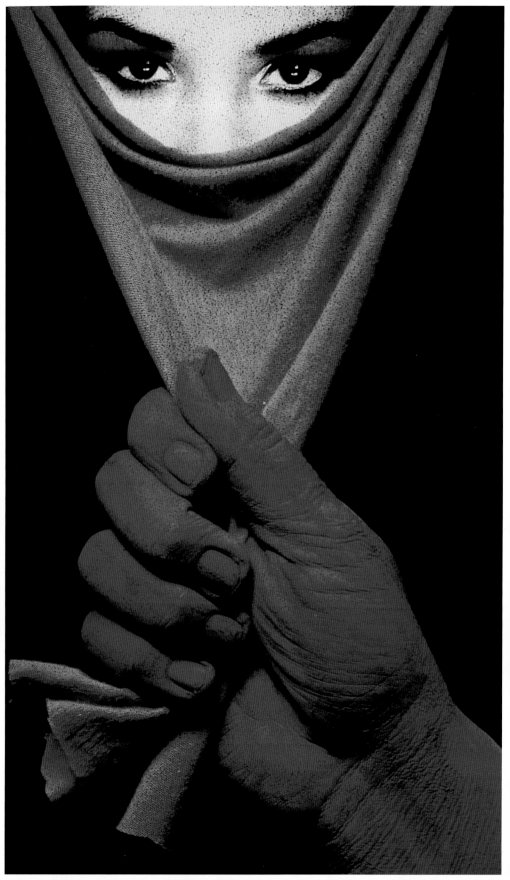

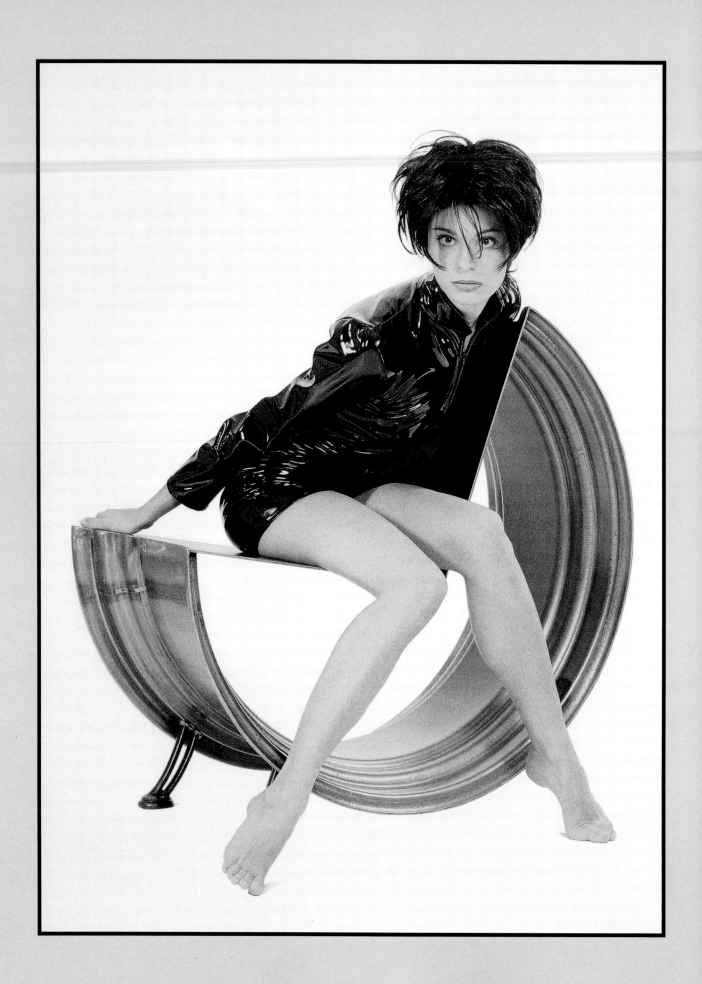

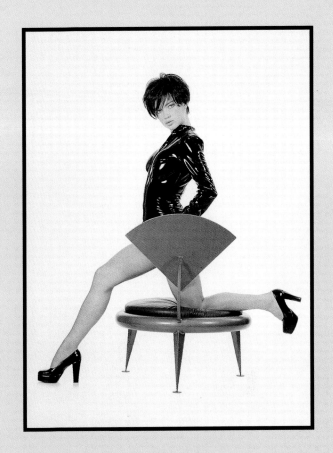

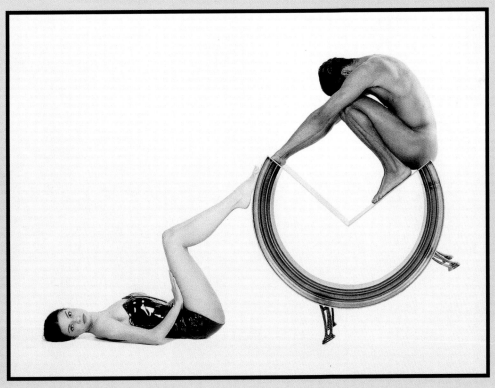

Herbert Thür
SWITZERLAND

197

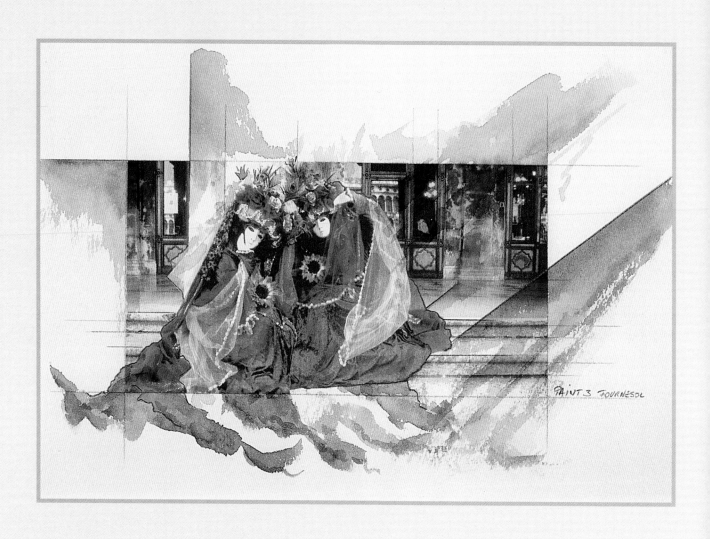

PAINT.3 TOURNESOL

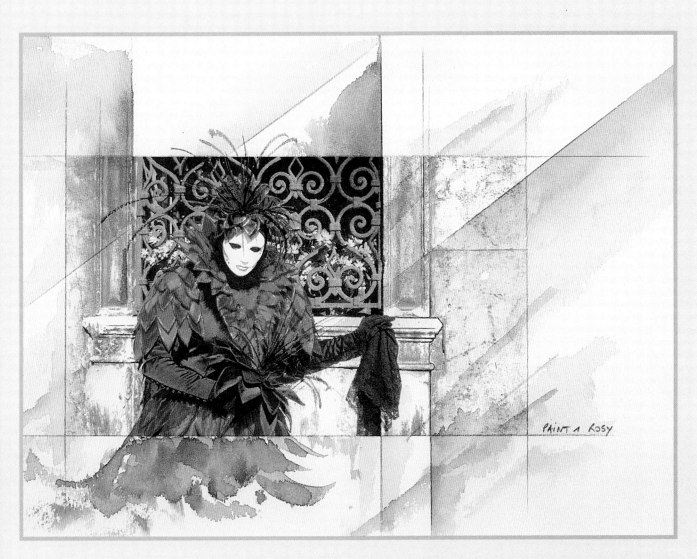

Alain Cassaigne

FRANCE

Sonja Ladenbauer
AUSTRIA

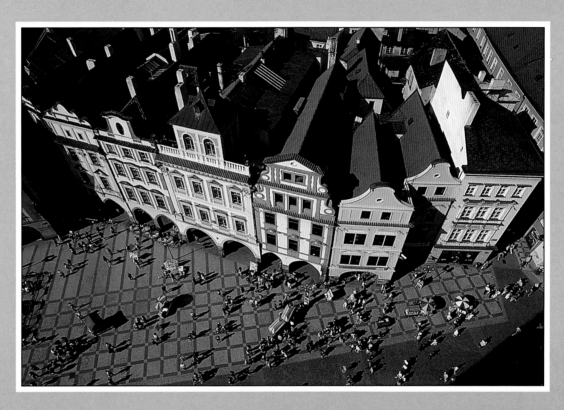

Giulio Veggi
ITALY

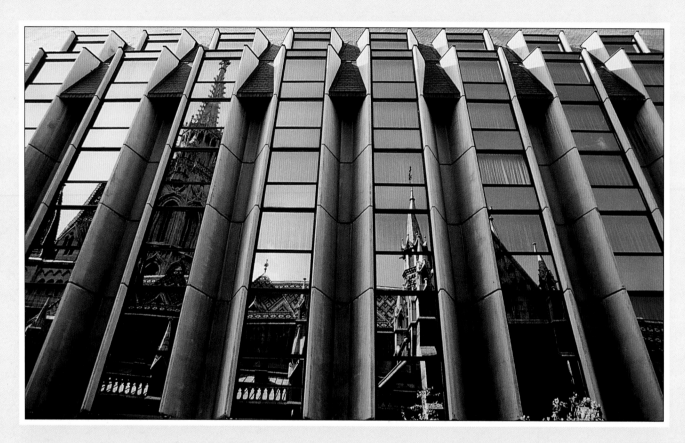

Norbert Gehrmann
GERMANY

Rudi Bieri
SWITZERLAND

202

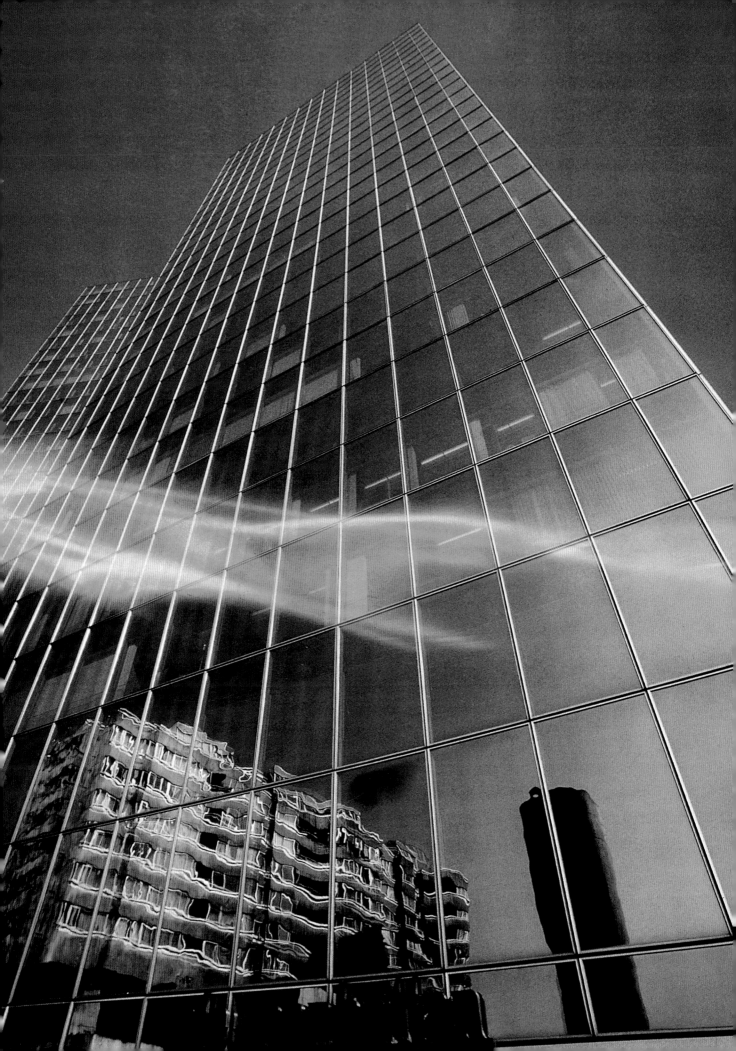

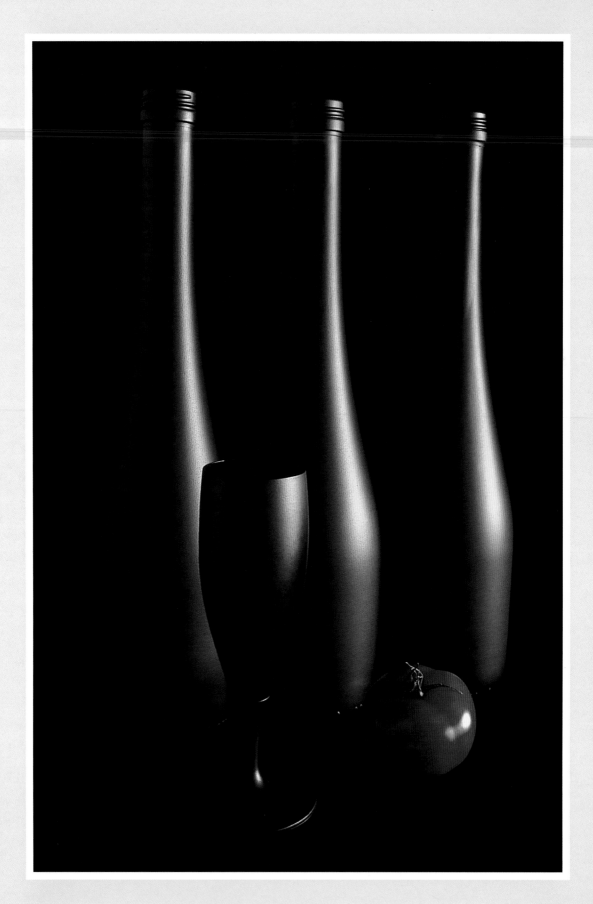

Cor Boers
NETHERLANDS

Emil Stephan
GERMANY

205

John F Gray
UNITED KINGDOM

Dietmar Carli
AUSTRIA

Jussi Laine
FINLAND

210

Marc Anagnostidis
FRANCE

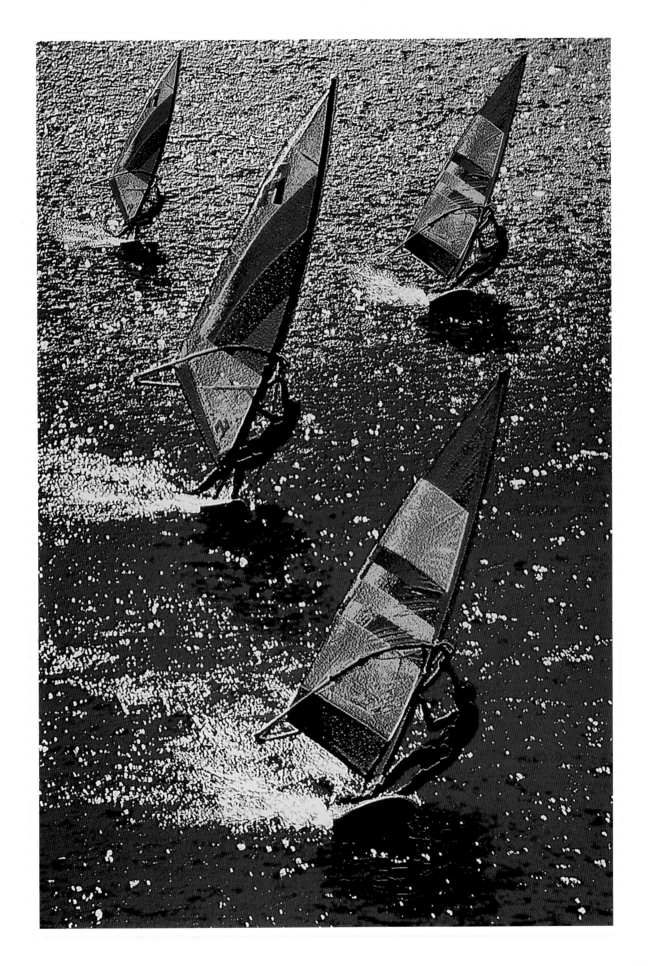

Klaus Rössner
GERMANY

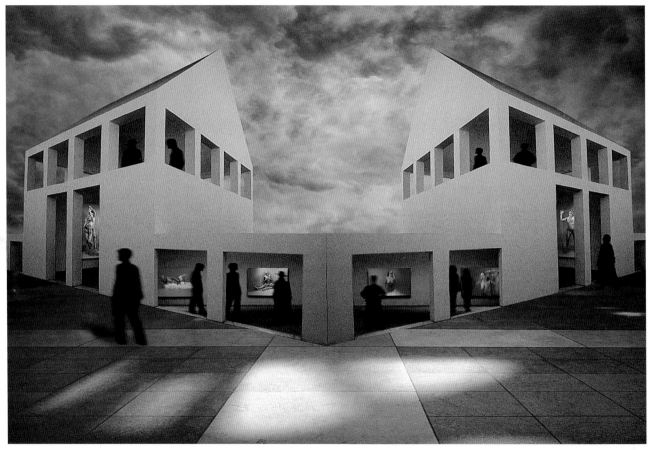

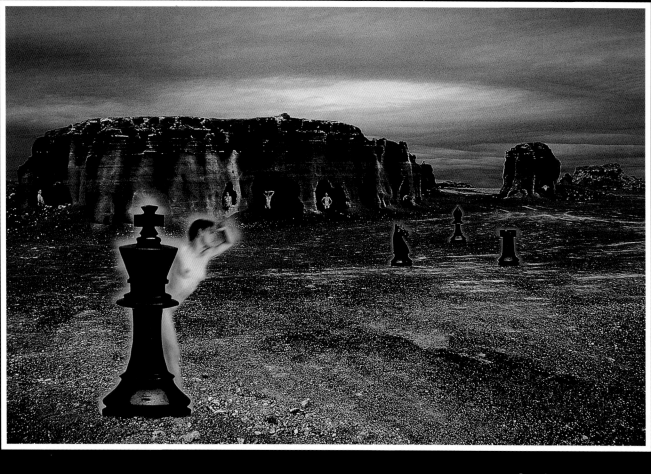

Manfred Kriegelstein

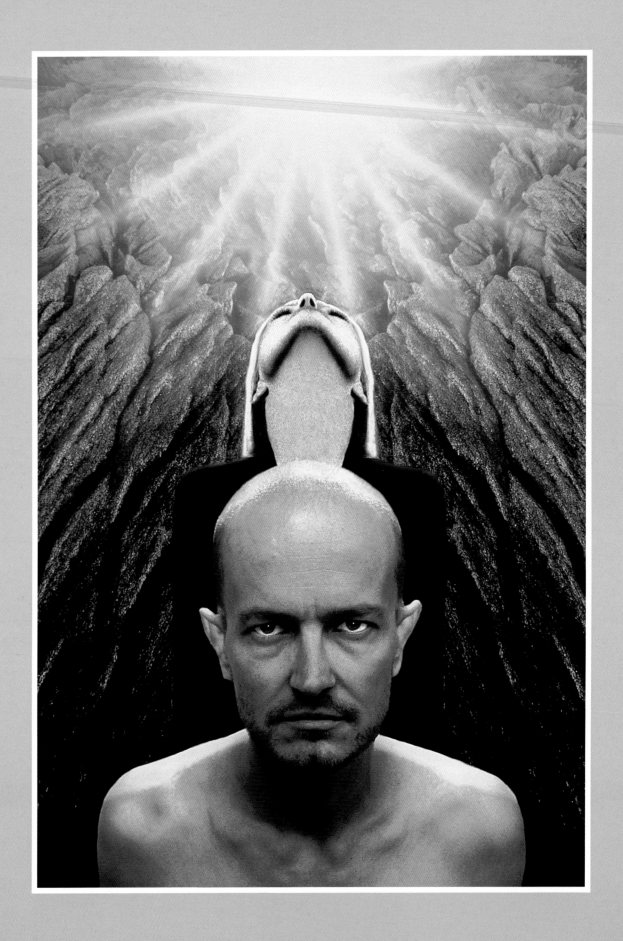

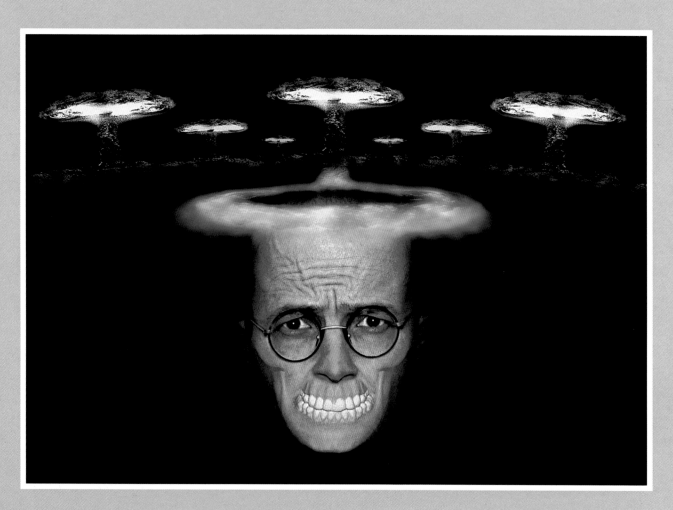

Manfred Holzer
AUSTRIA

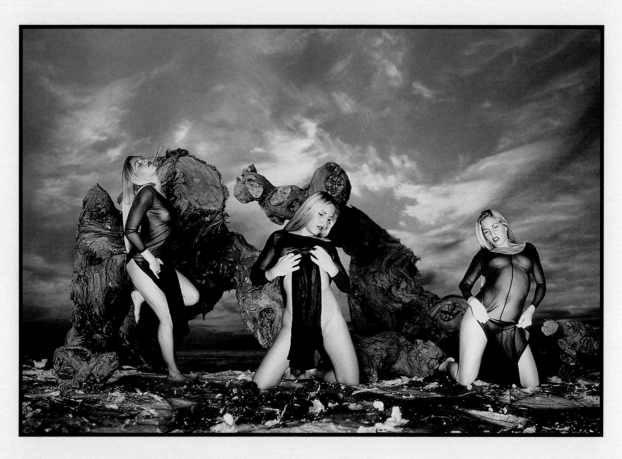

Edmund Steigerwald
GERMANY

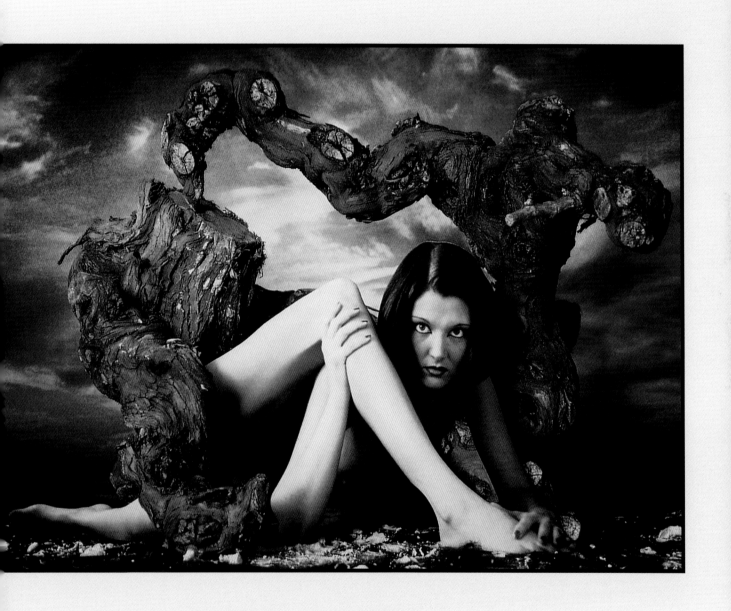

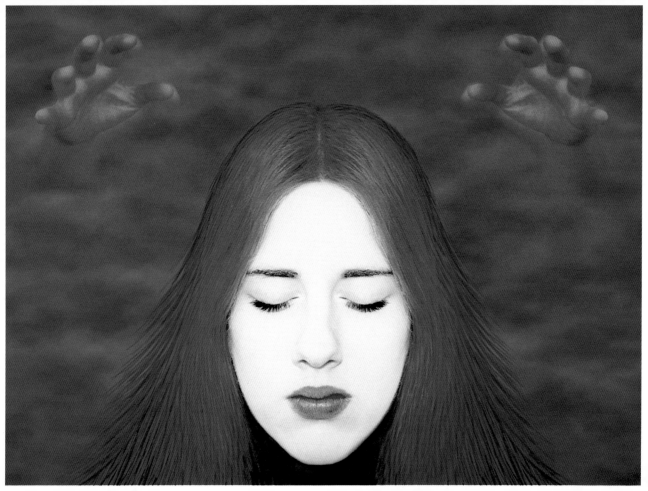

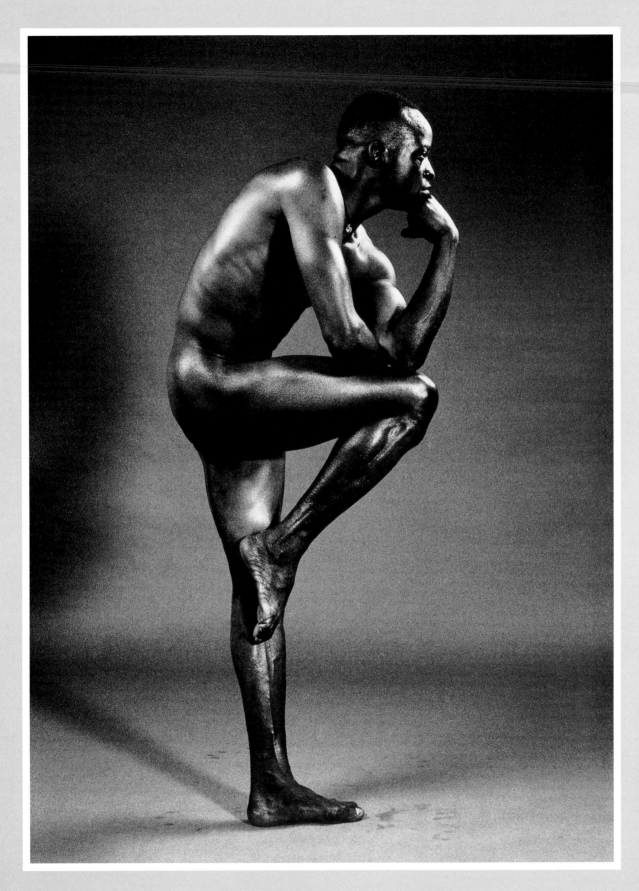

Vesselin Vulchev
BULGARIA

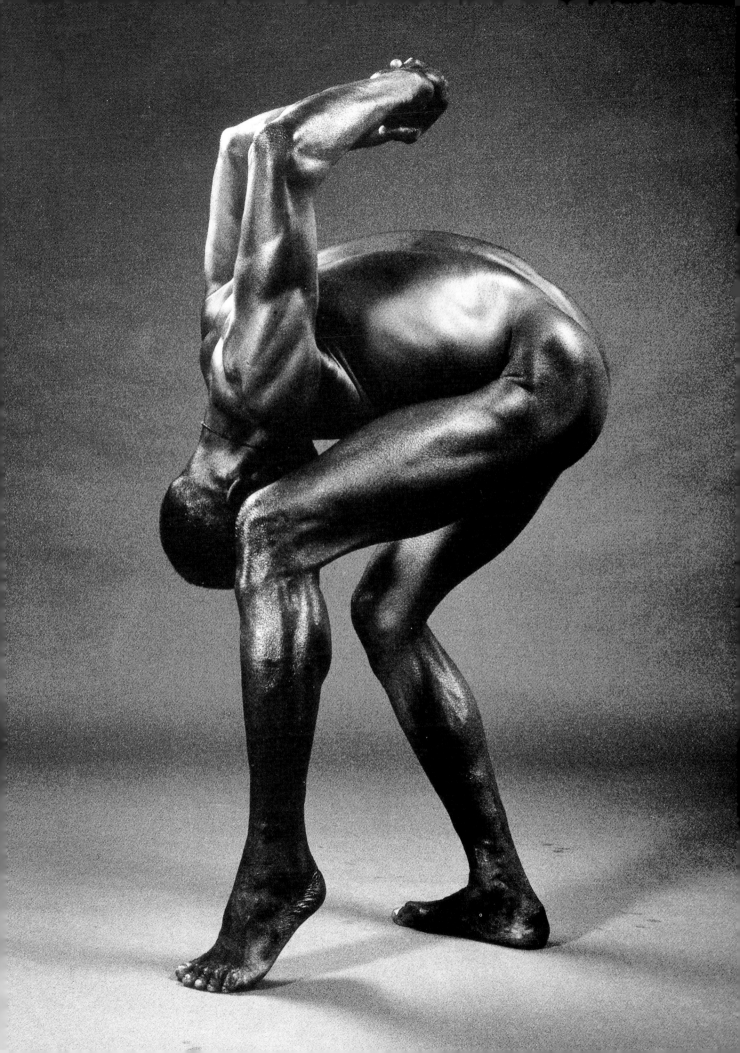

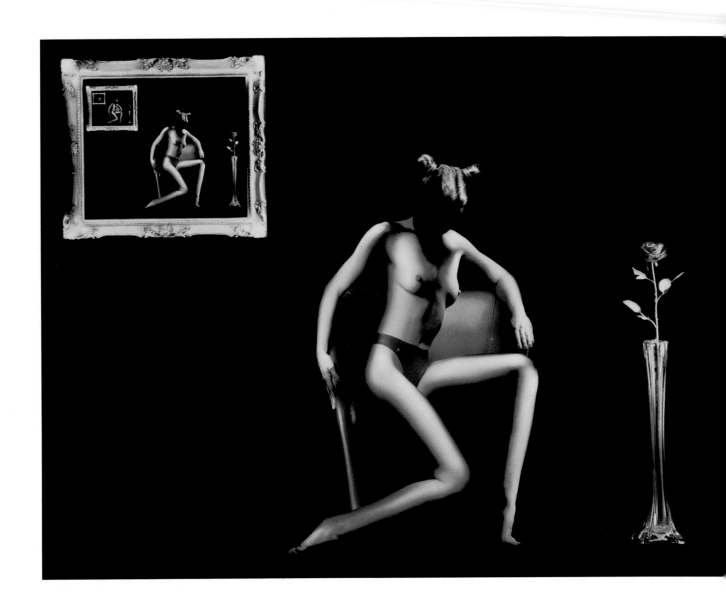

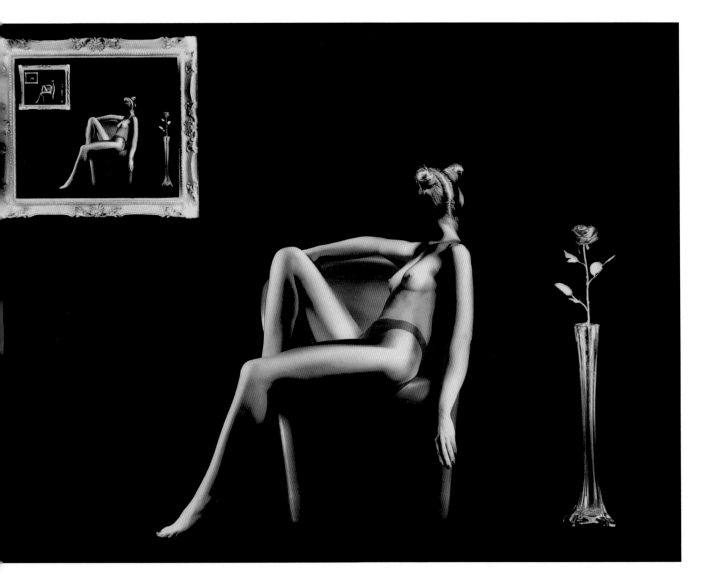

Viglio Ferrari
ITALY

227

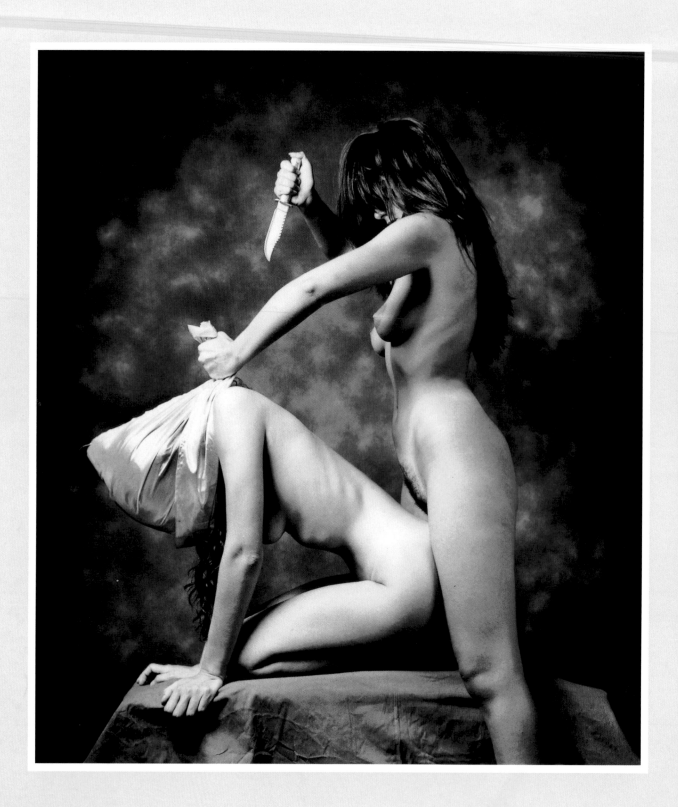

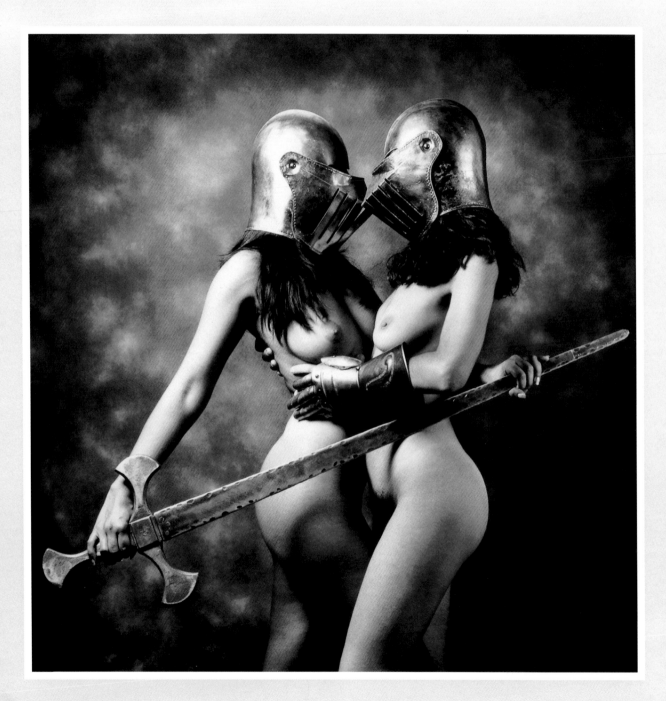

Mauro Paviotti
ITALY

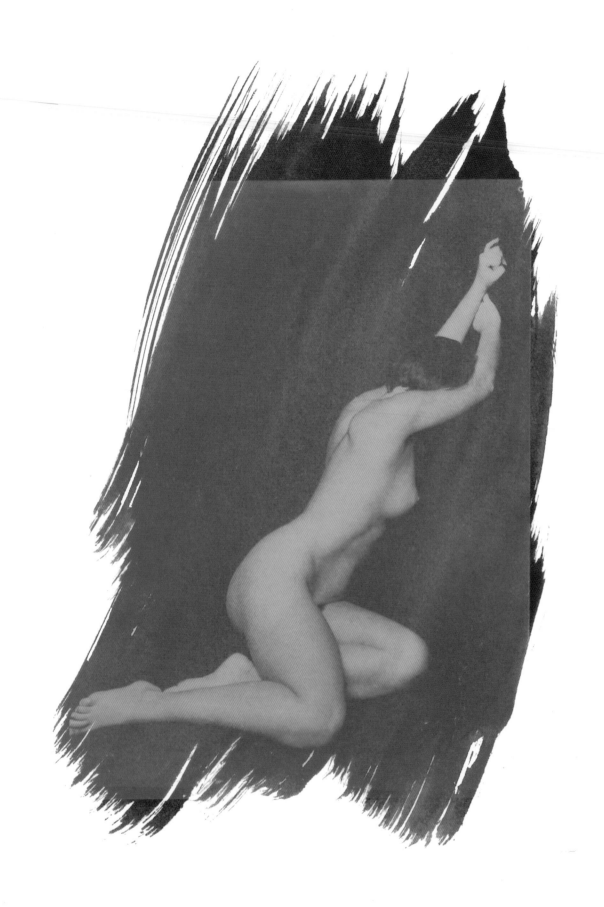

Ray Spence
UNITED KINGDOM

230

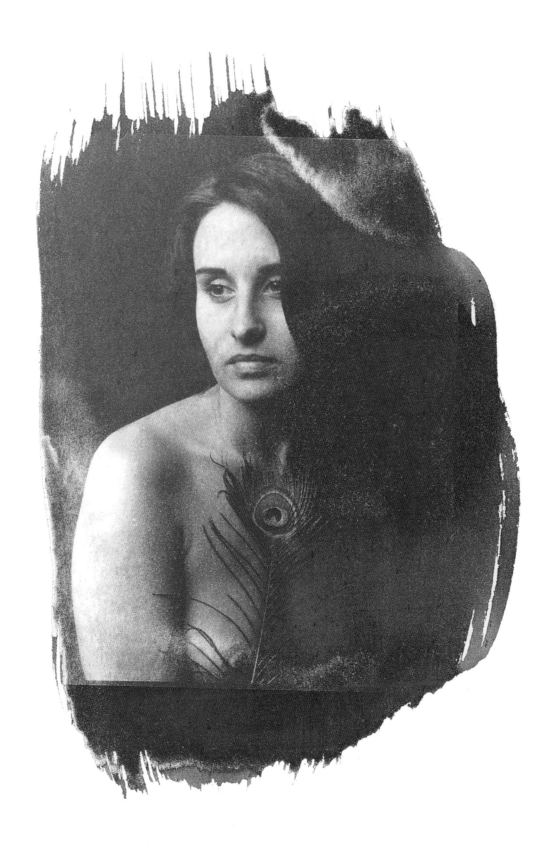

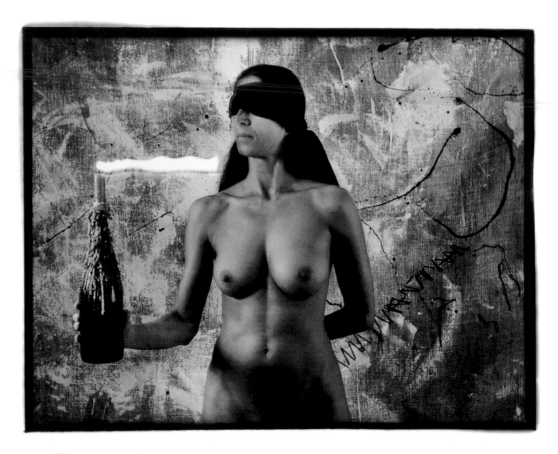

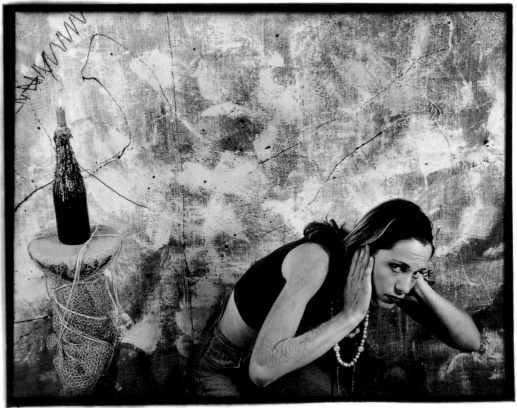

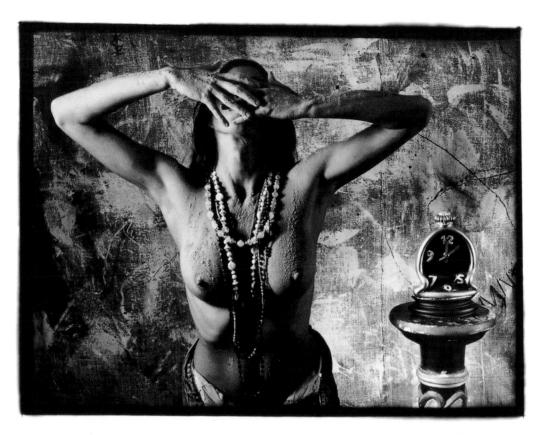

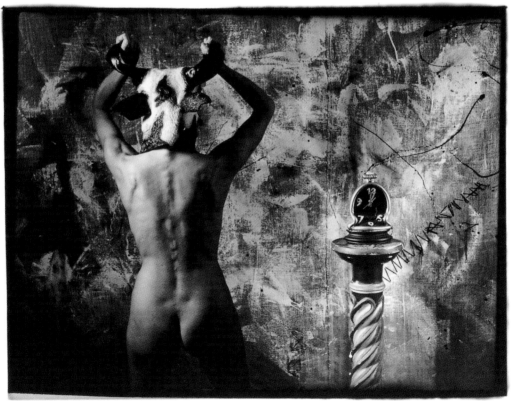

Carles Verdú Prats
SPAIN

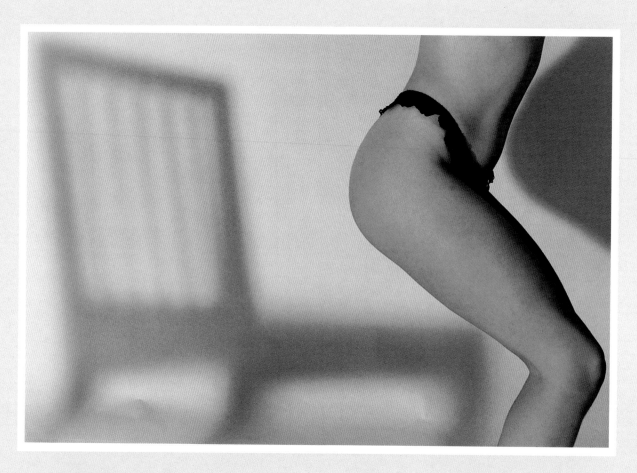

Kenneth Friberg
SWEDEN

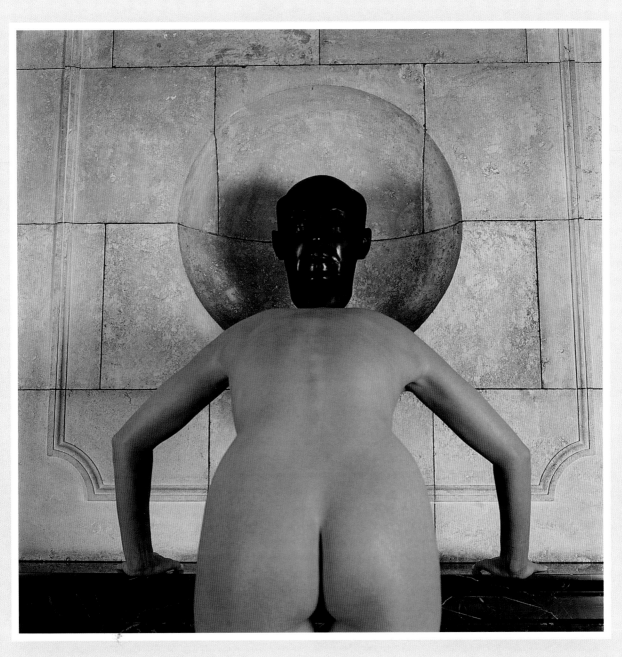

Klaus Rössner
GERMANY

Sarel van Staden
SOUTH AFRICA

TECHNICAL DATA

111
Photographer — Tien Chian Foong / Singapore
Camera — Nikon 75
Lens — Nikon 105 micro + 4 unit SB26
Film — Fujichrome Velvia 50
Subject/Location — Singapore

112
Photographer — Norbert Baranski / Germany
Camera — Canon EOS 1N
Lens — Canon EF 2,8/400 + Converter 2x
Film — Fujichrome Sensia 100
Subject/Location — Germany

113
Photographer — Barbara Lewis-White / United States
Camera — Canon T-90
Lens — Tamaron 200-500 mm f5.6
Film — Elite Chrome II 100 ASA
Subject/Location — The Philadelphia Zoo / United States

114
Photographer — Paul Hicks / United Kingdom
Subject/Location — Puffin

115
Photographer — Malcolm Freeman / United Kingdom
Subject/Location — Barn Owl
From: Hints and Tips, Photographing Birds published by Fountain Press

115
Photographer — Russell Hartwell / United Kingdom
Subject/Location — Heron
From: Hints and Tips, Photographing Birds published by Fountain Press

116, 117
Photographer — Anup & Manoj Shah / United Kingdom
Subject/Location — Orang Utans

118
Photographer — Cor Boers / Netherlands
Camera — Pentax ME Super
Lens — 35-70 mm SMC Pentax
Film — Fujichrome 100 ISO
Subject/Location — Haarlem / Netherlands

119
Photographer — Manfred Zweimüller / Austria
Camera — Canon T90
Lens — FD 3.5/50 Makro
Film — Kodachrome 200
Subject/Location — Salzburg / Austria

120
Photographer — Kenneth Cheng / Canada
Camera — Contax
Lens — Contax Zoom 28-85mm
Film — Kodak Ektachrome 100
Subject/Location — Kearney/Ontario / Canada

121
Photographer — Hans Jörg Richter / Germany
Camera — Canon EOS 50E
Lens — EF 70-200, 1:2.8L USM + Extender EF 2-fach
Film — Kodak Elite 100
Subject/Location — Walgau / Germany

122
Photographer — David Johnston / United Kingdom
Camera — Canon F1
Lens — 70 mm
Film — Kodachrome 64
Subject/Location — Malvern / Worcester / England

123
Photographer — Dario Riva / Italy

124
Photographer — Phyllis Brandano / United States
Camera — Nikon 90
Lens — 70-210
Film — Ektachrome 100S
Subject/Location — York / Maine / United States

125
Photographer — Arthur G. Sticklor / United States
Camera — Canon EOS A2e
Lens — Canon 100-300 mm EF
Film — Fujichrome Sensia 100 ASA
Subject/Location — Waterton Nat. Park, Alberta, Canada

126, 127
Photographer — Agustin Zambrana / Spain
Camera — Hasselblad 503 CX
Lens — Distagon 50 mm
Film — Ilford HP5 plus
Subject/Location — Valle de Baztan, Pirineos Occidentales / Spain

128
Photographer — Dieudonne Andrien / Belgien
Camera — Nikon F4S
Lens — Nikkor 80-200, f4.1/125
Film — Fujichrome Velvia
Subject/Location — Fiscal (Aragon) / Spain

129
Photographer — Andre Sangés / France
Camera — Nikon 801
Lens — Zoom Nikon 70-210
Film — Fujichrome Velvia
Subject/Location — Canyon of High Aragon / Spain

130
Photographer — Alberto Goiorani / Italy
Camera — Nikon F3
Lens — Micro Nikkor 200 mm f.4 IF
Film — Kodachrome 25
Subject/Location — Francia Centro-Sud, Drome

131
Photographer — Alberto Goiorani / Italy
Camera — Nikon F3
Lens — Nikkor 180 mm f. 2.8 ED
Film — Fujichrome Velvia
Subject/Location — Francia del Sud, Provenza

132
Photographer — Maureen Toft / United Kingdom
Camera — Canon EOS 1
Lens — Tamron 28-200 mm
Film — Fujichrome Sensia
Subject/Location — Low tide, South Uist, Scotland

	133
Photographer	Maureen Toft / United Kingdom
Camera	Canon EOS 1N
Lens	Tamron 28-200 mm
Film	Fujichrome Sensia
Subject/Location	Walking the dogs, Gower, Wales

	134
Photographer	Pascal Tordeux / France
Camera	Canon EOS 1N
Lens	20 mm
Film	Fujichrome Velvia 50 iso
Subject/Location	Laon / France

	135
Photographer	Alois Strasser / Austria
Camera	Minolta X-700
Lens	Minolta Rokkor 35mm
Film	Fujichrome Velvia
Subject/Location	Burgenland / Austria

	136
Photographer	John Doornkamp / United Kingdom
Lens	Telephoto zoom set at 100mm
Subject/Location	Dell Garden, Bressingham, Norfolk, England

	137
Photographer	John Doornkamp / United Kingdom
Film	Fujichrome Astia
Subject/Location	Bodnant Gardens, North Wales
	From: Hints and Tips, Photographing Plants & Gardens published by Fountain Press

	138, 139
Photographer	Derek Harris / United Kingdom
Camera	Fuji 617 Panoramic
Lens	105mm
Film	Fujichrome Provia
Subject/Location	*Top:* Trees at Westonbirt Aboretum
	Bottom: Chyverton garden, Zela, Truro, Cornwall

	140, 141
Photographer	Ruth Adams / United States
Scanners	Epson Expression 636, Relisys 4816
Printer	Epson 1520 ink jet printer
Subject/Location	Monstera II, Shaving brush, Hibiscus / Coral Gables, Florida, USA

	142
Photographer	Tony Worobiec / United Kingdom
Subject/Location	Sepia and blue toned print
	From: Beyond Monochrome A Fine Art Printing Workshop published by Fountain Press

	143
Photographer	Tony Worobiec / United Kingdom
Subject/Location	Blue and sepia toned print
	From: Beyond Monochrome A Fine Art Printing Workshop published by Fountain Press

	144, 145
Photographer	Joseph Horvat / Australia
Camera	Olympus OM2N
Lens	Tamron 28-200mm
Film	Kodak High Spped Infrared
Subject/Location	Wollongong / Australia

	146
Photographer	Roy Elwood / United Kingdom
Camera	Bronica ETRS
Lens	Zenzanon 150 mm
Film	Kodak TMX
Subject/Location	Thornton Force / Yorks / England

	147
Photographer	Wolfgang Scheuer / Austria
Camera	Nikon F2
Lens	Nikon 200 mm
Film	Kodak 64
Subject/Location	Skogafoss / Island

	148
Photographer	Rosemary Calvert / United Kingdom
Camera	Canon EOS 10s
Lens	20-35mm
Film	Fujichrome Velvia
Subject/Location	Falls in Treman State Park, New York, USA

	149
Photographer	Rosemary Calvert / United Kingdom
Camera	Canon EOS 10s
Lens	28-105mm
Film	Fujichrome Velvia
Subject/Location	Aspen Woods, Colorado, USA

	150/151
Photographer	Helmut Resch / Austria
Camera	Leica R8
Lens	1:2.8/100 Apo
Film	Kodak Ektrachrome
Subject/Location	Wienerwald / Austria

	152
Photographer	Alfons Vlaminckx / Belgium
Camera	Nikon F90
Lens	Nikon Zoom 28-70 1:3.5-4.5D
Film	Fujichrome 100 Sensia II
Subject/Location	Keukenhof / Netherlands

	153
Photographer	Anette Mortier / Belgium
Camera	F801S
Lens	300mm
Film	Sensia 100
Subject/Location	Bevekom / Belgium

	154
Photographer	Piotr Powietrzynski / United States
Camera	Mamiya 645 PRO
Lens	55/2.8
Film	Kodak Ektar 25
Subject/Location	Long Island / United States

	155
Photographer	Piotr Powietrzynski / United States
Camera	Mamiya 645 PRO
Lens	80/1.9
Film	Kodak Ektar 25
Subject/Location	Sopot / Poland

	156, 157
Photographer	Paavo Merikukka / Finland
Camera	Canon T90
Lens	Canon 200 mm Macro
Film	Fujichrome Velvia
Subject/Location	Helsinki / Finland

158
Photographer Robert L. Morgan / United States
Camera Nikon F4
Lens Nikon 50-135 200 m
Film Fujichrome Velvia
Subject/Location Snoqualmie Nat. Forest / United States

159
Photographer Murphy M. Hektner / United States
Camera Pentax LX
Lens Pentax FA 28-105
Film Fujichrome Velvia
Subject/Location Snoqualmie Nat. Forest / United States

160
Photographer Manfred Baumgartner / Austria
Camera Minolta 9000
Lens Minolta 20mm/2.8
Film Kodak Infrarot / Fujichrome Sensia 100 / (sandwich)
Subject/Location Neu-Guntramsdorf / Austria

161
Photographer Cor Boers / Netherlands
Camera Pentax ME Super
Lens 24 mm SMC Pentax
Film Fujichrome 100 ISO
Subject/Location Grate-Peel-Limburg / Holland

162
Photographer Tam Gim-Kou / Hong Kong

163
Photographer Ng Man-Kuen / Hong Kong
Camera Hasselblad 500 G/M
Lens 250 f5.6 Sonar
Film Fujichrome 100
Subject/Location China

164
Photographer Manfred Kriegelstein / Germany
Camera Leica R5
Lens 35 mm
Film Kodachrome 200
Subject/Location Montmartre / Paris / France

165
Photographer Manfred Kriegelstein / Germany
Camera Leica R5
Lens 35 mm
Film Kodachrome 200
Subject/Location Bombay / India

166/167
Photographer Shivji / India

168
Photographer Italo di Fabio / Italy
Camera Topcon Resuper
Lens 28 mm Topcor
Film Kodachrome
Subject/Location Rimini / Italy

169
Photographer Rashid Un Nabi / Bangladesh
Camera Nikon FE 2
Lens Nikor 28-85mm
Film Fujichrome HR 100
Subject/Location Feni River/Chittagong / Bangladesh

170
Photographer Lan Van Nguyen / United States
Camera Rolleiflex Single Lense Reflex
Lens 80 mm F.2.8
Film Kodak 100 ASA
Subject/Location Vietnam

171
Photographer Le Hong Linh / Vietnam
Camera Nikon F-601
Lens AF Nikkor 28-85 mm
Film Agfa 100 ASA
Subject/Location HCM City / Vietnam

172
Photographer Tan Yam Heng / Malaysia

173, 174
Photographer Leong Fook Hoe / Malaysia
Camera Canon EOS 1N
Lens Canon 28-70mm f2.8L
Film Kodak Gold II 100 ASA
Subject/Location Bekenu Village, Miri, Sarawa / Malaysia

175
Photographer So Chung Shek / Hong Kong

176
Photographer L.S. Tak / India

177
Photographer Gerardus van Mol / Netherlands

178
Photographer Karl-Heinz Papenhoff / Germany
Camera Nikon F4
Lens 2,8 100 mm
Film Kodak Elite 100
Subject/Location Nyaung U / Bagan in Myammar

179
Photographer Junid B. Osnam / Singapore
Camera Nikon F4
Lens Nikon ED, 180 mm 1:2.8 & Libc Filter
Film Kodak Ektachrome EPP 135-36

180
Photographer Huynh Ngoc Dan / Vietnam
Camera Nikon F.3 HP
Lens 20 mm f.3.5 Nikkor A.1
Film Kodakchrome Elite II
Subject/Location Khai Dinh Temple / Hue City / Vietnam

181
Photographer Lam Kin Cheong / Macao
Camera Nikon FM-2
Lens Nikon 24 mm F2.8
Film Fuji
Subject/Location China

182, 183
Photographer Omero Tinagli / Italy
Camera Canon EOS 1
Lens Canon Zoom - 20/35 f2.8
Film Kodak TRI-X 400 ASA
Subject/Location Scanno - Regione Abruzzo / Italy

184
Photographer Sergey Buslenko / Ukraine
Camera Mamiya RB 67
Lens Mamiya Sekor f=90mm
Film Fujichrome NPH400
Subject/Location Odessa / Ukraine

	185
Photographer	Vladimir Vitow / Russia
Camera	Canon EOS 1N
Lens	Canon EF 70-200 mm f2.8
Film	Fujichrome
Subject/Location	St. Petersburg / Russia

	186, 187
Photographer	Elena Martynyuk / Ukraine
Camera	Yashica FX-3 Super 2000
Lens	Yashica ML 50mm 1:1.9c
Film	Svema 400
Subject/Location	Studio / Ukraine

	188, 189
Photographer	Romualdas Pozèrskis / Lithuania

	190
Photographer	Tillman Kleinhans / United Kingdom
Camera	Canon EOS 5
Lens	28-105 Canon EF
Film	Agfa CTX 100
Subject/Location	Warrington / England

	191
Photographer	Bjarne Nygard / Norway
Camera	Canon EOS 600
Lens	Sigma 24-70, 3.5-5.6
Film	Fujichrome Sensia 100
Subject/Location	Molde / Norway

	192
Photographer	Karl Vock / Austria
Camera	Canon EOS 5
Lens	Canon 28-105 mm
Film	Ilford FP4+
Subject/Location	Studio / Austria

	193
Photographer	Didier Depoorter / France
Camera	Mamiya 645
Lens	150 mm
Film	FP4 plus
Subject/Location	Studio / New Orleans / United States

	194, 195
Photographer	Augusto Biagioni / Italy
Camera	Nikon F2AS
Lens	Micro-Nikkor 55/2.8
Film	Fujichrome Velvia 50 iso
Subject/Location	Studio / Lucca / Italy

	196, 197
Photographer	Herbert Thür / Switzerland
Camera	Mamiya RZ
Lens	Mamiya 140mm Macro
Film	120 T-max 100 ASA
Subject/Location	Studio / Basel / Switzerland

	198
Photographer	Alain Cassaigne / France
Camera	Nikon 801
Lens	50 mm
Film	Fujichrome Sensia 100 ASA
Subject/Location	Venice / Italy

	199
Photographer	Alain Cassaigne / France
Camera	Nikon 801
Lens	28 mm
Film	Fujichrome Sensia 100 ASA
Subject/Location	Venice / Italy

	200
Photographer	Sonja Ladenbauer / Austria
Camera	Yashica 230 AF
Lens	35-105 mm
Film	Fujicolour 200 ASA
Subject/Location	Prague / Tschechia

	201
Photographer	Giulio Veggi / Italy

	202
Photographer	Norbert Gehrmann / Germany
Camera	Nikon F4S
Lens	Nikkor 20mm 1:2.8
Film	Fujichrome Sensia 100
Subject/Location	Budapest / Hungary

	203
Photographer	Rudi Bieri / Switzerland
Camera	Pentax LX
Lens	SMC-Pentax-Zoom 4/24-50
Film	Kodachrome 64
Subject/Location	La Défense / Paris / France

	204
Photographer	Cor Boers / Netherlands
Camera	Pentax M.E. Super
Lens	35-70 mm SMC Pentax
Film	Fujichrome 100 ISO
Subject/Location	Haarlem / Netherlands

	205
Photographer	Emil Stephan / Germany
Camera	Contax ST
Lens	Carl Zeiss Vario Sonnar 4/80-200
Film	Kodak Elite 50 ASA
Subject/Location	Nuremberg / Germany

	206
Photographer	John F. Gray / United Kingdom
Subject/Location	Creative Brushwork, Sunflower, Watercolours

	207
Photographer	John F. Gray / United Kingdom
Subject/Location	Football Pools!, Washday Reflections

	208
Photographer	Dietmar Carli / Austria
Camera	Nikon 801 S
Lens	Nikon 85 mm 1.8
Film	Fujichrome Sensia II 100
Subject/Location	Innsbruck / Austria

	209
Photographer	Dietmar Carli / Austria
Camera	Nikon 801 S
Lens	Nikon 70-210 mm 4-5.6
Film	Fujichrome Sensia II 100
Subject/Location	Innsbruck / Austria

	210
Photographer	Jussi Laine / Finland
Camera	Canon T90
Lens	Canon FD 15mm/F1:2.8
Film	Fujichrome Sensia 200
Subject/Location	Hanko Peninsula / Finland

	210			**220**
Photographer	Jussi Laine / Finland		Photographer	Edmund Steigerwald / Germany
Camera	Canon T90		Camera	Canon EOS5 u. EOS 600
Lens	Canon FD 15mm/F1:2.8		Lens	Canon 18-50 mm u. 3.5-5.6 - 28.80 mm USM
Film	Kodachrome 200		Film	Agfa Scala 200 u. Elite 100
Subject/Location	Hanko Peninsula / Finland		Subject/Location	Hannover / Germany
	211			**221**
Photographer	Jussi Laine / Finland		Photographer	Edmund Steigerwald / Germany
Camera	Canon T90		Camera	Canon EOS5 u. EOS 600
Lens	Canon FD 15mm/F1:2.8		Lens	Canon 28-80 mm 3.5-56 USM u. 1.8-50
Film	Fujichrome Sensia 200		Film	Elite 100
Subject/Location	Lappeenranta / Finland		Subject/Location	Hannover / Germany
	211			**222, 223**
Photographer	Jussi Laine / Finland		Photographer	Manfred Holzer / Austria
Camera	Canon T90		Camera	Nikon F90X
Lens	Canon FD 15mm/F1:2.8		Lens	Nikon Zoom 28-70
Film	Fujichrome Sensia 200		Film	Elite II 100 ASA
Subject/Location	Oahu, Hawaii / United States		Subject/Location	Vienna / Austria
	212			**224, 225**
Photographer	Marc Anagnostidis / France		Photographer	Vesselin Vulchev / Bulgaria
Camera	Nikon F4		Camera	Pentax 645
Lens	Nikkor AF 80-200 mm f/2,8		Lens	75mm
Film	Sensia 100		Film	Ilford 400
Subject/Location	Vichy / France		Subject/Location	Bulgarien
	213			**226, 227**
Photographer	Marc Anagnostidis / France		Photographer	Viglio Ferrari / Italy
Camera	Nikon F4		Camera	Mamiya RB67 Pro S
Lens	Nikkor ED 300 mm f/4 AF		Lens	Mamiya Aekor C f=90mm 1:3,8
Film	Sensia 100		Film	Kodak Ektrachrome 100 Plus EPP
Subject/Location	Cannes / France		Subject/Location	Studio / Scandiano / Italy
	214			**228, 229**
Photographer	Klaus Rössner / Germany		Photographer	Mauro Paviotti / Italy
Camera	Mamiya RB 67		Camera	Hasselblad 500 c/m
Lens	KL 127		Lens	Planar 80 mm f.2,8
Film	Kodak 100 SW		Film	Kodak T Max 100 ASA
Subject/Location	Studio / Stadtsteinach / Germany		Subject/Location	Studio / Fr. Morsano-Castions di Strada / Italy
	215			**230, 231**
Photographer	Klaus Rössner / Germany		Photographer	Ray Spence / United Kingdom
Camera	Nikon F90X		Subject/Location	Cyanotype prints
Lens	Sigma 2,8/90mm macro			*From: Beyond Monochrome A Fine Art Printing*
Film	Kodak Elite 100			*Workshop published by Fountain Press*
Subject/Location	Studio / Stadtsteinach / Germany			
	216			**232, 233**
Photographer	Manfred Kriegelstein / Germany		Photographer	Carles Verdú Prats / Spain
Camera	Leica R5		Camera	Mamiya 645 PRO
Lens	15 mm		Lens	Mamiya Sekor C 1:1.9 f: 80 mm
Film	Ektrachrome 100		Film	Kodak T-Max 100 ASA
Subject/Location	Frankfurt / Germany		Subject/Location	Studio / Barcelona / Spain
	217			**234**
Photographer	Manfred Kriegelstein / Germany		Photographer	Kenneth Friberg / Sweden
Camera	Leica R5		Camera	Nikon F4
Lens	28 mm		Lens	Nikon 35-70/2,8
Film	Kodakchrome 64		Film	Fujichrome NPS160
Subject/Location	Lanzarote / Canary Islands		Subject/Location	Studio / Stockholm / Sweden
	218, 219			**235**
Photographer	Manfred Holzer / Austria		Photographer	Klaus Rössner / Germany
Camera	Nikon F90X		Camera	Hasselblad 503 CXI
Lens	Nikon Zoom 28-70		Lens	2,8/80mm
Film	Elite II 100 ASA		Film	Kodak 100 SW
Subject/Location	Vienna / Austria		Subject/Location	Mainleus / Bavaria / Germany
				236/237
			Photographer	Sarel van Staden / South Africa